Origin of Place Names in

PECKHAM

and

NUNHEAD

John D. Beasley

AMBERLEY

First published 2010

Amberley Publishing
Cirencester Road, Chalford,
Stroud, Gloucestershire, GL6 8PE

www.amberley-books.com

Copyright © John D. Beasley, 2010

The right of John D. Beasley to be identified as the
Author of this work has been asserted in accordance with the Copyrights,
Designs and Patents Act 1988.

British Library Cataloguing in Publication Data.
A catalogue record for this book is available from the British Library.

ISBN 978 1 84868 224 5

Typesetting and origination by Amberley Publishing
Printed in Great Britain

CONTENTS

FOREWORD

by Tessa Jowell,
Member of Parliament for Dulwich and West Norwood

Dulwich means 'marshy meadow where dill grows', while Peckham means village by a hill – probably Nunhead Hill. Nunhead is a local name with an uncertain origin.

John Beasley is a prolific local historian and writer who shares his evident love of Peckham and Nunhead with us. This catalogue of local place names and their history is clearly a project motivated by fascination and an evangelism which wants to ensure that others with similar curiosity will be similarly well informed.

It shows a dedication to home and neighbourhood that is rare in London now, where people move on usually without the opportunity to put down roots or to develop the curiosity which gives expression to attachment to neighbourhood.

This book catalogues street and place names. It also covers the origin of pub names and more recent local shops. It reminds us that Peckham and Nunhead were developed in two stages. Most of the early development was comfortably Victorian. The later development started in the late 1930s and continued with the development of pre-and post-war housing estates. Small terraces of cottages which stood under their own names were gradually parcelled up and renamed as Bellenden Road, Consort Road, Ondine Road and so on.

This book has added to my curiosity about this special part of London, which it is such a privilege to represent in Parliament. I look forward to John's next volume.

AUTHOR'S PREFACE

Abraham Lincoln admitted: 'I have changed my mind and I don't think much of a man who isn't wiser today than he was yesterday.' This book would not have been written if I had not changed my mind.

L. S. Sherwood compiled 'Camberwell Place and Street Names and Their Origin' which was typed and issued by Camberwell Borough Council in 1964.

It was obvious that the work Mr Sherwood did on Peckham names needed updating and expanding, but I felt that a book on the origin of names in Peckham and Nunhead would leave too many questions unanswered.

However, I decided to write the book through seeing an Aylesham Centre sign in Hanover Park as I drove to work at 7.20 a.m. on 16 July 1986. Though I didn't like the name of the new shopping centre I felt that people had the right to know why it was so called. Then followed a fascinating search for the origins of over 800 names in SE15. They were included in the first edition of this book called *Origin of Names in Peckham and Nunhead* (published by South Riding Press in 1993).

I owe a great debt to Leslie Sherwood for his research. Though he lived at 138 Copleston Road, close to my home, I never met him but did receive a letter from him in 1981 when he was eighty-two. He described his research as 'a very absorbing job, completed just before my retirement in 1964'.

It has not been possible to check all Leslie Sherwood's sources. Some origins may be inspired guesswork. A few errors have been corrected.

Many primary sources have been impossible to find because information was destroyed or not recorded; some may be hidden in the *South London Press* and other local newspapers which are not indexed.

Some records were destroyed after the Greater London Council was abolished so the origins of some names used in the last forty-five years cannot be traced.

Dates given for streets built in the nineteenth century are as published in London County Council records but are not necessarily the dates on which streets were built.

In *The Streets of London*[1] Sheila Fairfield wrote: 'At times of rapid expansion, particularly in south and north-west London, streets rolled out like matting in all directions, and dozens of names were needed all at once. Anything would do that sounded pleasant: lists of English towns, Scottish lochs, holiday resorts, great rivers and famous peaks were all pressed into service from 1850 onwards. They had no local relevance at all; they were a kind of topographical formica.'

Achievement: A Short History of the London County Council [2] stated: 'When London was a small City surrounded by a wall and a number of isolated villages it was understandable that each community should have a High Street, or a Church Street, or a George Street or a James Street (called after the king of the day). When London had coalesced into one great metropolis there was, in consequence, great duplication and repetition of street names through the area. There were dozens and dozens of streets with similar names. The Board of Works had, in its time, changed the names of over 3,000. The Council, prodded by the Post Office, carried out a programme of renaming, and by 1935 had altered another 2,700 street names. In 1935 it decided to abolish all duplicate street names in the County. There were then nearly 4,000 of them. One of the headaches was to find acceptable new names. Old maps were consulted, old field names were revived, and historical and local associations were made use of.'

What may surprise many readers is that some more recent names have no local connections. Shakespeare and Shelley had no known links with Peckham but properties have been named after them. Southwark Council has a list of well-known people from which names are selected. Telephone directories have been used in the same way.

Flats on the North Peckham Estate were named after places in Hampshire; some are no longer in that county because of boundary changes. There is a link with nearby Southampton Way built on land owned by the D'Uvedales whose principal estates were in Hampshire. The Gloucester Grove Estate had blocks named after places in Gloucestershire.

Where names include 'The', such as The Aylesham Centre and various pubs, this has been omitted, except in a few cases.

A lot of names have ceased to be used since research for this book began e.g. Claudia Jones Youth Club. Much of north Peckham has been rebuilt for a second time since the Second World War.

Many people assisted by providing information and making useful suggestions. I am grateful to them all. Special thanks must go to Stephen Humphrey, Ian Ogden, Stephen Potter and Ron Woollacott. I also greatly appreciate the foreword written by Tessa Jowell.

The first edition of this book was dedicated to Walter Finch (see Finch Mews). He suggested that I should write a book to mark the centenary of the South London Mission so *The Bitter Cry Heard and Heeded* was published.

Walter Finch proposed the name Cherry Tree Court for the new flats on the site of the former Queen's Road Methodist Church opened in 1865 and demolished in 1972. If the origin of every name in SE15 had been as well recorded as Cherry Tree Court this book would be comprehensive.

This new book is dedicated to Walter Finch and his wife Connie (*d.* 20 November 2008 aged ninety-two) and to Walter's older brother Harold and his wife Hilda. All four were energetic stalwart members of Peckham Methodist Church for many years. Harold and Hilda are a remarkable couple who are now both aged ninety-six. Harold has been a Methodist Local Preacher since 1935.

Harold and Hilda Finch worked at the Bermondsey Settlement with the founder, Dr John Scott Lidgett. Later Harold worked for the Youth Service in Tower Hamlets for twenty-seven years. Through his contacts there I became a Social Worker in that borough for over twenty years. Harold and Hilda Finch performed the official opening of the present Peckham Methodist Church in 1974.[3] My baby daughter Josephine was present on that happy occasion. Harold christened my daughter Kathryn two years later. As a tribute to the highly regarded Finch family my son was christened Michael John Finch Beasley.

I hope readers will provide missing information and point out any errors. Please write to me at 6 Everthorpe Road, Peckham SE15 4DA. All material sent to me will be deposited in Southwark Local History Library, 211 Borough High Street, SE1 1JA (020 7525 0232) where much research for this book was done.

As I travel outside SE15 I am intrigued by other names. Every district needs a book giving the origin of its names. I hope this volume will inspire other local historians, in the London Borough of Southwark and other parts of Britain, to compile similar books.

Since the first edition of this book was published I have deposited the origins of new SE15 names in the highly acclaimed Southwark Local History Library which has provided most of the photographs for this book. I am delighted that Amberley Publishing Ltd wanted to produce this new edition.

Many of the names in the first edition can no longer be seen in Peckham but they are included in this book. Five estates were demolished in north Peckham so the old and new names are here. A lot of pubs have been demolished or converted into residential accommodation. The names of all the pubs that existed in 1993 are included.

Peckham Society News has published the origins of most of the new names that have appeared in SE15 since 1993. Anyone who wants to learn about the origins of future names will also be able to do so by reading the Peckham Society's magazine.

In Peckham's first map[4] for residents and tourists, which achieved national publicity, I stated: 'People's lives are enriched by local history. The more they know about their locality the more interesting the area becomes to them. It is knowledge that makes dull streets spring to life.'

J.D.B., Peckham, 2010

PS Harold Finch died peacefully in his sleep on 4 April, Easter Day, 2010. A thanksgiving service for his life was held at Peckham Methodist Church on 1 May.

KEY

(P) Pub

(e.g. Warburton Road) Indicates either the former name of the road or the names of individual terraces or houses or former names of parts of road.

[] Key to sources and further reading. See page 143.

1 *The Streets of London: A dictionary of the names and their origins* by Sheila Fairfield. Papermac, 1984.

2 *Achievement: A Short History of the London County Council* by W. Eric Jackson. Longmans, 1965.

3 *The Bitter Cry Heard and Heeded* includes photographs of Harold and Hilda Finch plus information about Dr Scott Lidgett and the Bermondsey Settlement. [613]

4 *Discover the Real Peckham featuring the Bellenden Renewal Area.*

A

ABBEY (formerly ABBEY NATIONAL), 97 Rye Lane National Building Society, formed in 1849, and Abbey Road Building Society, which began in 1874, merged in 1944. The branch in Rye Lane was opened in 1971 and the name was changed to Abbey in 2003. It is now Santander named after the Spanish port of Santander. [310, 311, 526, 605]

ABBEY ROSE, Blackpool Road Founder of Abbey Rose, Gwyn Reid Thomas, bought the bankrupt business of Abbott Iles & Co. in 1902. There were premises at Canal Head at that time. Mr Thomas renamed the business Abbey Rose because he was keen on churches and flowers, and ABB starts most listings. The firm moved to Blackpool Road in 1988. [250, 251]

ABBOTSBURY MEWS, Nunhead Grove 1989 Abbotsbury in Dorset. [5, 344]

ABERDARE HOUSE, Sumner Estate 1951 Aberdare Canal. [1, 2, 12, 18]

ACORN ESTATE 1963 Camberwell Borough Council built Acorn Estate on the site of Acorn Place (1872). Previously the houses had been known as Emily's Cottages, Leonard's Cottages, End Cottages, Marsh's Cottages, Acorn Cottages and Mary's Terrace. Rose Cottages became part of Acorn Place in 1899. [7, 11, 14]

ACORN PARADE, Acorn Estate 1963 Fruit of the oak. [1, 14, 19]

ACORN WHARF, Frensham Street 1855 Timber importer Richard May acquired his premises at the side of the Grand Surrey Canal which he appropriately named Acorn Wharf. See *Who Was Who in Peckham*. [17, 36, 146]

ADYS ROAD 1878 (Warburton Road, Ravensdale Terrace, Rollistone Terrace, Oakover Terrace, Casterton Terrace, Lockington Terrace) John Adye, legal adviser to Edward Alleyn. In his diary Alleyn recorded that he dined with John Adye of Southwark on 22 September 1619. [1, 7, 10, 165]

ADYS ROAD SCHOOL 1884 It is now St John's and St Clement's C of E Primary School. [475]

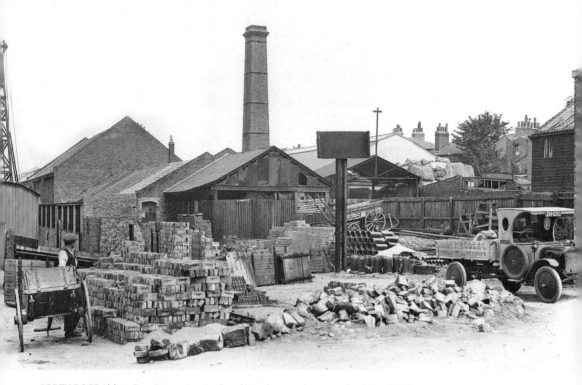

ABBEY ROSE Abbey Rose's premises at Canal Head were photographed in *c.* 1910.

AINSWORTH CLOSE 1996 The name was chosen by the developer from Southwark Council's namebank. The name was taken from an A-Z atlas. [455]

ALBERT WAY off Studholme Street. Prince Albert as it was in Consort Ward. [481]

ALDER CLOSE, North Peckham Estate Daniel Alder, landowner. Alder Street was built in 1863 and demolished when the North Peckham Estate was built. It was off Sumner Road south of Davey Street. [12, 20, 190]

ALDER HOUSE, North Peckham Estate 1950 See Alder Close. [2, 12]

ALDERHOLT WAY, North Peckham Estate 1971 Alderholt in Dorset. [2, 5, 12, 15, 22]

ALL SAINTS' CHURCH, Blenheim Grove Consecrated on 24 July 1872. All Saints' Day (1 November) is a feast to celebrate all the Christian saints, known and unknown. [3, 284]

ALLIANCE, 260 Sumner Road (P) Shown on an 1870 map. Origin not traced. [296]

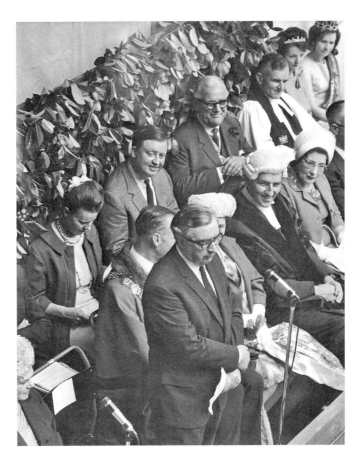

ACORN ESTATE George Brown, Deputy Leader of the Labour Party, opened the Acorn Estate on 20 July 1963.

ALMOND CLOSE, Atwell Estate 1964 Almond tree. [2]

ALMONDSBURY COURT, Gloucester Grove Estate 1975 Almondsbury in South Gloucestershire. [2, 5]

ALPHA STREET Reputed to be the first street built in the Choumert Road district. Alpha is the first letter in the Greek alphabet. [1]

ALYS COURT, Blenheim Grove *c.* 1985 Origin not traced. [322]

AMBLESIDE POINT, Tustin Estate 1965 Ambleside in Cumbria. [2, 5, 14]

AMMON, 40 Sumner Road This residential home for elderly people was named after Lord Ammon (1873–1960) who was Labour MP for North Camberwell (1922–31 and 1935–44). The home was opened by one of his daughters, Miss Ada Ammon, M.B.E., on 20 March 1971. [38, 39, 58, 59]

AMOTT ROAD 1876 John Amott or Amyott was a friend of John Allen, Master of Dulwich College in the 1830s. [1, 7, 10]

AMSTEL COURT, Garnies Close 1971 River Amstel, Netherlands. Presumably because of Camberwell Borough Council's (and Southwark Borough Council's from 1965) friendship link with Deventer in the Netherlands. [26, 361, 410]

ANDOVERSFORD COURT, Gloucester Grove Estate 1977 Andoversford in Gloucestershire. [2, 5, 12]

ANGELINA HOUSE, Oliver Goldsmith Estate 1958 *Edwin and Angelina*, a ballad by Oliver Goldsmith written in 1764 and included in *The Vicar of Wakefield*. [1, 2, 23]

ANN BERNADT NURSERY AND EARLY LEARNING CENTRE, Chandler Way Officially opened by Harriet Harman, MP for Camberwell and Peckham, on 2 December 1997. It commemorates Ann Bernadt (1948-96) who was elected to the Inner London Education Authority for Dulwich in 1986 and to Southwark Council in 1990. [469, 470]

ANSDELL ROAD 1872 Probably Richard Ansdell (1815-85), animal painter. [1, 6, 7]

ANSTEY ROAD 1872 Anstey in Leicestershire or poet Christopher Anstey (1724-1805). A monument to him is in Poets' Corner in Westminster Abbey. [1, 5, 6, 7]

APEXX 138 Gordon Road A variation on the spelling of apex, the highest part of the building. [604]

APOSTOLIC FAITH CHURCH, 95 Fenham Road This international evangelistic organisation holds to the teachings and practices of the Apostles and has for its motto: 'Earnestly contend for the faith which was once delivered unto the saints' (Jude 3). [387]

APPLEGARTH HOUSE, Friary Estate 1952 Applegarthtown, in Dumfries and Galloway, where there was a monastery. [1, 5, 173]

ARCHERS WALK, Camden Estate 1976 Archer's Row was nearby in the nineteenth century. [2, 7, 400]

ARGOS, 54 Rye Lane Opened on 15 November 1991 in part of the former premises of Marks and Spencer. According to *The Collins English Dictionary* 'argosy' was 'a large abundantly laden merchant ship, or a fleet of such ships'. According to Greek mythology, Jason sailed out in the 'Argo' in search of the treasured Golden Fleece. The name was picked from a list of suggested names for the catalogue store chain by Richard Tomkins, the company's founder; the company began trading under the name in 1973. [239, 246]

ARNOLD DOBSON HOUSE, St Mary's Road 1978 Arnold Dobson was born in Preston in 1882 and came to London with his parents in about 1890. He went to Camberwell in 1892

and lived in Peckham Park Road until his marriage to Miss Elsie Swannell in 1921 when they moved to 285 Upland Road.

When he left Albany Road School, he worked first for a grocery company delivering tea by horse and cart, and then as a park attendant for Camberwell Borough Council on the newly opened One Tree Hill. After studying and passing his examinations, he joined the staff of the Borough Engineer's Department. In the First World War he served with the field ambulance section of the RASC in France, Salonika, Palestine and Egypt. After the War he turned to Public Health and was appointed Sanitary Inspector in the Old Kent Road district.

The Second World War brought him varied duties as an ARP instructor, billeting and rehousing officer, home guard and fire-watcher as well as supplying his family with the produce of his allotment.

When he retired in 1948, his interests broadened in several ways. He was appointed to the East London Rent Tribunal, joined the Family Welfare Association, of which he was vice president. He took a special interest in the Camberwell Housing Society which was responsible for the Troy Town flats and social centre.

He became a manager of three schools. He also worked part-time for Thomas Cook's. He became a registered London Guide and acted as a courier from time to time on weekly coach tours.

After his wife died in 1961 Arnold Dobson enjoyed several overseas holidays including one to Canada and the USA Arnold Dobson took a lively interest in all these activities until the last two years of his life when he was housebound until his death on 5 September 1980. [2, 84, 85, 86]

ASHDENE, Acorn Estate 1962 Ash tree. Dene means vale. [1, 2, 14, 19]

ASHMORE CLOSE 2000. Arthur John Ashmore, first superintendent of Peckham Rye Park. [488]

ASTBURY ROAD 1874 (York Terrace) Probably after the Cheshire village of Astbury. [1, 5, 7]

ASYLUM ROAD 1867 (Bath Road) The Licensed Victuallers' Asylum (now Caroline Gardens) situated in that road. [1, 4, 7, 11]

ASYLUM TAVERN, 40 Asylum Road (P) See Asylum Road. [3]

ATHENLAY ROAD 1886 Ath = a ford; Lay = old form of lea i.e. meadow. [7, 350]

ATWELL ESTATE 1963 See Atwell Road. The estate was built on the sites of Atwell Road and Atwell Street (1879). [7, 14, 21]

ATWELL HOUSE See Atwell Road.

ATWELL ROAD 1864 (Rose Cottages) Hugh Atwell (or Attawel or Attewell) actor who was a member of Edward Alleyn's company, *d.* 1621. [1, 6, 7]

AUSTIN'S, 11-23 Peckham Rye George Austin. See Austin's Court. [17]

AUSTIN'S COURT, 11-23 Peckham Rye 1996. Built on the site of Austin's of Peckham which closed on 5 November 1994. Austin's was one of the largest antique and second-hand dealers in Europe. The firm was started by George Austin (1844-1925) who was born in the Oxfordshire village of Blackthorn. He moved to London and by 1876 had opened Oxford Farm Dairy at No. 39 Brayards Road.

When the milk round was finished he used the milk cart for household removals. Billboards in the 1880s advertised 'Cows kept for Infants and Invalids – Milking hours 5 till 7 a.m., 1 till 3 p.m.' The same billboards showed an illustration of a horse-drawn furniture van and advertised 'Household Removals – Furniture Warehoused'. In 1905 the Peckham Rye site was acquired.

George Austin served on the Camberwell Vestry from 1894 until the Vestry was superseded by Camberwell Borough Council; he served on that for three years.

George Edward Austin, son of the firm's founder, with his four sons built the business to international recognition in the 1930s. Derek Austin, George's great grandson, joined the firm in 1949 after demobilization as a pilot for the RAF. A decade later he was joined by his sister Valerie. They ran the famous store until it closed in 1994 as they were unable to find anyone to continue the business.

The list of show business personalities and Royals who were clients reads like *Who's Who*. Among the customers were actors – David Niven, Sean Connery, Maggie Smith, Rex Harrison, Yvonne de Carlo and June Whitfield; writers – Muriel Spark, Elizabeth Jane Howard and Beryl Bainbridge; theatre designer Cecil Beaton and singer Shirley Bassey. Royalty included Princess Margaret and Princess Beatrix who is Queen of the Netherlands. [413, 414, 415, 567]

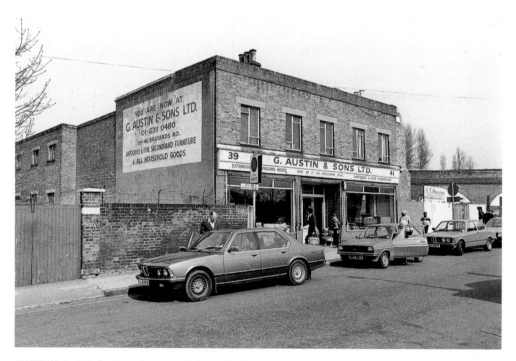

AUSTIN'S Austin's first premises were in Brayards Road.

AVINGTON WAY, North Peckham Estate 1971 Avington in Hampshire. [2, 5, 12, 15]

AVONDALE RISE 1873 (Avondale Road; previously Gothic Villas, Cambridge Villas, Merrow Cottages, Anchor Villas, Harefield Villas, Osman Cottages, Yaxley Villas, Seaton Terrace, Gilbert Villas, Clarence Terrace, Girard Terrace, Walmer Villas) Probably Lord Evandale in Sir Walter Scott's novel *Old Mortality*. [1, 7, 23]

AYLESBURY HOUSE, Friary Estate 1939 Franciscan community at Aylesbury in Buckinghamshire. [5, 14, 37, 361]

AYLESHAM CENTRE Kent mining village. Commemorates the link between Southwark Council and Aylesham during the miners' strike (1984-85). The Peckham Society wanted the shopping centre to be called the Thomas Tilling Centre. Trading began some time before the official opening ceremony was performed by Princess Margaret on 21 July 1988. [33, 34, 301]

AYRE, J. F. See J. F. Ayre.

AZENBY ROAD 1868 (Azenby Road, Aylmer Road, Aspenlow Terrace, Azenby Square) Azenby (now Asenby) in North Yorkshire. [1, 7, 370, 371]

B

BAMBER ROAD Theodore Mark Bamber (1891-1970) attended The Rothschild School at Brentford. When he left school he became a clerk in the offices of the Great Western Railway. In 1913 he went to Spurgeon's College to train for the Baptist Ministry.

His first pastorate was in Cambridgeshire at Centenary Baptist Church, March (1917-21). From there he went to Frinton-on-Sea (1921-26). In 1926 the Rev Theo Bamber went to Rye Lane Chapel and remained there as pastor for thirty-five years.

He was a powerful preacher who exercised a very effective ministry. During the Second World War he often challenged Winston Churchill in his sermons regarding post-war plans and wrote to Churchill giving his views.

In 1961 Theo Bamber retired as pastor of Rye Lane Chapel. He died on a train in Devon while on his way to preach in Bristol. [17]

BANFIELD ROAD 2001 Charles Banfield, coach operator. [569]

BANSTEAD STREET 1883 (Surrey Lane) In an attempt to reduce the number of times Surrey was used in local names, the Surrey village of Banstead was chosen as an alternative. [1, 7]

BARFORTH LODGE, **Barforth Road** 1992 See Barforth Road. [339]

BARFORTH ROAD 1868 Barforth in Durham. [1, 5, 7]

BARMUR HOUSE, 75 Consort Road In 1995 named by Harinville Ltd. Barmur was an anagram of part of two directors' names: Mr Barrett and Mr Murphy. The firm's offices used to be Gold Diggers Arms public house. [184, 568]

BARNABY, 224 Ilderton Road (P) *Barnaby Rudge* by Charles Dickens. Barnaby closed in 2006. [23, 295, 547, 548]

BARSET ESTATE 1981-82 See Barset Road. [2]

BARSET ROAD 1877 (Salisbury Terrace) Probably in honour of Anthony Trollope's Barsetshire novels. *The Last Chronicle of Barset* was published in 1867. Trollope (1815–82) regarded it as his best novel. Salisbury was the main model for Barchester. [1, 4, 7, 23, 410]

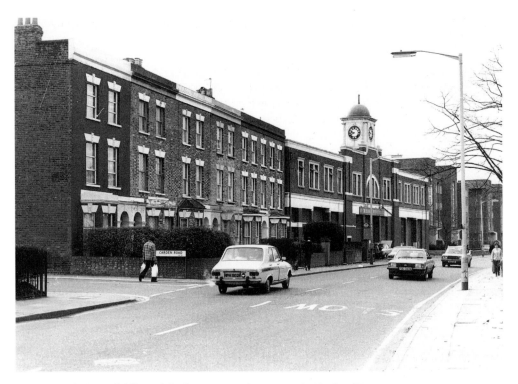

BANFIELD ROAD Banfield's used the former steam bus garage in Nunhead Lane.

BARSET WARD See Barset Road.

BARTON CLOSE, New James Street Estate 1978 Elizabeth Barton was a nun in the time of Henry VIII; she was known as the Holy Maid of Kent. She was beheaded at Tyburn on 20 April 1534 for predicting that the King would die suddenly if he persisted in his intention to divorce Catherine of Aragon and marry Anne Boleyn. Elizabeth Barton was said to be gifted with occult powers, and had a great following in her day. Even Sir Thomas More, the Lord Chancellor, believed in her prophesies. [2, 6, 88, 180, 340]

BASING COURT 1936 (Basing Place) Basing Manor House stood nearby. In writing about the Manor of Basing, W. H. Blanch stated: 'This Manor gave name to a family of some note.' [3, 8]

BASINGSTOKE HOUSE, Sumner Estate 1938 Basingstoke Canal. [1, 2, 12, 24]

BASSWOOD CLOSE, Linden Grove Estate 1980 Basswood is a variety of the lime tree family. [2, 168]

BATH CLOSE, Brimmington Estate 1978-80 Proximity to Asylum Road, formerly Bath Road. [2, 143]

BATTLE HOUSE, Friary Estate 1952 Benedictine community at Battle in East Sussex. [1, 5, 8, 14, 37]

BEATON CLOSE 1999 Norman Lugard Beaton (1934-94) was born in Georgetown, British Guiana, where he became a deputy headmaster of the Government Teachers' Training College. He moved to Britain in 1960 and became a teacher in Liverpool. Later he became a full-time actor and took leading roles at the Old Vic, the National Theatre and the Royal Court Theatre. In 1974 he started the Black Theatre of Brixton which was instrumental in developing contemporary black theatre in Britain.

His most memorable role was as the barber's shop owner in the situation comedy *Desmond's* which was based on a barber's shop at 204 Bellenden Road (now called Desmonds). It ran for six years on Channel 4 until the final episode was shown in December 1994. Some of the filming was done in Peckham. [552, 626]

BEDENHAM WAY, North Peckham Estate 1972 Bedenham in Hampshire [2, 12, 15, 25]

BEECHDENE, Acorn Estate 1963 Beech tree. Dene means vale. [1, 2, 14, 19]

BEEHIVE, 122 Meeting House Lane 1892 (P) The beehive has long been a symbol of industry. [295, 456]

BEESTON HOUSES, Consort Road 1834 Cuthbert Beeston, Master of the Worshipful Company of Girdlers in 1570. [11, 28]

BELFORT ROAD 1938 (Wellington Road) Belfort in France which suffered a siege of three months' duration during the Franco-Prussian War. Throughout the First World War Belfort was the right-hand pivot of the Allied line on the Western Front. [1, 8, 26]

BELLENDEN OLD SCHOOL Opened 9 April 1877. See Bellenden Road. [475]

BELLENDEN PRIMARY SCHOOL, Reedham Street 1981 See Bellenden Road. [144]

BELLENDEN ROAD 1873 (Troy Villas, Victoria Terrace, Bellenden Terrace, Cedar Cottages, St John's Terrace, Selwyn Terrace, Myrtle Villas, Oxford Terrace, Erith Villas, Devonshire Villas, Argyle Villas, Chapel Terrace, Ida Mount, Bellenden Villas, Leamington Villas, Meadow Terrace, Denmark Villas, Alpine Villas) Probably Lady Margaret Bellenden in Sir Walter Scott's novel *Old Mortality* (pub. 1816). The name was extended north along the present road, which originally consisted of numerous individually named groups and terraces, two of which were called Bellenden. The northern section, off Peckham High Street, was formerly Basing Road, and the manor house of Basing lay east of it. [1, 4, 7, 10, 23]

BELLENDEN WARD See Bellenden Road.

BELLS GARDEN ROAD 1863 (Bell's Gardens' Road) Built on the site of nursery gardens belonging to Mr Bell. [1, 3, 7, 10]

BELLENDEN ROAD An old house stood in Basing Road (now part of Bellenden Road).

BELLS GARDENS ESTATE 1979-80 See Bells Garden Road. [2]

BELLWOOD ROAD, Waverley Park Estate 1887 Bellwood, in Midlothian, reminiscent of *Waverley* the first of the novels by Sit Walter Scott (pub. 1814). [1, 7, 23, 27]

BELVEDERE, 43 Linden Grove (P) 1851 Originally a kind of turret constructed in a high place so as to afford a 'fine view', which is what the word means. [144, 295, 340]

BELVEDERE MEWS, Nunhead Grove 1989 Built near to 'The Belvedere' public house. [170]

BERKELEY COURT was a marketing name chosen by developers for the flats made from the former headquarters of the Amalgamated Engineering and Electrical Union in Peckham Road. [485, 498]

BEWICK MEWS off Naylor Road 2001 Name chosen by Ian Ogden of Southwark Council. It has no significance. There is only one other Bewick street name in London. [493]

BIANCA ROAD 1879 Probably after Shakespeare's character in *The Taming of the Shrew*. [1, 7, 29]

BIBURY CLOSE, Gloucester Grove Estate 1974 Bibury in Gloucestershire. [5, 12, 400]

BIDWELL STREET 1868 Bidwell in Bedfordshire. [1, 5, 7]

BIRCH CLOSE, Atwell Estate *c.* 1964 Birch tree. [2]

BIRD-IN-BUSH ROAD 1873 (Hereford Place, Brunswick Terrace, Westbourne Terrace, Westbourne Cottages, Flora Cottages, Oxford Terrace, Montrose Cottages, Havelock Terrace, Radnor Terrace, Smyrren Terrace, Bournemouth Cottages, Cooper's Terrace) Revival of an early field name of which the derivation is unknown. [1, 8,10]

BIRDLIP CLOSE, Gloucester Grove Estate 1974 Birdlip in Gloucestershire. [2, 5, 12, 400]

BISHOP WILFRED WOOD CLOSE, Moncrieff Street The Rt Revd Dr Wilfred Wood became Bishop of Croydon in 1985. He officiated at the opening of the six family houses on 6 December 1989. The houses were built for the African Refugee Housing Action Group. This was the first permanent housing scheme to house families who had to seek refuge in Britain from persecution and oppression in Africa and Third World countries. In recognition of the Bishop's record of support for housing initiatives, and for helping to meet the needs of refugees in particular, the houses were named after him. Bishop Wilfred Wood was Archdeacon of Southwark (1982-85). [193, 194, 195, 196]

BLACKPOOL ROAD 1938 (Russell Road 1872-1938) The seaside resort of Blackpool. [1, 5, 8]

BLACKTHORN COURT, Cator Street 1993 Blackthorn tree. [443, 444]

BLAKES APARTMENTS, Blakes Road 2008 Built on land owned by General Blake in the 1830s. [232]

BLAKES ROAD 1878 (Elizabeth Terrace, Grove Terrace, George's Terrace, Gracefield Terrace, Mardling Terrace, Clifton Terrace, Sanders Terrace) Built on land owned by General Blake in the 1830s. [7, 232]

BLANCH CLOSE, Brimmington Estate 1981 William Harnett Blanch (1836-1900) was born on the *Royal George* as it crossed the equator en route to Australia. On the death of both his parents by an explosion in 1839 he was sent to England to be brought up by his grandparents, John Blanch I and his wife, in Camberwell; his father was John Blanch II.

William conducted his own business as a gunmaker in Liverpool (1861-67) and was the inventor of several rifle accessories. A target rifle using his sights was named after him.

He moved back to London around 1868. He wrote the most comprehensive history of the Parish of Camberwell. *Ye Parish of Camerwell* (published in 1875) is the principal source of information about Peckham's history in the nineteenth century. (A facsimile reprint was published by Stephen Marks for The Camberwell Society in 1976.)

W. H. Blanch conceived the idea of writing a brief history of Camberwell when he was Assistant Overseer of the poor for the Camberwell Vestry, with access to all kinds of documents and numerous contacts.

He was a Fellow of the Royal Historical Society, a regular contributor to *The South London Press* and was at one time the editor and proprietor of the short-lived Conservative journal

The South London Courier. He was the author of *Dulwich College and Edward Alleyn, School Life in Christ's Hospital* (his own school), *The Volunteer's Book of Facts*, and various booklets and pamphlets on rating assessment, on which subject he became an independent adviser after he left the Camberwell Vestry.

When he was an Assistant Overseer he lived at 11 Denman Road. He died in Gravesend and was buried in what today is known as Camberwell Old Cemetery. [2, 17, 552]

BLENDWORTH WAY, North Peckham Estate 1971 Blendworth in Hampshire. [2, 5, 12, 15]

BLENHEIM GROVE (Hollawell Terrace, Victoria Cottages, Dudley Cottages, Auckland Terrace) Dewhirst's 1842 map shows Marlborough House to the north of the High Street (where part of Oliver Goldsmith Estate is today). Opposite, on the south side of the High Street, Blenheim House is marked. In *Ye Parish of Camerwell* (1875) Blanch records: 'Near the High Street, where Marlborough Road now stands, stood Marlborough House, a fine old mansion, supposed at one time to have been the residence of some portions of the Marlborough family. It has not been pulled down many years, and before its demolition it was used as a workhouse where the city paupers were farmed. The building contained a noble entrance-hall and a fine oak staircase, and frescoes adorned the walls and ceilings. Blenheim House, in the High Street, now occupied by Mr Balls, is thought to have been a minor building attached to the mansion.'

Blenheim Palace, seat of the Duke of Marlborough, near Woodstock in Oxfordshire, was conceived as a national monument and virtually as a royal palace. It was the gift of Queen Anne and Parliament to the 1st Duke in gratitude for his victory over the army of Louis XIV at the battle of Blenheim in 1704. [1, 3, 4, 8, 26, 143]

BOATHOUSE WALK 1892 (Maria Terrace, Angler's Terrace, Esther Place, Hayden Place, Globe Cottages, Amis Cottages, Bedford Place, Globe Place, Canal Bank) This path originally approached sheds for craft using the Grand Surrey Canal (completed in 1826; filled in during 1972). [1, 8, 10, 16]

BONAR ROAD 1894 Possibly hymn writer Horatius Bonar (1808-89). [1, 6, 8]

BOOTS, 20 Rye Lane Jesse Boot (1850-1931), British entrepreneur and founder of a pharmacy chain. In 1863 Jesse Boot took over his father's small Nottingham shop trading in medicinal herbs. Recognising that the future lay with patent medicines, he concentrated on selling cheaply, advertising widely, and offering a wide range of medicines. In 1892 he began to manufacture drugs. Jesse Boot had more than 1,000 shops by his death. [227]

BORLAND ROAD 1863 (Marylebone Road, Arnolds Road, Alice Villas, Elsie Villas) John Borland served on Camberwell Vestry in 1870 and was a director of Peckham Pension Society. He lived at 184 High Street. [1, 3, 8, 10, 182]

BOURNEMOUTH CLOSE See Bournemouth Road.

BOURNEMOUTH ROAD 1866 The seaside resort of Bournemouth. [1, 5, 8]

BOWNESS HOUSE, Tustin Estate 1965 Bowness-on-Windermere in Cumbria. [2, 5]

B&Q, Old Kent Road Opened 31 January 1992. B & Q was formed in 1969 by Richard Block and David Quayle. [240, 241]

BRABOURN GROVE 1878 Henry Brabourne (alias Brabon) descended from John Brabourne keeper of the Hawks to Edward IV. The family was related by marriage to the Bowyer family. [2, 3, 8]

BRACKLEY AVENUE Ernest Brackley, gate-keeper at Nunhead Cemetery. [513]

BRADFIELD CLUB, Commercial Way On 20 October 1891 a Men's Institute for the Parish of St. Luke, Camberwell, was founded at nos. 7 & 9 Commercial Road. It became known as St Luke's Lads' Club and in December 1911 the Club was adopted by Bradfield College, Berkshire. Prince Philip visited Bradfield Club in 1952. He next visited in May 1985 when he opened the newly refitted building. It is now called Bradfield Youth & Community Centre. [101, 102, 103, 184]

BRANCH STREET 1999 The Rosemary Branch stood at the junction of what today are Commercial Way and Southampton Way. [482]

BRAYARDS ESTATE 1960 See Brayards Road. [2]

BRAYARDS ROAD 1864 (Woodbine Cottages, Alice Terrace, Brockley Terrace, Chin Chu Cottages, Manvers Terrace, Victoria Terrace, Empress Terrace, Rock Terrace, Oakley Terrace, Lanvanor Terrace) An ancient arable field known as Brayard. [8, 125]

BREAMORE HOUSE, Friary Estate 1950 Austin Canons community at Breamore in Hampshire. [5, 14, 37, 361]

BRECKNOCK HOUSE, Sumner Estate 1938 Brecknock and Abergavenny Canal. [1, 2, 12, 30]

BREDINGHURST SCHOOL, Stuart Road Opened in 1948 in a building erected in 1874 for Camberwell Poor Law Union. The Manor of Bredinghurst or Bretinghurst at Peckham Rye was named after the Bretynghurst family. This Manor adjoined a wood grubbed up in the middle of the 18th century. In an ancient Roll of the Barony of Maminot it was mentioned lying in Kent. There was a small bridge near which was a way leading to Bradinghurst; this was confirmed by an Inquisition taken in the reign of Richard II. [3, 353, 360]

BRIDEALE CLOSE The accessway leading to the site formerly known as the Colegrove Road Travellers Site was named Brideale Close on 6 December 1993.

 Up to the nineteenth century a young couple might be given a hopeful start in life by the holding of a bride-wain, bidden-wedding or bridge-ale. The bride would brew a special brew-ale (from which 'bridal' derives), which she sold to her friends at a good profit, or sometimes a wagon visited the homes of the couple's friends, collecting corn, wood, wool and other useful stores. [416, 417, 427]

BRIDGNORTH HOUSE, Friary Estate 1937 Franciscan community at Bridgnorth in Shropshire. [1, 5, 14, 37, 361]

BRIMMINGTON ESTATE 1978-82 Brimmington Road was one of the nineteenth century roads where the Brimmington Estate was built. It was named after Brimington (sic.) in Derbyshire. Three other adjacent streets had Derbyshire place names. [1, 2, 5, 21]

BRIMMINGTON PARK 1982 See Brimmington Estate. [345]

BROCK STREET Late 1970s Charles Thomas Brock (1843-81) had a firework factory at Nunhead.

In a supplement to the *Greenwich & Deptford Chronicle* dated 21 November 1874, a journalist began a description of his visit to Mr Brock's factory in this way: 'Our visit extends to a point beyond the eastern end of the Green, where we enter upon a rather desolate region. On the left is a brick-work, and on the right a grass field, with an area of about seven and a half acres, used for grazing and occupied for another of its uses, as Messrs. Brock and Co's Fireworks Manufactory.'

Impressive firework displays were held at Crystal Palace and Charles Brock was the sole pyrotechnist. The displays developed to such an extent that eventually nearly two tons of combustible matter was fired on every occasion of a grand display.

Charles Brock was pyrotechnist to the Sultan of Turkey and he established for the Sultan a firework factory at Constantinople.

In 1870, at the time of the Franco-Prussian war, Charles Brock was asked to manufacture two million paper cartridge tubes for the French War Department. Mr Brock obliged and erected three large sheds especially for the order which was completed in a short space of time.

An advertisement of Messrs. C. T. Brock & Co. in 1874 declared: 'Displays undertaken in any part of the world.'

Charles Brock was not the first pyrotechnist in his family. Brock's Fireworks Ltd. was established before 1720. [17, 392]

BROCKLEY FOOTPATH Perhaps from 'Broca's Wood'. [324]

BROCKWORTH CLOSE, Gloucester Grove Estate 1974 Brockworth in Gloucestershire. [5, 12, 400]

BROMYARD HOUSE, Ledbury Estate 1965 Bromyard in Herefordshire. [2, 5]

BROOKSTONE COURT, Peckham Rye 1940 Businessmen Mr Brook and Mr Stone who were the first owners. [315]

BRUNSWICK WARD Celebrating the marriage of George IV to Caroline, daughter of the Duke of Brunswick. [1]

BRYANSTON HOUSE, Basing Court 1933 Built by Church Army Housing Association whose headquarters were in Bryanston Street, W1. [1, 171]

BUCHAN ROAD 1877 Possibly after Andrew Buchan (*d.* 1309?), Bishop of Caithness. [1, 6, 7]

BUDE HOUSE, Sumner Estate 1937 Bude Canal. [1, 2, 12, 31]

BUDLEIGH HOUSE, Lindley Estate 1964 (part of Sidmouth Grove Estate) Budleigh Salterton, Devon. [1, 2, 5]

BULL YARD, Peckham High Street Next to the Red Bull public house.

BULLER CLOSE 1981 (part of Peckham Park Road) General Rt. Hon. Sir Redvers Henry Buller (1839-1908). His most famous, if controversial, command was in Natal during the Boer War of 1899-1900. [1, 10, 32, 400]

BUN HOUSE, 96 Peckham High Street (P) 1898 On the site of a confectioner's. [321]

BUNBURY HOUSE, Oliver Goldsmith Estate 1959 Amateur artist and caricaturist Henry William Bunbury (1750-1811) who was a friend of Oliver Goldsmith's. [2, 6, 14, 23]

BURCHELL ROAD 1868 Probably after William John Burchell (1782?-1863), explorer and naturalist. (SHERWOOD) Probably laid out by Burchells, builders active in this area at the time. (FAIRFIELD) [1, 6, 7, 10]

BURCHER GALE GROVE George Burcher Gale (1794-1850) is believed to have been born in Fulham. He was originally an actor who performed small parts in minor theatres in London. In 1831 he went to America where he played Mazeppa for 200 nights at the Bowery Theatre in New York. Here he first met a balloonist. After returning to London he later became a coast blockade inspector in the north of Ireland for seven years. On the strength of this he assumed the title of lieutenant.

When he tired of this work he made an unsuccessful attempt at returning to the London stage. He then took to ballooning.

George Gale had a gas balloon manufactured at the Montpelier Gardens in Walworth. He made his first ascent with success from the grounds of the Rosemary Branch tavern in Peckham (at the corner of what today are Southampton Way and Commercial Way) on 7 April 1847. 'Persons of scientific character' had been publicly invited to attend. At 34,000 cubic feet this was a much smaller balloon than the modern hot-air balloon type. It was inflated with coal gas supplied by the Metropolitan Gas Company.

Three years later, on 8 September 1850, he made his 114th ascent with the Royal Cremorne balloon, seated on the back of a pony suspended from the basket. He descended at Auguilles and the pony was released. Unfortunately his rope holders mistakenly let go and he was carried out of sight. His body was found several miles away on 9 September with 'limbs all broken'. He was buried two days later in the protestant cemetery at Bordeaux. [552]

BURGESS PARK Mrs Jessie Burgess was first elected to the Metropolitan Borough of Camberwell in 1934. She was Camberwell's first woman Mayor (1945-47). In 1958, when she was 67, she was made an Honorary Freeman of the Borough of Camberwell. For

forty-four years she served on various committees of Camberwell Council and then Southwark Council. She died on 9 January 1981 in St Francis Hospital, East Dulwich, where St Francis Place was built. [117, 118, 119]

BURGESS WARD See Burgess Park.

BURLINGTON COURT, Fenwick Road 1988 Property developers chose the name from the approved list of names suggested by Southwark Council. The list was compiled at random from the Outer London telephone directory. [201]

BURNHILL CLOSE off Gervase Street 1995 Name taken from a telephone directory. [448]

C

CABOT CLOSE, Lyndhurst Grove 1996 Name was chosen by developer, Rydon Construction Ltd, from Southwark Council's namebank. Name was taken from an A-Z atlas. [455]

CACTUS CLOSE, Lyndhurst Grove 1996 Name was chosen by developer from Southwark Council's namebank. Name was taken from an A-Z atlas. [455]

CADLEIGH ARMS, 43 Lyndhurst Grove (P) Probably Cadeleigh in Devon. [5]

CALEDONIAN HOUSE, **178 Queen's Road** Origin not traced.

CALYPSO CRESCENT Linked to West Indian community music and culture. [553]

CAM COURT, Gloucester Grove Estate 1976 Cam in Gloucestershire. [2, 5, 12]

CAMDEN ESTATE Completed in 1976. Started by Camberwell Borough Council, it was designed in 1969.
 Built on the sites of Camden Avenue, Camden Grove and Camden Street. Nearby was Camden Chapel which stood on the site now occupied by the block of flats in Peckham Road called Voltaire. Camden Chapel was built on a piece of ground in Camden Row Field leased from a Mr Havill. The Chapel was opened on 10 September 1797 for the Countess of Huntingdon's Connexion. It was much enlarged in 1814 and was bombed in the Second World War. The Anglican parish of Camden was formed in 1844. [2, 3, 11, 12, 35, 61, 106, 107, 410]

CAMDEN SQUARE 1976 See Camden Estate. [2, 12]

CAMELOT PRIMARY SCHOOL, Bird-in-Bush Road 1951 Camelot was the name given in medieval romance to the seat of King Arthur, legendary king of Britain. The present school was previously known as Asylum Road School (opened c. 1888), Bird in Bush School (1893), Arthur Street School (1894) and Camelot Street School (1938). [20, 26, 87, 571, 572]

CAMILLE COURT, Waghorn Street 1994 Artist Camille Pissarro (1830-1903). [418, 419]

CANAL BRIDGE, Old Kent Road Demolished 1992-93. Crossed the Grand Surrey Canal. [20, 184]

CANAL GROVE The Grand Surrey Canal ran parallel with the north west side of this street. [2, 10]

CANAL HEAD 1913 The Peckham branch of the Grand Surrey Canal (completed in 1826) terminated here. [7, 16]

CANDLE GROVE A roman candle is a firework; Charles Thomas Brock had a firework factory in Nunhead. [513]

CANTERBURY ARMS, 871 Old Kent Road (P) On the road from London to Canterbury.

CANTIUM RETAIL PARK, Old Kent Road 1992 Cantium is Latin for Kent. [257, 258]

CAPUCHIN FRANCISCAN CHURCH OF OUR LADY OF SEVEN DOLOURS, Friary Road Opened on 4 October 1866 by Thomas Grant, Bishop of Southwark. Archbishop, later Cardinal, Manning preached the opening sermon.

Capuchins. A reform of the Franciscan order instituted by Matteo di Bessi of Urbino, who, being an Observantine Franciscan at Monte Falco, and having convinced himself that the *capuche* or cowl worn by St Francis was different in shape from that worn by the friars of his own time, adopted a long-pointed cowl, according to what he conceived to be the original form.

Franciscans. This order takes its name from its founder St Francis of Assisi, who died in 1226.

Dolour. Pain, grief, anger.

Dolours of the Blessed Virgin. St John mentions that the Blessed Virgin, with other holy women and with St John, stood at the foot of the cross when the other Apostles fled.

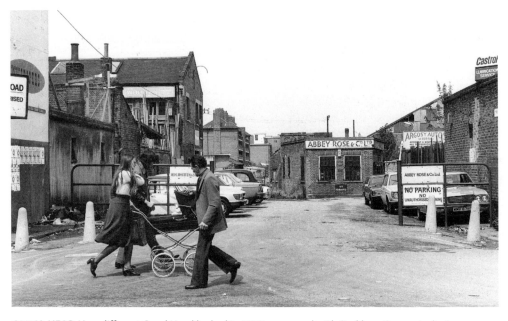

CANAL HEAD How different Canal Head looked in 1979 compared with Peckham Square today!

The seven founders of the Servite order, in the thirteenth century, devoted themselves to special meditation on the Dolours of Mary, and from them the enumeration of the Seven Sorrows (i.e. at the prophesy of Simeon, in the flight to Egypt, at the three days' loss, at the carrying of the cross, at the crucifixion, at the descent from the cross, at the entombment) is said to have come. [210, 299, 300]

CARDEN ROAD 1868 Carden – a Cheshire parish. [1, 7, 25]

CARDIFF HOUSE, Friary Estate 1936 Franciscan community at Cardiff, Wales. [1, 5, 14, 37, 361]

CARDINE MEWS 1982 Elizabeth Cardine Naylor mentioned by L. S. Sherwood. Cardine is probably a misspelling of Caroline. Elizabeth Caroline Naylor was a resident of Peckham in the 19th century, See Naylor Road. [1, 180]

CARISBROOKE GARDENS, Rosemary Road 1962 Carisbrooke on the Isle of Wight. [5, 361]

CARLTON GROVE 1880 (Frances Terrace, Victoria Terrace, Lilbourne Cottages, Willow Cottages, Franks Cottages, Alice Cottages, Clyde Terrace) Possibly after politician Henry Boyle, Baron Carleton (d. 1725), owner of Carlton House, London. [1, 6, 7]

CARLTON TAVERN, 45 Culmore Road (P) *c.* 1855 Probably Baron Carleton. See Carlton Grove. [144]

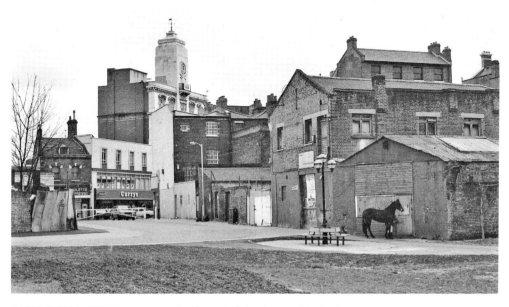

CANAL HEAD In 1987 there was no Peckham Arch to obscure this view!

PRINCE ALBERT LAYING THE FOUNDATION-STONE OF THE NEW WING OF THE LICENSED VICTUALLERS' ASYLUM.—(SEE PRECEDING PAGE.)

ng purchase. In this condition they were left to the action of the | the entrance. By this time the other vessel, the *Ocero*, came up | the river since the accident occurred. The vessels have the appear-
flood tide, and at half past two the *Lustre*, collier, floated. A power- | with the tide, and was at once hauled out, thus freeing the lock of the | ance of wrecks, and now lie on the shore below the entrance. The
ful tug then took hold of her and towed her into the river, clear of | serious obstruction which had interrupted all communication with | mishap will occasion a serious loss to the company.

CAROLINE GARDENS Prince Albert laid the foundation stone of a new wing of the Licensed Victuallers' Asylum (now Caroline Gardens) in 1858. [616]

CARNICOT HOUSE, Clifton Estate 1981 A misspelling of Carlingcott, Bath. [2, 199, 200]

CAROLINE GARDENS, Asylum Road 1827-70s. Caroline Sophie Secker was a resident in the Licensed Victuallers' Asylum.

She was the widow of Sergeant James Secker of the Marines who served with Horatio Nelson at the Battle of Trafalgar in 1805. When Nelson was mortally wounded, Sergeant Secker and two seamen rushed across to lift him up. The three marines carried Nelson below to the cockpit.

Mrs Secker died at the Asylum on 1 January 1845 aged fifty-six. [17]

CASTLE HOUSE, 1-27 Sumner Road Probably built in the 1930s but not named Castle House until 1988 when Newgate Press purchased the building. The reason for the name was that the firm's logo featured a castle. The Galleria (q.v.) was built on the site. [184, 218]

CATOR STREET 1862 (James Street, John Street, Woodland Terrace, Nepaul Cottages, Wickwar Place) Probably P. Cator, a Governor of Dulwich College in 1858. [1, 3, 7]

CAULFIELD ROAD 1884 (Merton Terrace, Prince's Terrace, Horley Terrace and part of Lugard Road) Possibly James Caulfield (1764-1826), author and printseller. [1, 6, 7]

CHADWICK ROAD This house in Chadwick Road, photographed in 1982, was saved from demolition in 2008.

CAVERSHAM HOUSE, Friary Estate 1956 Caversham Court, a rectory of the Augustinian Canons, in Berkshire. [1, 169, 361]

CELESTIAL CHURCH OF CHRIST, Glengall Road Uses former St Andrew's Church consecrated on 23 October 1865 by the Bishop of Winchester. The Celestial Church of Christ was founded in 1947 by the Reverend Pastor Prophet Founder Samuel Bilehou Joseph Oshoffa. The church's constitution states – The name of the Church came down from Heaven by divine revelation through Mr Alexander Yanga, who was at that time undergoing spiritual healing at the residence of the Pastor Founder and who was held in trance for seven days. At the end of the seventh day, he asked for a piece of chalk and wrote the name of the Church on the wall thus: 'EGLISE DU CHRISTIANISME CELESTE', meaning 'Celestial Church of Christ'. [3, 346, 347]

CENTRE FOR WILDLIFE GARDENING See London Wildlife Garden Centre.

CERISE ROAD 1878 (Trench Road) Cerise was a daughter of Sir Claude Champion de Crespigny. She was born on 6 December 1875. In 1899 she married Capt. the Hon. Robert Francis Boyle (*d.* 1922). [1, 4, 7, 10, 47, 48]

CHABOT DRIVE Edwin Chabot (1806-93), a surgeon who lived in Linden Grove. [513]

CHADWICK ROAD 1877 (Albert Grove, Camden Terrace, Bodenberg Cottages, Albert Terrace, Raglan Cottages, Montague Cottages, Adelaide Terrace, Neptune Villas and Lime Cottages) William Chadwick (1797-1852), railway engineer and a wealthy freeholder. [1, 7, 10, 139, 180]

CHANDLER WAY 1997 Author Raymond Chandler who attended Dulwich College. [461]

CHARLES BARCLAY HOUSE, 25 Kirkwood Road Architect Charles Barclay. [556]

CHARLES COVENEY ROAD 1997 Former Southwark Councillor Charles Coveney. [460]

CHEAM STREET 1979 Cheam in the London Borough of Sutton. [5, 400]

CHELTENHAM ROAD 1938 (Hall Road) Cheltenham Villas, Hall Road. [7, 180]

CHEPSTOW WAY, Camden Estate 1975 Close to where Chepstow Terrace and Chepstow Hall used to be. [2, 178]

CHERRY TREE COURT, 1 Wood's Road 1974 The cherry tree from which Cherry Tree Court derived its name stood outside the main entrance to Peckham Methodist Church until 2003. It was planted there by James Shirley when he was a tenant of 1 Harder's Road. (The cottage was demolished in 1972. At that time that part of Wood's Road was called Harder's Road.) Jim Shirley obtained the tree as a young sapling from an allotment in Crofton Park. He carried it to Peckham on a number 36 bus. This was in about 1960. The name Cherry Tree Court was suggested by Walter Finch who was a property steward of Peckham Methodist Church. See Finch Mews. [43, 559]

CHERRYCROFT, Dewar Street Cherry trees grow in the grounds of the home. See Wilkinson House. [554]

CHESTERFIELD WAY 1978 Chesterfield in Derbyshire. [5, 400]

CHLOE COURT, Rye Lane 2006 Suggested by an employee of Servite Houses, W6. Reason not recorded. [602, 603]

CHOUMERT GROVE 1877 (Albert Grove, Elizabeth Terrace, New Cottages and Hopewell Cottages). George Choumert (? - 1831) was born in Lorraine, France. An Act for Naturalization was passed for him in 1796. He married into a wealthy family and inherited estates in Bermondsey which by 1831 produced an annual rental of £6,000.

Holly Grove, formerly South Grove but originally named George Street after George Choumert, was a private road in 1875. The residents contributed a sum not exceeding thirty shillings a year to keep the road, footpath and shrubbery in repair. Trustees were chosen by the tenants annually under a deed of George Choumert, dated 1831, to manage the property, and to inspect the treasurer's annual accounts. A notice of the audit had to be posted on the shrubbery for at least two hours each day for fourteen consecutive days.

Holly Grove Shrubbery is owned by Southwark Council. [1, 7, 17]

CHOUMERT MEWS off CHOUMERT ROAD 2000 See Choumert Grove. [487]

CHOUMERT ROAD 1873 (Montpelier Road) See Choumert Grove. [1, 4, 7, 10]

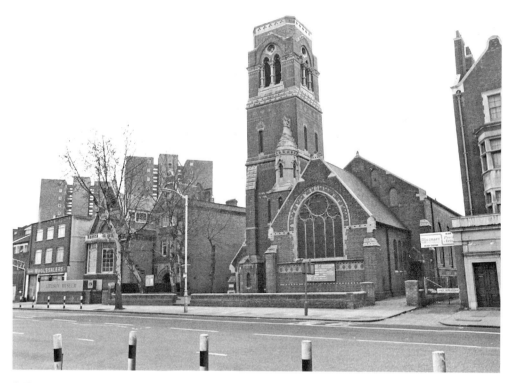

CHRIST CHURCH, OLD KENT ROAD A photograph of Christ Church and the Livesey Museum was taken in 1980.

CHOUMERT SQUARE 1876-1882 See Choumert Grove. [433]

CHOUMERT WALK 2003 See Choumert Grove. [184]

CHRIST CHURCH, McDermott Road Erected in 1880. Named after the founder of the Christian Church. [286]

CHRIST CHURCH, Old Kent Road Consecrated on 1 July 1868. See above. [3]

CHURCH OF SAINT GEORGE, Newent Close Consecrated on 1 August 1982 by the Bishop of Southwark. St George. [202]

CHURCHILL COURT, 3A Blenheim Grove 2004 Sir Winston Churchill. [614]

CICELY ROAD 1878 (Rymill Road) Cicely, a daughter of Sir Claude Champion de Crespigny (b. 20 April 1847) of Champion Lodge, Camberwell. Cicely was born on 19 October 1874. On 19 March 1886 she married George Granville Lancaster (*d.* 1907), son of John Lancaster of Bilton Grange, Warwickshire. [1, 7, 10, 47, 48]

35

CINNAMON CLOSE 2001 One of the road names based on African or Caribbean influences to connect with many people who live in Peckham. [614, 630]

CITRON TERRACE, Linden Grove Estate 1980 Citron tree. [2, 168]

CLAIRE COURT, 98 Peckham Rye These flats were built by the Tilt Estate Company which was formed by Mr H. J. Tilt in October 1934. When he retired his daughter, Mrs Constance Harvey, became Governing Director. She died on 21 May 1976 and left her Estate in trust to her daughter, Frances, and her three grandchildren, Claire, Tiffany and Dominic. This block of flats was named after Claire. Tiffany Court and Dominic Court, SE22, were named after the other two grandchildren. [83]

CLANFIELD WAY, North Peckham Estate 1971 Clanfield in Hampshire. [2, 5]

CLARKSON ARMS, **61 Carlton Grove** (P) Origin not traced. See Tulsi House.

CLAUDE ROAD 1877 (Brinsmead Street, New Claude Road and Brighton Villas) Major Sir Claude Champion de Crespigny (*b.* 20 April 1847) who lived at Champion Lodge, Camberwell. He served in the Royal Navy (1860–65) and in the 60th Rifles (1866–70). He succeeded his father to the title as 4th Bart in 1868. On 19 September 1872 he married Georgiana Louisa Margaret, second daughter of Robert McKerrell. They had nine children. Sir Claude was adjudged bankrupt in 1881. His estates were heavily mortgaged and his gross income from them had been reduced since 1868 from £8,000 a year to under £3,000. [1, 4, 8, 10, 47, 48]

CLAUDIA JONES YOUTH CLUB Used Bellenden Road School built in 1876. Claudia Jones (1915–64) was born in Port-of-Spain, Trinidad. She grew up in the urban poverty of Harlem. In her youth she was actively involved in organising in trade unions and became a member of the Communist Party of America. In 1948 she was arrested, tried and imprisoned for her political views and membership of the CPA. On release she was given the option of deportation to the West Indies or emigration. She chose the latter and Britain as her destination.

She arrived in Britain in 1955 and continued her political activity with the Communist Party of Great Britain and the Caribbean Labour Congress. She became an activist within the black community and helped to organise the carnivals set up in the wake of the 1958 Notting Hill riots.

During the same period she established, edited and published the Brixton based *West Indian Gazette*. Claudia Jones died in London and her grave is next to that of Karl Marx in Highgate Cemetery. [45, 46, 184]

CLAYTON ARMS, 1-5 Clayton Road (P) See Clayton Road.

CLAYTON ROAD 1880 (Elizabeth Place, Claro Cottages, Upper Clayton Road, Edward Villas, Cambridge Terrace, Ernest Terrace, Warwick Villas) Sir William Clayton (1762–1834), landowner of the sitein the 1830s. [1, 4, 10, 66, 232]

CLIFTON COURT, Studholme Street 1975 Built on the site of Clifton Congregational Church which was opened in 1859 and closed in 1972. [17, 21, 400]

CLIFTON CRESCENT 1881 (The Crescent, Clifton Grove) Clifton in Derbyshire. (One of a series of roads to the east of Asylum Road named after places in Derbyshire.) [5, 7, 21]

CLIFTON ESTATE 1967 Clifton Square was demolished to make way for the Clifton Estate. [2, 21]

CLIFTON WAY 1938 Clifton Way was called Clifton Road from 1867. Prior to that the houses were named Washington Villas, Commercial Place, Lansdowne Terrace and Olive Villas. In 1917 Clifton Villas and part of Carlton Place were incorporated into Clifton Road. [4, 7, 8, 21]

CLYDE HOUSE, Sumner Estate 1954 Forth and Clyde Canal. [1, 2, 12, 42]

COCKNEY'S, 610 Old Kent Road (P) Demolished 2003. In 1617 Minsheu wrote –A *Cockney or Cockny*, applied only to one borne within the sound of Bow-bell, that is within the City of London, which tearme came first out of this tale: That a Cittizens sonne riding with his father ... into the Country ... asked, when he heard a horse neigh, what the horse did his father answered, the horse doth neigh; riding farther he heard a cocke crow, and said doth the *cocke neigh* too? and therfore Cockney or Cocknie, by inuersion thus: *incock, q, incoctus* i. raw or unripe in Country-mens affaires. [210, 524]

COLEGROVE ROAD 1879 (Bangor Terrace and Langdale Road) Properly Colegrave. David Colegrave was a Camberwell Vestryman and Overseer of the Poor. He lived in Peckham Grove. (Blanch records numbers 54 and 64.) [1, 3, 7, 10]

COLESBOURNE COURT, Gloucester Grove Estate 1976 Colesbourne in Gloucestershire. [2, 5]

COLLEGE HALL, Burchell Road Part of Peckham Collegiate School which stood at the corner of Queen's Road and Burchell Road. In 1875 the School was run by the Revd Thomas Ray, LL.D. [3]

COLLINGWOOD SCHOOL Admiral Collingwood [6, 551]

COLLINSON HOUSE, Lindley Estate 1951 Peter Collinson (1694-1768) wrote in his diary: 'Being sent at two years old to be brought up with my relatives at Peckham in Surrey, from them I received the first liking to gardens and plants.'

After he was married he had his own garden at Peckham in which he carried out experiments with exotic plants. In 1731 he wrote a letter from this Surrey village in which he said: 'I have here retreated from the hurrys of the town and breathe the air of content and quiet, being the centre of my humble wishes, a little cottage, a pretty garden, well filled, a faithful loving partner, a little prattling boye, the pledge of mutual love, surrounded with these blessings I pronounce myself happy.'

In 1745, Peter Collinson sent to Benjamin Franklin an account of some new electrical experiments recently made in Germany, and some parts of the apparatus for carrying

them out. This was the first intimation which Benjamin Franklin had received regarding the advances of electrical enquiry in Europe. Franklin acknowledged his gratitude to Collinson, and they established a lasting friendship.

Peter Collinson was visited in 1748 by Peter Kalm, the Swedish traveller who was *en route* to America. Kalm wrote: 'June 10, in the afternoon., I went to Peckham, a pretty village which lies 3 miles from London in Surrey, where Mr Peter Collinson has a beautiful little garden, full of all kinds of the rarer plants, especially American ones, which can endure the English climate and stand out the whole winter. However neat and small it is there is scarcely a garden where so many kinds of trees and plants, especially the rarest, are to be found.'

In 1749 Peter Collinson moved to Mill Hill where his botanic garden became famous both in England and abroad; many visitors came to see it. Peter Collinson considerably improved the English system of horticulture.

A first edition of John Evelyn's *Sylva* is preserved which has manuscript notes by Peter Collinson. He refers to two fine Chestnut trees in Sir Thomas Bond's (q.v.) garden at Peckham.

Peter Collinson died peacefully while on a visit to Lord Petre in Essex. [1, 2, 17]

COLLS ROAD 1874 Benjamin Colls who was a Camberwell Vestryman and a Guardian of the Poor. He was a successful builder active in South London in the 1860s, He lived at 246 Camberwell Road. Colls Road School opened on 24 August 1885. [1, 3, 4, 7, 10, 78, 475]

COLLYER PLACE 1881 (Collyer Cottages) Dr William Bengo' Collyer (1782-1854) was born at Deptford and was christened William Bengow at the Church of St Paul. In 1801 he began his ministry at Peckham in a large but almost empty building with a membership of only ten people. The congregation rapidly increased so in 1808 the Meeting House was closed for repairs and enlargement. Two side galleries were made. Subsequently it was found necessary to rebuild the chapel entirely. This was done in 1816. The following year it was opened; the Dukes of Kent and Sussex attended the opening service.

The close union of members of the Royal House of Hanover with the ministry of Dr Collyer led to the Meeting House receiving the name Hanover Chapel. At the corner of Rye Lane and Peckham High Street is a plaque which states: 'Site of the old Hanover Chapel 1717-1910 made famous under the ministry of Dr W.B. Collyer 1801-1852.'

His publications included sermons, hymns and tracts. He died at Chislehurst and was buried in Nunhead Cemetery. [552]

COLMORE MEWS, Wood's Road 1996 Colmore Group, whose head office was located there in May 1990. The founders of the Colmore Group were a Mr Cole and a Mr Dunmore. [454, 535]

COMET, Cantium Retail Park Comet was named by the firm's founder, George Hollingbury. Unfortunately the exact origin of the name is not known. Comet began in 1933 in Hull as Comet Battery Services Limited. A store was opened in Hanover Park on 21 November 1987. This was closed when a larger store was opened in the Old Kent Road in 1992. [225, 226]

COMFORT STREET 2002 Origin not traced. [614]

COMMERCIAL WAY 1936 (Commercial Road from 1871) The road bridged the Peckham branch of the Surrey Commercial Dock Company's Grand Surrey Canal which helped the establishment here of many small businesses. In the nineteenth century the street was called Commercial Road, the name replacing an earlier sequence of thirty-five names extending down the length of the street; two of these were Commercial Place and Commercial Terrace.

Commercial Wharf (later named Hope Wharf) was on the east bank of the canal just north of Globe Bridge. This was the only named wharf in 1842 on the system west of the Old Kent Road, except for the two terminal basins. In 1870 it was a timber wharf. [1, 7, 10, 62, 335]

COMPTON CLOSE Denis Compton (1918-1997) was born in Hendon, Middlesex. When he was sixteen he played as a left winger for Nunhead Football Club before signing as an amatuer for Arsenal in 1932. He played soccer eleven times for England during the Second World War. He won an FA Cup winner's medal in 1950.

He was a Middlesex cricketer and played for England seventy-eight times. During his cricketing career (1936-57) he made 38,942 runs and took 622 wickets. He made 123 centuries in first-class cricket. [505, 552]

CONSORT ESTATE 1978-81 See Consort Road. [2]

CONSORT PARK 1985 See Consort Road. [345]

CONSORT ROAD 1938 (Albert Road from 1879) Albert, Prince Consort (1819-61), husband of Queen Victoria. The name was changed because there were many other 'Albert' street names. The road was built along the line of an old lane called Cow Walk. [1, 8, 10, 26, 190]

CONSORT WARD See Consort Road.

CONSTANCE COURT, 47 Blenheim Grove 1983 Built by Tilt Estate Company and named after the daughter of the founder of Tilt, Mrs Constance Harvey. She took over the company from her father, Mr H. J. Tilt. Constance Harvey died on 21 May 1976. [63, 83]

CO-OPERATIVE HOUSE, Rye Lane The Royal Arsenal Co-operative Society (formed in 1868) opened a store at 259-267 Rye Lane in 1913. This was remodelled and opened as Co-operative House on 12 October 1932. The store closed in 1980 and has been replaced by a new Co-operative House opened in 2008. [184, 220]

COPELAND ROAD 1868 (Cow Lane, Copeland Terrace, Woodbine Terrace, Caroline Terrace, John's Terrace and Royal Terrace) Chief Justice John Copeland, who was Sheriff of Surrey in 1735. He was an active member of Hanover Chapel during the time of Dr John Milner. He contributed to the building fund. He died at Peckham on 21 or 22 August 1761 aged 87. [1, 3, 7, 10, 17, 67, 254, 330, 331, 332, 466]

COPLESTON CENTRE, Copleston Road See Copleston Road. The Copleston Centre was opened in 1979 in St Saviour's Church. [79]

COPLESTON MEWS 1990 See Copleston Road. [184]

COPLESTON PASSAGE See Copleston Road.

COPLESTON ROAD 1873 (Rose Bank, Clyde Villas, Elizabeth Villas, Claremont Villas, Bulmer Villas, Herbert Villas, Dynevon Villas, Swiss Villas, Clyde Terrace, Brooklyn Villas, Cleveland Villas, Clara Villas and Arthur Terrace; from 1903 Placquett Road and Ardley Terrace became part of Copleston Road) Edward Copleston (1776-1849), Bishop of Llandaff. [1, 6, 7, 10]

COPNER WAY, North Peckham Estate 1971 Copner, a district of Portsmouth. [2, 5]

CORBDEN CLOSE should have been Cobden Close. Cobden Street was where Burgess Park is today. A typing error in Southwark Council's namebank caused an 'r' to be included in the new name. [503]

CORINTH HOUSE, Sumner Estate 1938 Corinth Canal, a tidal waterway across the Isthmus of Corinth in Greece, joining the Gulf of Corinth in the north-west with the Saronic Gulf in the south-east. It was opened in 1893. [1, 2, 64]

COSSALL ESTATE 1977-81 See Cossall Walk. Cossall Street (1868) was off Burchell Road and was one of a number of Victorian streets demolished to make way for Cossall Estate. [2, 7, 21]

COSSALL PARK See Cossall Walk. The park was created in 1977. [43]

COSSALL WALK 1977 Cossall in Nottinghamshire. [1, 2, 5]

COSTA STREET 1874 (South Street, Garibaldi Cottages, St James's Terrace, Regent's Place, Rose Cottages and Howard Terrace) Probably Sir Michael Costa (1810-84), a conductor and musical composer born in Naples, Italy. He conducted at the Crystal Palace which was particularly famous for the performances of music written by George Frederick Handel. The first 'Great Handel Festival' was held in 1857. There were over 2,000 singers and 386 instrumentalists in the central transept of the Palace, conducted by Michael Costa. The Great Handel Festival was such a success that it was repeated in 1859 to commemorate the centenary of the composer's death. After that, similar events were held every three years. Until 1880 they were conducted by Michael Costa. [1, 6, 7, 65]

COTTAGE WALK, Camden Estate 1976 Cottage Grove was demolished when the Camden Estate was built. [2, 7, 400]

CRABTREE WALK, Camden Estate 1976 Close to where Crab Tree Shot Road used to be. Crab Tree Shot was a field name in the lands owned by the Trevors, by Martha Hill and later by the Shards. [2, 7, 410]

CRANE HOUSE, Pelican Estate 1964 Water-fowl. [1, 2]

CRANE STREET 1997 Artist Walter Crane. [460]

CREDENHILL HOUSE, Ledbury Estate 1967 Credenhill in Herefordshire. [2, 5]

CREED HOUSE, Nunhead Estate 1956 George Creed (1807-82) omnibus proprietor in the parish of Camberwell. [1, 2, 3, 340]

CREWYS ROAD 1877 Believed to be misspelt. Cruwys Morchard in Devon. [1, 5, 7]

CRINAN HOUSE, Sumner Estate 1938 Crinan Canal in Scotland. [1, 2, 42]

CROMFORD HOUSE, Sumner Estate 1937 Cromford Canal in Derbyshire. [1, 2, 42]

CRONIN STREET North Peckham Estate 1994 Cronin Road existed on this site prior to the estate being built. Daniel Cronin was a wealthy freeholder in the Parish of Camberwell. He owned the estate in Hill Street formerly owned by Sir Thomas Bond. Daniel Cronin was a philanthropist who supported various London charities. He provided almshouses known as 'Camden Houses' where the Camden Estate was built. [1, 3, 21, 443, 444, 445]

CROSS CLOSE, Gordon Road 1995 Built on the site of Nazareth House, which was a convent in 1857. It became a workhouse and was demolished in 1994. There was a large cross on the top of the building. A picture of Nazareth House is shown in *Peckham and Nunhead Churches* on page 80. [420, 447]

CROWN, 119 Peckham High Street (P) W. H. Blanch (1875) wrote:- 'John Barleycorn* is proverbially loyal, and therefore "The Crown" (High Street, Peckham) is a favourite sign.' (*The personification of alcoholic drink.) The Crown was renamed Sally O'Brien's in 1994. [3, 184]

CROWN MANSIONS, Peckham High Street Crown Theatre was opened in 1898 on the corner of Marmont Road and the High Street (where Gaumont House is today). It was later known as the Peckham Hippodrome. [16, 35]

CULMORE ROAD 1872 (Carlton Road, Culmore Terrace, Lincoln Terrace, Falcon Terrace, Shaftesbury Villas) Possibly Culmore in Ireland. [1, 7]

CURLEW HOUSE, Pelican Estate 1957 Water-fowl. [1, 2]

D

DAIRY FARM PLACE, 195-201 Queen's Road. New Hatcham Dairy Farm occupied the site. [514, 515]

DAMILOLA TAYLOR CENTRE (formerly Warwick Park Youth Centre) was named on 27 November 2001 exactly a year after Damilola was murdered in north Peckham. Damilola (1989-2000) was born in Nigeria and attended Oliver Goldsmith School. [502]

DANBY STREET 1873. (Wilton Terrace, Love Villas, Norbury Villas, Tudor Villas, Woodbine Villas, Macduff Terrace, Danby Villas, Victoria Villas, Myrtle Villas, Box Villas, Ashbourne Villas, St. Ivians Villas, Laurel Villas, Niton Villas, Gloucester Villas, Danby Terrace, The Firs, Crystal Villas, Danby Cottages) Danby Villas, Danby Terrace and Danby Cottages. Danby may have been the builder of these three. [1, 7, 10]

DANIEL GARDENS 1938 (Daniel Street) Probably Revd G.W. Daniel, Chaplain to Dulwich College. [1, 8, 80]

DANIELS ROAD 1863 Henry Daniel (1805-67) was a monumental mason and was the first to establish a mason's yard at Nunhead. His workshops were opposite the cemetery's main gates in Linden Grove. Henry Daniel served on Camberwell Vestry in the 1860s. He was buried in his family vault. Nunhead Cemetery closed in 1969 and Henry Daniel's old house, a landmark for over a century, and his workshops were demolished. [7, 10, 81, 145, 180]

DANUBE COURT, Daniel Gardens 1971 River Danube. [26, 361]

DAVEY STREET 1863 Probably Peter Davey, tenant of land nearby *c.* 1830. He lived at Champion Hill. [1, 7, 60]

DAYAK COURT, Consort Road 2008 The Dayak are a group of around three million aboriginal tribespeople indigenous to the tropical forests of Borneo (including Sarawak), in South East Asia. There are over 200 different ethnic and cultural entities within the Dayak but they all share common traits and a collective history based on their animist beliefs. Despite religious differences within the Dayak social cohesion is pronounced, for example men and women have traditionally possessed equal rights in status and property ownership. This is

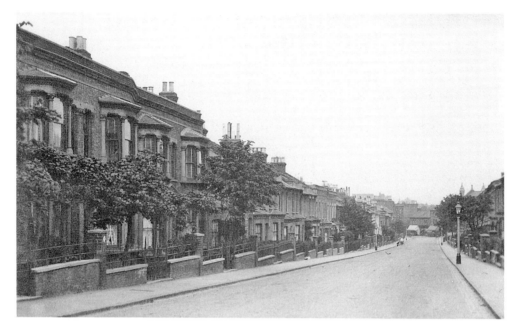

DANBY STREET How Danby Street looked in the early part of the twentieth century!

embodied in the practice of living in longhouses – communal structures often hundreds of metres long which house as many families as there are doors – a longhouse with 200 doors will be occupied by 200 families. [558]

DAYTON GROVE 1880 Origin not traced. [7]

DEANERY LODGE, Bellenden Road Founded in 1987 by Mrs Lorna Lucas, together with other members of the churches in the Dulwich Deanery. The hostel was opened to its first young women residents in November 1992, and closed in November 2001. [421, 422, 491]

DEERHURST HOUSE, Friary Estate 1956 A Benedictine house at Deerhurst in Gloucestershire. [1, 14, 37, 361]

DE LAUNE CYCLING CLUB, 93 Choumert Road 1971 Mr Chapman Delaune Faunce-De Laune (d. 1893). High Sheriff of Kent in 1886, landowner and magistrate. He lived at Sharsted Court, Sittingbourne. [355, 356]

DENMAN ARMS, 86 Denman Road (P) See Denman Road. [3]

DENMAN ROAD 1858 (Ash Villas, Abbey Cottages, Grove Villas, Cleveland Villas, Oakfield Terrace, Oak Villas, Magdala Terrace, Georgie Cottages, Rose Cottages, Myrtle Cottages and Colaba Villas) Thomas, Baron Denman (1779-1854) who was made Attorney General in 1830. This is one of a group of names taken from the legal profession. [1, 3, 6, 7, 10]

DENMEAD WAY, North Peckham Estate 1971 Denmead in Hampshire. [2, 5]

DENSTONE HOUSE, Friary Estate 1952 Denstone in Staffordshire. Denstone College was founded by Nathaniel Woodard in 1873. The Woodard School is a religious foundation. [1, 5, 68]

DEVONSHIRE GROVE 1900 County of Devon or the Earls of Devon. [1, 7]

DEVON STREET 1938 (Devonshire Street) County of Devon or the Earls of Devon. [1, 8, 20]

DEWAR STREET 1876 Sir James Dewar (1842-1923), British chemist and physicist who invented the vacuum flask. [1, 7, 10, 26]

DIAMOND STREET Before 1842. (Shakespeare Terrace, Diamond Cottages, Rosemary Cottages) Built by a plumber whose diamond brought him the means to build the street. [1, 3, 7, 10, 143]

DONATO CLOSE, St George's Way. Donatello (real name Donato di Betto Bardi) (1386-1466), a Florentine sculptor. His marble relief of 'St George Killing the Dragon' (1416-1417) shows his innovative use of perspective. [518, 519]

DORTON CLOSE takes its name from the former Dorton Street which was named after a village in Buckinghamshire. [1, 520]

DOWNEND COURT, Gloucester Grove Estate 1976 Downend in South Gloucestershire. [2, 5]

DR HAROLD MOODY PARK was the name given in 2002 to the Consort Open Space after it had been refurbished. In 1904 Harold Arundel Moody (1882-1947) came to London from Jamaica. He studied medicine at King's College and qualified as a doctor.

He was invited to preach at Clifton Congregational Church, Asylum Road. (This church stood at the corner of Studholme Street. It was opened in 1859 and closed in 1972.)

The people of Peckham took to Dr Moody and he took to them. As a result, in 1913 he set up in practice as a doctor at 111 King's Road, now King's Grove. He was also energetic in his work at Clifton Congregational Church, where he became Sunday School Superintendent.

Dr Moody was concerned about the discrimination experienced by black people in Britain before the last war. In 1931 he was instrumental in forming the influential League of Coloured Peoples. His home, at 164 Queen's Road, was the base for the League's activities. In 1933 he was invited by the Lord Mayor of Hull to co-operate in the civic commemoration of the centenary of the death of William Wilberforce. His speech at the Commemoration Dinner made a great impression.

Dr Moody's funeral service was held in Camberwell Green Congregational Church, Wren Road, where he had become a member. The service was attended by a large company of people of many walks of life, from grateful patients whose homes were in the humble streets of Peckham to leaders in the religious, political and social life of Britain and the Commonwealth. [17, 511]

DRAGON ROAD reuses a former name. The original Dragon Road was close to St George's Church, hence the name. [1, 20, 486]

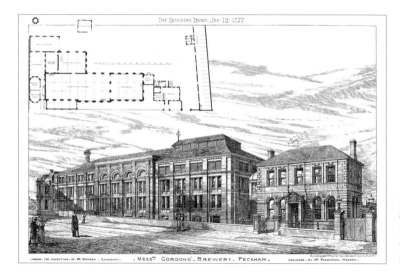

DRAYMANS MEWS
Cullet from Gordons' Brewery was found when Draymans Mews was being built.

DRAYMANS MEWS, Chadwick Road. A reminder of Gordons' Brewery which stood in Chadwick Road. Cullett was found on the site. [21, 510, 557]

DROITWICH HOUSE, Sumner Estate 1938 Droitwich Canal. [1, 2, 69]

DROVERS, 720-722 Old Kent Road (P) Formerly the Kentish Drovers which appears to be first mentioned on Cary's map of 1830. It is assumed that the name derived from the fact that in the days of 'animals on the hoof', on the way to Smithfield Market in London, the Old Kent Road was a much frequented drove road. Drovers became Links Vietnamese Club and later the New Saigon restaurant. [3, 293, 341, 543]

DROVERS PLACE 1987 Not far from Drovers pub (see above) where a mural depicts rural Peckham. [184, 203, 400]

DUKE OF SUSSEX 77 Friary Road (P) 1906 The Duke of Sussex had links with Peckham. He attended the opening of Hanover Chapel on 17 June 1817. He was a son of King George III. [3, 410]

DUKE, THE See The Duke and Edinburgh Castle.

DUNDAS ROAD 1871 Sir Thomas Dundas, art collector. [1, 7, 10, 80]

DUNSTALL HOUSE, Oliver Goldsmith Estate 1955 John Dunstall played Jarvis in *The Good Natur'd Man* by Oliver Goldsmith. [1, 2, 93]

DURSLEY COURT, Gloucester Grove Estate 1976 Dursley in Gloucestershire. [2, 5]

DYMOCK COURT, Gloucester Grove Estate 1975 Dymock in Gloucestershire. [2, 5]

E

EAGLE WHARF, Peckham Hill Street Eagle Saw Mill was situated on the east side of the Peckham branch of the Grand Surrey Canal where Eagle Wharf is today. 'The Eagle' public house was in nearby Bells Garden Road. A Christian and heraldic symbol, the eagle has been used as an inn sign since the fifteenth century. [17, 21, 62, 295]

EAST DULWICH BAPTIST CHURCH, Amott Road Opened on 9 August 1958. Dulwich comes from two Old English words, and means 'marshy meadow where dill grows'. Baptists trace their origins in modern times to the action of John Smyth, a Separatist exile in Amsterdam who, in 1609, reinstituted the baptism of conscious believers as the basis of the fellowship of a gathered Church. [207, 284, 285]

EAST DULWICH ROAD ESTATE 1954 See East Dulwich Baptist Church. [2]

EAST SURREY GROVE 1862 (Swan Terrace, Caroline's Terrace, Mary's Terrace, James Grove) Peckham was in Surrey until the London County Council came into being in 1889. As many London streets used the name Surrey, East may have been added to distinguish it from others. Leslie Sherwood suggested that it probably commemorated the battle honours of the East Surrey Regiment but that name was not used until 1881. Villiers' Regiment of Marines (31st Foot in 1751) and 2nd Battalion of the 31st Foot in 1756 (70th Foot in 1758) became the 1st and 2nd Battalions of the East Surrey Regiment in 1881. [1, 7, 362, 363]

EATON WALK, Camden Estate 1975 Close to where Eaton Place used to be. [2, 155]

EBLEY CLOSE, Gloucester Grove Estate 1974 Ebley in Gloucestershire. [5, 400]

EDGAR WALLACE CLOSE Though born at Greenwich, author Edgar Wallace (1875-1932) went to school in Peckham. He 'found himself one of the noisy conglomeration of children at the big Board School in Reddin's Road'. Haymerle School in Haymerle Road now stands on the site. (See Elfrida Rathbone School.) Edgar Wallace remained at Reddin's Road School until he was twelve years of age but he learned little or nothing there that interested him. He described the school as 'A big yellow barracks of a place, built (or rumour lied) on an old rubbish pit into which the building was gradually sinking. We used to put chalk marks on the wall near the ground to check the subsidence. And every morning when I turned the

corner … and saw the Board School still standing where it did, I was filled with a helpless sense of disappointment.'

The young Edgar Wallace patronised a coffee shop in Glengall Road, near Trafalgar Avenue. The shop was kept by a lady with a strong literary bent. She and her youthful customer had many chats about the latest books. These chats played some part in laying the foundations of his literary career. He went on to become a prolific author, one of the masters of the pure 'thriller'. Among his works was an 80,000 word novel based on the life of Charles Peace, a notorious criminal who lived in Nunhead.

The first novel to make Edgar Wallace famous was *The Four Just Men*. He wrote plays and sometimes had two or three plays running in London at the same time.

During twenty-eight years of authorship more than 170 of his books were published.

Edgar Wallace died suddenly in Hollywood, California, where he had been writing motion picture stories. The first of these, *King Kong,* was produced shortly after his death. [17, 529]

EDINBURGH CASTLE, 57 Nunhead Lane (P) 1935 The castle is famous well beyond Scotland because of its annual military tattoo. The pub changed its name to PAGE 2 (q.v.) in 2003, then became The Duke (q.v.) and in 2008 was renamed The Village Inn. It is now La Costa Smeralda (q.v.). [184, 205, 206, 340]

EDNAM HOUSE, Friary Estate 1957 A medieval religious house at Ednam in Scotland. [175, 361]

EDWIN HOUSE, Oliver Goldsmith Estate 1959 *The Hermit, or Edwin and Angelina*, a ballad by Oliver Goldsmith written in 1764, and included in *The Vicar of Wakefield*. Angelina, benighted in the wilderness, and sorrowing for her lost Edwin, whom she believes is dead, is welcomed to the Hermit's cell and in answer to his question reveals the cause of her sorrow. The Hermit then acknowledges himself to be Edwin. [2, 23]

EGLINGTON COURT, East Dulwich Road Estate 1954 Revd Arthur Eglington, Vicar of St John's, Goose Green, 1901-09. [1, 2, 82, 398]

ELCOT AVENUE 1878 (Stanley Villas) Probably after Elcot Park, near Newbury in West Berkshire, laid out by Sir William Paxton in 1848. [1, 7, 75]

ELFRIDA RATHBONE SCHOOL, Reddins Road Elfrida Rathbone (1871-1940) was born in Liverpool into a well-to-do family well-known for its philanthropic activities and prominent in local affairs.

She was one of eleven children. In 1916 Elfrida Rathbone became a teacher in a special kindergarten for mentally handicapped children in the King's Cross area of London. Three years later she established an Occupation Centre for 'ineducable' children who were excluded from schools. The work there proved that these outcast children could be taught and trained successfully while remaining in the community. This venture proved so successful that in 1922 it was taken over and run by a well established charity, The Central Association for Mental Health.

Elfrida Rathbone recruited people to sit on the Care Committees of Islington's Special Schools for 'mentally defective' children so that their needs could be better met.

Consequently children who had previously been excluded were able to enjoy school, holidays, convalescence, outings and parties.

As the children whom Elfrida Rathbone had taught in the kindergarten reached school leaving age, the need for an After Care provision became a priority. In 1923 a Girls Club was formed followed by a Married Girls class with a creche. In 1930 a befriending scheme was set up for those rejected mentally defective children confined in a Public Assistance home and other types of institutions.

Elfrida Rathbone fought for the rights and interests of a group of people rejected, stigmatised and punished by society because of handicaps they suffered through no fault of their own.

The school changed its name to Haymerle School in November 1992. [76, 439]

ELIM HOUSE, 86 Bellenden Road Formerly Peckham Seventh Day Adventist Church, Elim House was opened in 1987 as the base of the Black Elderly Group Southwark. The name Elim House was decided upon following a competition among the users of the centre to give the new centre a name. Elim is a biblical name meaning place of rest and refreshment. The building had previously been used by Joseph Starkey Ltd. [123, 256, 606]

ELKSTONE COURT, Gloucester Grove Estate 1976 Elkstone in Gloucestershire. [2, 5]

ELLAND ROAD 1869 (Elland Street) Elland in West Yorkshire. In 1869 Thomas Drake applied to the Metropolitan Board of Works to register two streets – Elland Road and Siddall Street. Siddal (sic.) is in West Yorkshire. [1 ,5, 7, 204, 283]

ELLERY STREET 1879 (George Street) Possibly in honour of Robert Lewis John Ellery (1827-1908), Government astronomer of Victoria, Australia. He was born at Cranleigh in Surrey and visited England in 1875 when he attended a dinner to celebrate the bi-centenary of the foundation of the Royal Observatory. [1, 7, 205, 206]

ELLESMERE HOUSE, Sumner Estate 1951 Ellesmere and Chester Canal. [1, 2, 77]

ELM GROVE 1889 (Elm Villas, Barton Terrace, Washington Place, Elm Cottages, Priory Villas, The Priory) Elm Villas and Elm Cottages. [1, 4, 7]

ELMHURST VILLAS, Peckham Rye Close to the site of a house called Elmhurst. [154]

ELVEN MEWS, St Mary's Road 2010 Pamela Elven was a member of the Peckham Pioneer Health Centre and has energetically promoted its important work throughout her adult life. See Pioneer Centre and Pearse Street. [613]

ELY HOUSE, Friary Estate 1950 Benedictine community at Ely in Cambridgeshire. [1, 5, 14, 37, 308, 361]

EMMANUEL MIRACLE TEMPLE OF BETHANY FELLOWSHIP OF GREAT BRITAIN, 36-38 Gautrey Road In 1991 this church moved into the former Nunhead Baptist Church, opened in 1889. Emmanuel means 'God with us' and the church felt that God guided them over the

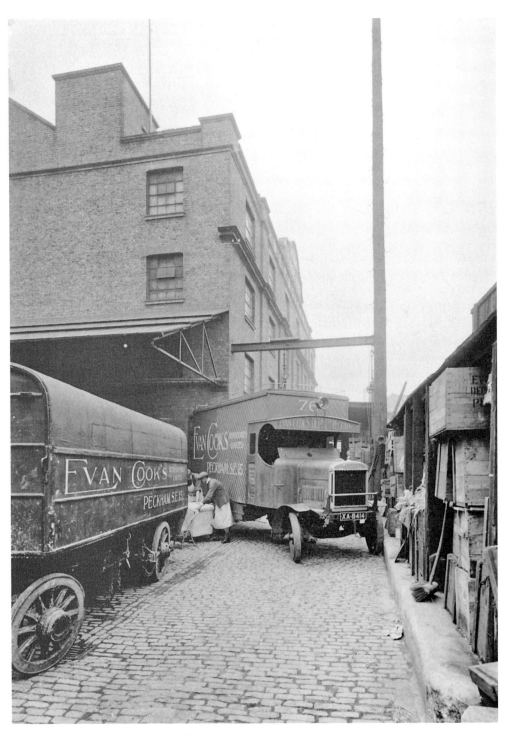

EVAN COOK CLOSE Evan Cook's was a busy firm in *c.* 1920.

purchase of the premises. The congregation was previously based in Wandsworth where miracles are said to have occurred. [383, 384]

ETHNARD ROAD 1888 (Moor Terrace, Union Cottages and part of Downes Street). Not traced. Leslie Sherwood wrote: 'This could have been misread for Edward Road. Try writing Edward six times very carelessly and see the result!' More likely to be Ethnam in Kent misspelt. [1, 4, 7, 283]

EVAN COOK CLOSE, Lugard Road 2006 Evan Cook (1865-1947) founder of the international transportation firm bearing his name. The housing was built on the site of the firm's premises.

Evan Cook was born at Greenwich. His first job was as a pawnbroker's warehouse boy. He later learnt about furniture removing and set up his own second-hand furniture shop in 1893 at 72 Queen's Road. For the first few years his wife managed the new business while he continued his job as a pawnbroker's salesman in the City by day. In the evening he went out delivering the day's sales, and gradually built up a removals trade at the same time. The handcart he used, known as 'Number One Barrow', was preserved in the firm's depository at Fulham.

The handcart was later superseded by a horse and van. By the time mechanized transport began to be developed, there were thirty horses in the Evan Cook stable. But in 1908 every penny of the family's resources was invested in a steam wagon.

Evan Cook's firm developed, and was chosen to transport a very valuable consignment of Italian Art Treasures to Burlington House in 1930. Another event which created considerable press comment was the transporting of the historic Gog and Magog from Cheapside to America after they had been purchased by Henry Ford.

Apart from his business activities, Evan Cook devoted a lot of time to public affairs. In 1898 he was elected to the Board of Guardians and in 1912 he became a Camberwell Borough Councillor. He became Mayor of Camberwell in 1918 and was later appointed as a JP.

Evan Cook died in St Giles' Hospital on 24 September 1947. [17]

EVELINA ROAD 1869 (Argyle Terrace, Craven Terrace, Oxford Terrace, East Terrace, West Terrace and parts of Cemetery Road and Lausanne Road) Probably *Evelina*, a novel by Frances Burney (1752-1840) whose family lived over the border in Deptford. [1, 7, 23]

EVERTHORPE ROAD 1902 (Placquett Terrace and Normanton Terrace) Probably the hamlet of Everthorpe in East Yorkshire. [2, 5, 7]

EVOLUTION QUARTER RESIDENTS' ASSOCIATION was set up in October 2007. Evolution and South Quarter 2 were the marketing names used by Laing Homes and Countryside Properties within the boundaries used by the association. [566]

EXETER HOUSE, Friary Estate 1936 Franciscan community at Exeter in Devon. [1, 5, 14, 37, 308, 361]

EXETER ROAD, Camden Estate 1976 Exeter Place was demolished when the Camden Estate was built. [2, 7, 400]

F

FAITH CHAPEL, Bellenden Road Opened in 1885 as a United Methodist Free Church. Bought by Hanover Chapel in 1922. After Hanover United Reformed Church moved to St Saviour's Church, Copleston Road, in 1979 the building was bought by a congregation affiliated to the Pentecostal Assemblies of the World and renamed Faith Chapel. This name was chosen because the congregation had faith that they would manage to raise the money to buy the church. They had only £2,000 and the price was over £50,000. Hanover URC accepted £30,000 and the congregation succeeded in raising this amount. Their faith was justified so Faith Chapel became the new name and it opened in 1979. [67, 312, 313]

FALCON HOUSE, Pelican Estate 1964 Falcon, a bird of prey. [1, 2]

FARNBOROUGH WAY, North Peckham Estate 1971 Farnborough in Hampshire. [2, 5]

FARRIERS MEWS, Machell Road was chosen because the houses were built on the site of buildings which the developer believed had been used as stables. [486]

FENHAM ROAD 1866 Fenham in Northumberland. [1, 4, 5, 7]

FENWICK GROVE 1889 (Gledhill Road) Possibly Fenwick in South Yorkshire. [1, 5, 7]

FENWICK ROAD 1867 See Fenwick Grove. [1, 7]

FERDINAND DRIVE 2009 England and Manchester United footballer Rio Ferdinand who was born in King's College Hospital on 7 November 1978 and then lived at 18 Gisburn House on the Friary Estate for eighteen years. He attended Camelot Primary School before going to Blackheath Bluecoat School. He spent his leisure time in Leyton Gardens Adventure Playground, Peckham Leisure Centre, North Peckham Civic Centre Library and Peckham Rye Park. He also belonged to a drama club at the Peckham Settlement. [515]

FERNHOLME ROAD 1894 Fern<u>holme</u>: Holm = holly or island. [7, 350]

FILTON COURT, Gloucester Grove Estate 1977 Filton in South Gloucestershire. [2, 5, 9]

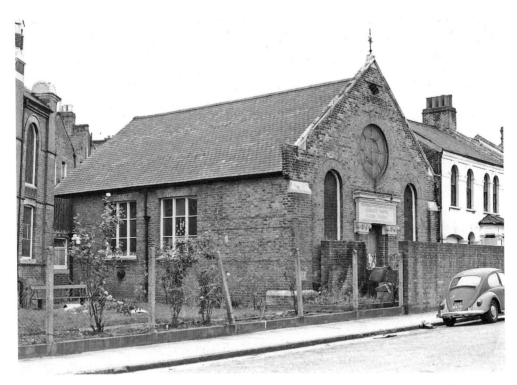

FAITH CHAPEL Hanover Chapel Sunday School, erected in Danby Street in 1871 and seen here in 1981, was used by Faith Chapel until it was destroyed in an arson attack in 1993.

FINCH MEWS 1997 Walter Harrington Finch (1919-1991) was born in Burchell Road. He was actively involved in Peckham Methodist Church for over sixty years. He was a microbiologist who became Vice Principal of Paddington College and was chairman of the Institute of Medical Laboratory Technology. After retiring he became a governor of Waverley School and was elected as chair. *Origin of Names in Peckham and Nunhead* was dedicated to him. [109, 402, 400]

FINCHDEAN WAY, North Peckham Estate 1971 Finchdean in Hampshire. [2, 5]

FIRBANK ROAD 1877 Built on land which belonged to a Mr Firbank in the 1870s. [1, 7, 10]

FLAMBOROUGH HOUSE, Oliver Goldsmith Estate 1956 Solomon Flamborough in *The Vicar of Wakefield* by Oliver Goldsmith. [2, 90]

FORESTER ROAD 1868 (The Avenue) Probably Sir Philip Forester in *My Aunt Margaret's Mirror* by Sir Walter Scott. [1, 7, 90]

FRANCIS BACON LODGE, Waghorn Street English statesman, essayist and philosopher Francis Bacon (1561-1626). The Rosicrucians, members of a mystical brotherhood, meet in

this former St Andrew's Mission Church built in 1902. This non-sectarian philosophic and scientific fraternity is known as the Ancient Mystical Order Rosae Crucis (AMORC). In the words of Bacon, its aim is 'To glorify God and benefit man's estate'. [26, 398]

FRASER LODGE, 42-44 Stuart Road Origin not traced.

FREDA CORBET CLOSE 1983 Freda Künzlen Corbet (1900-1993) was educated at Wimbledon County School and University College London. She was called to the Bar, Inner Temple, in 1932. She was MP for North-West Camberwell (1945–50) and the Peckham division of Camberwell (1950-74). [91, 95, 400, 423, 552]

FREE TRADER, 35 Green Hundred Road (P) The free trade doctrine is that international trade should be free of all restrictions, such as import duties or quotas. In the 1840s its main advocates were John Bright, MP for Manchester, and Richard Cobden, MP for Stockport. The Liberal Party adopted it as official policy, and it became national policy between 1860 and 1932. [295]

FRENSHAM STREET 1892 (Surrey Terrace and Canal Cottages) Frensham in Surrey. (Name chosen to reduce the number of street names beginning with Surrey.) [1, 5, 7]

FRIARY ESTATE See Friary Road.

FRIARY ROAD 1935 (Lower Park Road) Renamed in honour of the Capuchin Franciscan Church of our Lady of Seven Dolours and Monastery in this road. [1, 8, 299]

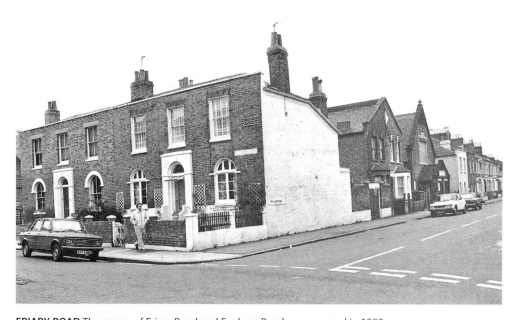

FRIARY ROAD The corner of Friary Road and Fenham Road was snapped in 1980.

FRIARY WARD See Friary Road.

FROBISHER PLACE, St Mary's Road 2000 The Frobisher Institute of Adult Education used the former Peckham Pioneer Health Centre. [184]

FROG ON THE GREEN DELI See Shergar.

FROME HOUSE, Rye Hill Estate 1938 River Frome. [2, 92]

FURLEY HOUSE, Friary Estate 1947 See Furley Road. [8]

FURLEY ROAD 1936 (Furley Street 1876 and Nelson Square) Furley in Devon. [1, 5, 7, 8, 21]

G

GALATEA SQUARE 1979 Close to where Galatea Road was built in 1868. Galatea was a sea nymph in Greek mythology. In John Gay's libretto to Handel's *Acis and Galatea* (1732) the contrast of the dainty sea nymph and the clumsy giant is pleasantly brought out by the music. [1, 7, 21, 94, 180]

GALLERIA, THE Sumner Road 2006 The building includes fifty studios for artists; galleria sounded better than gallery. It was built on the site of Castle House (q.v.). [540, 561]

GANDOLFI STREET Commemorates the Gandolfi family. Louis Gandolfi (1864-1932) was born in Clerkenwell, the son of an Italian plastercast maker. In 1880 he joined a firm of instrument makers and began to learn the craft of camera making. He married in 1885 and they set up home over a tobacconist's shop at 15a Kensington Place, Westminster. Here in the same year he started his own business. The family moved in 1896 to 752 Old Kent Road, opposite the gasworks, where Louis made cameras in a shed at the bottom of the garden. His wife Caroline did the French polishing of the cameras and all the paperwork – and by 1906 had six children to look after.

Louis did a roaring trade in do-it-yourself kits and special outfits for fitting a camera to a bicycle. By 1905 he was selling his own range of cameras.

Working long hours, Louis Gandolfi built up the business and the orders continued to pour in, with as many as 300 cameras a year going out to India and Burma. In 1913 the home and business were transferred to 84 Hall Road (now Cheltenham Road), Nunhead.

The outbreak of war in 1914 destroyed much of Louis Gandolfi's market but he was able to maintain production with the aid of a Royal Naval Air Service order for cameras. In 1924 a special camera was produced to photograph Queen Mary's dolls' house which was exhibited at the Wembley Empire Exhibition.

In 1928 the firm bought a former hatpin factory in Borland Road which had to be modified before the business could be transferred there in 1930. After Louis Gandolfi died in 1932 the firm was continued by his sons Thomas (*b.* 1890), Fred (*b.* 1904) and Arthur (*b.* 1906). It became the only firm left in the world still making wooden hand-made cameras. The centenary of the Gandolfi enterprise was marked by a special exhibition at the Science Museum in South Kensington beginning in November 1980.

Thomas died in 1965 aged seventy-five. Fred and Arthur retired on the last day of 1981 and so the family firm closed after 101 years. A new Gandolfi company came into being in 1982.

In 1985, the centenary of the firm's establishment, Fred and Arthur were awarded honorary life membership of The Royal Photographic Society and The British Institute of Professional Photographers. Fred died on 2 November 1990 aged eighty-five and Arthur died on 22 January 1993 aged eighty-six.

Two Gandolfi cameras are preserved in the Cuming Museum; one dates back to the 1890s. [17, 552]

GANNET HOUSE, Pelican Estate 1957 Gannet (seabird). [1, 2, 26]

GARDEN COURT, Camden Estate 1975 Garden Cottages were nearby in the nineteenth century. [2, 7]

GARNIES CLOSE, North Peckham Estate 1951-58 Close to where Garnies Street used to be. Edward Street became Garnies Street in 1882. Believed to have been named after Martin Garnar, Camberwell Vestryman in 1875. [1, 2, 7, 96]

GATEFIELD COURT, East Dulwich Road Estate 1954 The plot of land on which St. John's Church stands was called Gatefield or Catfield. [1, 2]

GATONBY STREET reuses a former street name. [494]

GAUMONT HOUSE, Peckham High Street. Built on the site of the Gaumont Cinema. [516]

GAUTREY ROAD 1937 (Edith Road) Thomas Gautrey was a Camberwell Vestryman and London County Council member.

He attended Wilson's Grammar School and the history of that school by D. H. Allport describes his as 'A Schoolmaster and notable Governor, with a longer record of service on the Board than any other.' He was a Governor from 1896 until 1946.

Thomas Gautrey was connected with the London School Board throughout its thirty-three year life as a teacher, union leader and member. He wrote a series of entertaining thumb-nail sketches of some of the Board members whom he described collectively as 'liberal minded men and women filled with confidence and buoyant hopes'.

When he was eighty-four he wrote 'Lux Mihi Laus' School Board Memories. The title was the motto carved over the entrance to the old School Board for London on the Embankment. In his book of reminiscences he wrote: 'It was a Peckham boy writing out the Lord's Prayer in school who wrote "Hallowed be Rye Lane"!'

When 'Lux Mihi Laus' (meaning 'light is my glory') was published in 1937 The Star stated: 'Mr Gautrey's memory is stored with reminiscences of the days before the L.C.C., in 1904, took over education from the School Board. To Mr Gautrey, London readers are indebted for the London Teachers' Association, of which he was to all intents and purposes the founder, besides being the first full-time secretary. From the smallest and most unpromising beginnings, Mr Gautrey by enthusiasm and hard work, raised the Association (which was the County Association of the N.U.T.) to a virile body with a membership of between 15,000 and 16,000 of the elite of the teaching profession.'

In My Heart's Right There William Margrie wrote in 1947: 'Thomas Gautrey is the Grand Old Man of Peckham. He is in his nineties and is still going strong. The greatest event

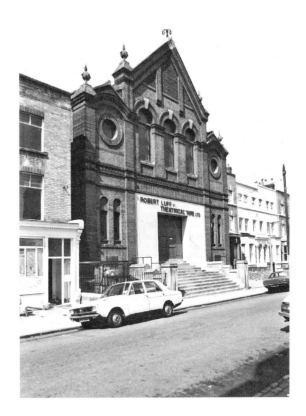

GAUTREY ROAD In 1981 a theatrical hire firm used what today is Emmanuel Miracle Temple of Bethany Fellowship of Great Britain in Gautrey Road.

in his life was the immortal Peckham by-election in 1908. Gautrey was the Liberal candidate.' [17]

GELDART ROAD 1883 Edmund Martin Geldart (1844-1885) Unitarian Minister. In 1877 he became minister of the Free Christian Church in Croydon. [1, 7, 104, 105]

GEORGE, 231 St George's Way (P) St George. This pub was demolished in 1998. [298, 474]

GERVASE STREET 1879 (George Street, Elizabeth Cottages, Charles Terrace) Possibly Gervase of Canterbury (c. 1145-1210), English chronicler, monk of Christ Church, Canterbury. Gervase Street is close to Christ Church and the Old Kent Road. [1, 7, 26]

GIBBON ROAD 1869 (Cemetery Road, Lausanne Road (part), Alexandra Terrace, Oswald Terrace, Fairlight Terrace, St John's Terrace, St James Terrace, Linden Terrace) Charles Gibbon (1843-1890) was the first editor of the *South London Press*, which began in 1865.

Charles Gibbon was born in the Isle of Man but moved to Glasgow with his parents at an early age. When he was seventeen he worked for a local newspaper in Scotland.

He later moved to London where he concentrated on writing novels. For many years he lived in South Grove, now called Holly Grove. Charles Gibbon wrote over thirty novels including *Robin Gray* and *For Lack of Gold*. Charles Gibbon died at Great Yarmouth. [17]

GIRDLERS COTTAGES, Choumert Road 1851 (Palyn's Almshouses) Built by The Worshipful Company of Girdlers. [3, 28, 144]

GISBURN HOUSE, Friary Estate 1950 Austin Canons community at Gisburn in Lancashire. [1, 5, 14, 37 361]

GLENGALL ARMS, 41 Glengall Road (P) See Glengall Road. This pub was converted into flats in 2000. [184]

GLENGALL ROAD 1880 (Glengall Grove, Derwent Road, Alexander Terrace, Derwent Terrace) The Countess of Glengall owned land in Peckham. Lady Glengall, who married into the Irish peerage in 1834, was formerly Miss Margaret Lauretta Mellish, daughter and co-heir of William Mellish, a multi-millionaire and government contractor of Woodford, Essex. [1, 7, 10]

GLENGALL TAVERN, 1 Bird-in-Bush Road (P) Close to Glengall Road.

GLENGALL TERRACE 1850 See Glengall Road. [424]

GLOBE, 58 Peckham Hill Street (P) A name now associated with Shakespeare because of the Globe Theatre, where his plays were performed during his lifetime. The Globe has always been a popular pub sign, and there are at least twenty pubs of this name in London. The pub was converted into apartments after closing in 2003. [295, 296, 517]

GLOUCESTER GROVE ESTATE 1972-78 See Gloucester School. Gloucester Road was demolished to make way for the estate. [2, 20]

GLOUCESTER SCHOOL, Daniel Gardens opened 16 August 1875. Robert Earl of Gloucester who was Lord of the Peckham Manor. [16, 124, 125, 376, 475]

GLOVER HOUSE, Nunhead Estate 1951 John Glover was a coachmaster in the parish of Camberwell in the nineteenth century. [1, 2, 3]

GODMAN ROAD 1878 (Donald Road) General Richard Temple Godman, Lieut.-Col. commanded 5th Dragoon Guards. He married Eliza Mary de Crespigny on 29 July 1871. She was a daughter of Sir William de Crespigny (*b.* June 1818). [1, 2, 10, 47]

GOLDEN ANCHOR, 16 Evelina Road (P) An heraldic reference to the arms of the Lord High Admiral. [295]

GOLDEN LION, 133 Sumner Road (P) A popular sign, referring heraldically to Henry I, or to the dukes of Northumberland, the Percys. [295]

GOLDSMITH ROAD 1872 (Back Walk, Park Lane, Daniel's Terrace, Francis Place, Park Terrace) Poet and playwright Oliver Goldsmith (1728-74) was born at Pallas, near Ballymahon, in Ireland. He attended Trinity College, Dublin, and in 1752 went to Edinburgh to study medicine.

In about 1756 he became an usher (assistant teacher) at Dr Milner's Academy in Peckham. This boarding school used a building (later known as Goldsmith House) at what is now the junction of Staffordshire Street and Goldsmith Road.

Oliver Goldsmith was unhappy at Dr Milner's Academy. He wrote later: 'The usher is generally the laughing-stock of the school. Every trick is played upon him; the oddity of his manners, his dress or his language, is a fund of eternal ridicule; the master himself now and then cannot avoid joining in the laugh; and the poor wretch, resenting his ill-usage, lives in a state of war with all the family'.

Goldsmith was probably alluding to his experience as an usher when a character in the *Vicar of Wakefield* said: 'I have been an usher in a boarding school … and … I had rather be an under-turnkey in Newgate'.

He became a prolific writer and achieved high dramatic honours with *She Stoops to Conquer*.

Oliver Goldsmith was buried in Temple Churchyard and a monument to him was erected in Westminster Abbey. [17]

GOLDWIN CLOSE 1978 Councillor Mabel Goldwin who was Mayor of Southwark (1971-2). [623, 624]

GOODWIN HOUSE, Nunhead Estate 1956 Mr Goodwin was a local coachmaster in the nineteenth century. [1, 2, 3]

GORDON ROAD 1875 (Stanley Villas, Hawthorn Villas, Hermon Cottages, The Terrace, Bordeaux Cottages, Nichol's Terrace, Gordon Cottages, Gordon Terrace North, Gordon Terrace, Magdala Terrace, Albion Terrace, India Terrace, Ann's Cottages, Wellington Terrace) General Charles George Gordon (1833-85), British soldier, the hero of Khartoum, born at Woolwich. [1, 4, 6, 10, 26]

GOSPORT WAY, North Peckham Estate 1971 Gosport in Hampshire. [2, 5]

GOWLETT ARMS, 62 Gowlett Road (P) See Gowlett Road. Since 2004 the pub has been called The Gowlett. [184]

GOWLETT ROAD 1879 (Gowlett Terrace) Believed to be the name of the builder. [1, 7]

GRANGE COURT, 101 Talfourd Road 1963 A private estate, named by the owners for personal reasons. [1]

GRANTHAM HOUSE, Friary Estate 1939 Franciscan religious house at Grantham in Lincolnshire. [1, 5, 14, 37, 308, 361]

GRANVILLE SQUARE 1987 Originally 'Pepys Square' was chosen but this was turned down as there is a Pepys Road in SE14. A selection of names was chosen at random by the developers, Balfour Beatty Homes, and Granville Square was accepted by the London Borough of Southwark. [208, 209]

GRASMERE POINT, Tustin Estate 1965 Grasmere in Cumbria. [2, 5]

GRATELEY WAY, North Peckham Estate 1971 Grateley in Hampshire. [2, 5]

GREEN HUNDRED ROAD 1877 Revival of an early place name. The Green Hundred was a plot of land held by the Gardyner family. [1, 8, 10]

GREENHIVE, 50 Brayards Road 2002 The residents of this Anchor residential home for elderly people were asked to suggest names for the home. Out of those suggested Greenhive was chosen. [512]

GRENARD CLOSE takes its name from the former Grenard Road. [7]

GRENIER APARTMENTS in the former Leo Street School. The marketing name chosen by the developers was Loft 48 as there are 48 units of accommodation. As this name was not acceptable to Southwark Council, the name Grenier was chosen as it is French for loft. [525]

GREYHOUND, 109 Peckham High Street (P) W. H. Blanch in *Ye Parish of Camerwell* (1875) refers to an unknown man who died at the Greyhound in 1747. The present building is not the original one. The sign, which dates from Tudor kings, appeared on the coats of arms of both Henry VII and VIII. [3, 297]

GREYSTOKE HOUSE, Friary Estate 1954 Greystoke in Cumbria. The Collegiate Church of Greystoke has deep roots in the past for it is interesting to note that the College of Priests founded 600 years ago was restarted again in 1957. [1, 70, 361]

GRIMWADE CLOSE 1994 See Grimwade Crescent. [184]

GRIMWADE CRESCENT 1877 Local landowner and builder of that street. It was demolished and replaced in 1994 by Grimwade Close. [1, 7, 10, 184]

GROVE NURSERY SCHOOL, Newent Close 1976 Built to serve the Gloucester Grove and North Peckham Estates. [375]

GROVE VALE ESTATE 1903-5 Grove Vale – from its natural contrast to Grove Hill. [1, 16]

GRUMMANT ROAD 1866 John Grummant was a Camberwell Vestryman and was an owner of a large amount of property in the parish of Camberwell. He lived at 1 Lawn Houses, Peckham Road. [1, 3, 7]

H

HABITAT CLOSE, Gordon Road. Houses were built by Southwark Habitat for Humanity. [541]

HALFORDS, Unit 2B Cantium Retail Park, Old Kent Road Opened 4 April 1992. Halfords was founded in 1892 by Frederick William Rushbrooke, a wholesale ironmonger. The name comes from the address of a warehouse that opened in 1902 in Halford Street, Leicester. The company officially adopted the name Halfords in 1965. [276, 277]

HANOVER PARK pre 1842 Named after Hanover Chapel (which was at the corner of Rye Lane and the High Street) attended by the Dukes of Kent and Sussex. The close union of members of the Royal House of Hanover with Dr William Bengo' Collyer led to the Meeting House receiving the name of Hanover Chapel. [1, 4, 7, 10, 17, 67, 143, 601]

HARDCASTLE HOUSE, Oliver Goldsmith Estate 1954 Mr Hardcastle, a country squire, in *She Stoops to Conquer* by Oliver Goldsmith. [1, 2, 90]

HARDER'S ROAD 1893 (Harders Place, Maud Villas, Gunnersbury Villas, Linden Villas, Cambrian Terrace, Mortlock Terrace, Lowless Terrace, Lansdowne Villas) Mr Harder was a landowner in Peckham. [1, 4, 7, 10]

HARDER'S ROAD MEWS See Harder's Road.

HARLESCOTT ROAD 1886 Harlescott in Shropshire. [5, 7]

HARRIS ACADEMY AT PECKHAM, THE Lord Harris of Peckham who grew up in Peckham. [627]

HARRY LAMBORN HOUSE, 9 Gervase Street 1984 Harry Lamborn (1915-82) was born in the Old Kent Road. When he was eighteen he worked in a local Royal Arsenal Co-operative Society store. In thirty-two years he worked his way up from a clerk to be a Director of the R.A.C.S.

Harry Lamborn became a Camberwell Councillor in 1953 and was Mayor in 1963. He was a London County Council member from 1964 until 1973.

Harry Lamborn was elected as Labour MP for Southwark in 1972 and was MP for Peckham from 1974 until his death. He was parliamentary private secretary to Denis Healey, Chancellor of the Exchequer, between 1974 and 1979.

Harry Lamborn died in an Eastbourne hospital after a long illness. Former Southwark Council leader John O'Grady declared in the *South London Press*: 'He served the people of Peckham extremely well.' [17]

HASLAM STREET The Peckham Partnership chose to reuse the name of a former Peckham street – Haslam Place. [21]

HASTINGS CLOSE, Bells Gardens Estate 1979 George Hastings in *She Stoops to Conquer* by Oliver Goldsmith. [2, 23, 93, 400]

HATCHAM ROAD 1876 (Samuel Place, Albert Place, Albion Place, Child's Place) The Saxon manor of Hatcham was called Hacchesham, meaning the home of Hacca. Its ownership is first recorded in 1086, and last in the mid-eighteenth century. A map of 1744 shows Hatcham House, moated and with extensive grounds. [7, 10, 369]

HATHORNE CLOSE 1961 Hathorne, a plot of land in Dulwich. [1, 80, 172]

HAVANT WAY, North Peckham Estate 1972 Havant in Hampshire. [2, 5]

HAVELOCK ARMS, 38 Meeting House lane (P) Sir Henry Havelock (1795-1857), British soldier who achieved the relief of Lucknow. [26, 295]

HAVELOCK COURT, 112 Naylor Road Built on the site of Havelock Arms. [184]

HAWKSLADE ROAD 1894 Hawk<u>slade</u>: Slade = valley or dell. [7, 350]

HAYMERLE HOUSE, Friary Estate 1942 See Haymerle Road. [8]

HAYMERLE ROAD 1879 (Belgrave Terrace, Argyle Terrace, Belgrave Place, Charterhouse Street) Baron Heinrich von Haymerle (1828-80). Austro-Hungarian minister at the Congress of Berlin in 1878. He was Prime Minister and Foreign Minister of the dual monarchy 1879-80. [1, 4, 7, 10, 100]

HAZEL CLOSE, Atwell Estate 1963 Hazel tree. [2, 26]

HEATON, 249 Rye Lane (P) Adjacent to Heaton Road. The pub was demolished to make way for the present Co-operative House. [184]

HEATON ROAD 1868 (Heaton Villas) Either philanthropist Isaac Heaton who was brother-in-law of Sir Claude Champion de Crespigny, or the Revd Heaton de Crespigny, son of the 2nd Baronet de Crespigny, since the road cuts through former de Crespigny land. [1, 7, 10, 17, 47, 180]

HEATON ROAD CHURCH, Heaton Road Opened on 21 September 1873. See Heaton Road. [3]

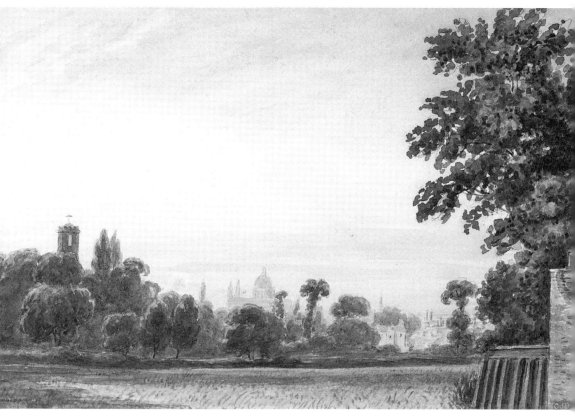

HEATON ROAD J. B. Cuming painted Heaton's (also spelt Eton's) Folly in 1810.

HELENA DAY NURSERY, Camden Square Councillor Mrs Helena Day (1892-1977) was born in Southwark. She was educated at Trinity Square Church School and at a private school in Thurlow Park Road, Dulwich. She trained as a pupil teacher at Ealing but did not continue in the profession. She became a post office worker at Borough High Street. She married Robert Day, a technical engineer.

Helena Day served on Camberwell and Southwark Councils from 1949 to 1977. She was elected leader of Southwark Council's Tory opposition in 1974. She was a manager of Bredinghurst School. [223, 233, 234, 440, 552]

HENLEY COURT, Peckham Rye 1990 Selected by the developers of the property 'because they felt it to be a nice name'. It sounded attractive because of its association with Henley Regatta. [235, 404]

HENSLOW HOUSE, Lindley Estate 1948 Botanist John Stevens Henslow (1796-1861). [1, 2, 6]

HEREFORD RETREAT, Bird-in-Bush Road Revival of name of row of nineteenth-century houses behind St Andrew's Church. Origin of name not traced. [7, 20]

HERON HOUSE, Pelican Estate 1957 Heron. All the blocks on this estate are named after birds. [1, 2, 26]

HEVERSHAM HOUSE, Tustin Estate 1965 Heversham in Cumbria. [2, 5]

HICHISSON ROAD 1891 (Paddington Road, Oxford Villas, Kingsdown Villas, Cambridge Villas, Marlborough Villas) Joseph Geldart Hichisson was active in Camberwell's local government. He was a Vestryman in the 1890s and later served on Camberwell Borough Council as an Alderman. [1, 7, 10]

HIGHSHORE ROAD 1938 (Hanover Street) See Highshore School. [8]

HIGHSHORE SCHOOL, Bellenden Road Opened on 30 January 1970. In 1955 water deep down showed where an old stream flowed to the Peckham branch of the Grand Surrey Canal. During the building of the present school, this watercourse was again uncovered. The 'adventure hill' marks the point of the High Shore above the watercourse. It is probable that in days gone by this zone was referred to as the Highshore. An eighteenth-century map shows a stream from the hills beyond passing the area where the school now stands on its way to the Thames. [366, 380]

HILLBECK CLOSE 1969 Hillbeck in Cumbria. [2, 5]

HINCKLEY ROAD 1879 Hinckley in Leicestershire where John Jennings (*d*. 1723) became minister of the Presbyterian congregation in 1722. He removed his academy to Hinckley where a new meeting house was immediately built for him. Prior to moving to Hinckley John Jennings ran a nonconformist academy at Kibworth. His most distinguished student was Philip Doddridge. [1, 6, 7]

HOLBECK ROW 1900 (Park Row) Holbeche Hospital in the County of Lincoln. [1, 7, 37]

HOLLY GROVE 1939 (South Grove) The holly bushes in the shrubbery bordering this road. [1, 4, 8]

HOLLY GROVE SHRUBBERY See Holly Grove. The Shrubbery existed in 1875.
 Holly Grove, formerly South Grove but originally named George Street after George Choumert, was a private road in 1875. The residents contributed a sum not exceeding thirty shillings a year to keep the road, footpath and shrubbery in repair. Trustees were chosen by the tenants annually under a deed of George Choumert, dated 1831, to manage the property, and to inspect the treasurer's annual accounts. A notice of the audit had to be posted on the shrubbery for at least two hours each day for fourteen consecutive days. [17]

HOLLYDALE ROAD 1871 (Halton Terrace and Shirley Terrace) Probably an association of ideas: Hollydale and Ivydale in close proximity. [1, 4, 7]

HOLLYDALE SCHOOL opened on 10 September 1877 as Hollydale Road School and rebuilt in 1931. See Hollydale Road. [236, 475]

HOLLYDALE TAVERN, 115 Hollydale Road (P) See Hollydale Road. The pub is now called Hollydales. [184]

HOLLYDENE, Acorn Estate 1963 Holly – evergreen tree. [1, 2, 26]

HOLME HOUSE, Studholme Street 1956 Part of street name. [172]

HOMELEIGH ROAD 1893 Origin not traced. [7]

HONEYWOOD HOUSE, Oliver Goldsmith Estate 1954 Sir William Honeywood in *The Good Natur'd Man* by Oliver Goldsmith. [1, 2, 93]

HONITON GARDENS, Gibbon Road 1961 Honiton in Devon. [5, 400]

HOOKS CLOSE, Cossall Estate 1978 Hook's Road was demolished to make way for the Cossall Estate. Hook's Road (1866) was named after Hook Lane which is shown on an 1830 map. It disappeared in 1872 when Kirkwood Road was laid out. [2, 7, 180, 212]

HOOPER HALL, Consort Road 1907 The Misses Hooper who were the wife and sister-in-law of the Vicar of St Mary Magdalene, the Revd Michael Biggs (1815-85) who served at St Mary's for twenty-two years (1860-81). [264, 265, 340]

HOPE, 66 Rye Lane (P) In Greek mythology Pandora was given a box that she was forbidden to open. She disobeyed out of curiosity and released from it all the ills that beset man, leaving only hope within. [298, 323]

HORDLE PROMENADE EAST, NORTH, SOUTH and WEST, North Peckham Estate 1971 Hordle in Hampshire. [2, 5]

HORNSHAY STREET 1881 Edward Ashford Sanford (1794-1871), the street's owner. Hornshay Farm in Minehead, Somerset, belonged to his family. [621, 622]

HOVE STREET Origin not traced.

HOWARD COURT, Peckham Rye 1938 The foundation stone was laid by Peggy and Pat Hopwood, the twin daughters of the owner, but no record has been found of who Howard was. [364, 365]

HOWBURY MISSION 1892 See Howbury Road. Formerly a mission chapel connected with Peckham Rye Congregational Church and later run by the London City Mission which demolished the Victorian building and replaced it with the Peckham Christian Centre opened on 18 April 1997. [340, 351, 600]

HOWBURY ROAD 1877 Probably Howbury at Slade Green in the London Borough of Bexley. [1, 4, 7]

HOWDEN STREET 1876 Possibly after Howden in East Yorkshire. [1, 5, 7]

HOYLAND CLOSE, Ledbury Estate 1965 and 1969 Upper Hall Street became Hoyland Road in 1934. This was near where Hoyland Close was built. Hoyland Road may have been named after the 18th century poet Francis Hoyland. [1, 2, 6, 8, 20]

HUDDERSFIELD HOUSE, Sumner Estate 1938 Huddersfield Canal. [1, 2, 108]

HUGUENOT SQUARE 1978. Built close to where Huguenot Road (1878 – formerly Cadenham Road) used to be. The de Crespigny family owned land in this area. Huguenots were French Protestants of the sixteenth and seventeenth centuries. Civil rights were granted to the Huguenots by Henry IV of France in the Edict of Nantes (1598). After the revocation of the Edict by Louis XIV in 1685 very many Huguenots fled to Britain. Claude Champion de Crespigny (*b.* 17 May 1620) was an officer of high rank in the French service but at the revocation of the Edict of Nantes he left France with the whole of his family and came to England. [1, 7, 21, 26, 47, 361]

HYNDMAN'S STREET Henry Mayers Hyndman (1842-1921) social writer and politician. [1, 6]

I

ILDERTON ROAD 1879 Ilderton in Northumberland or Lucy and Nancy Ilderton in *The Black Dwarf* by Sir Walter Scott. [1, 5, 7, 90]

INDUS COURT, Garnies Close 1971 River Indus, Pakistan. [26, 361]

INFORUM MEWS rear of 220A Commercial Way 2007 Named after the developer Inforum Ltd. [614]

INNES STREET 2002 Dr Innes Pearse (1889-1978) was co-founder of the Peckham Pioneer Health Centre, which became known as the Peckham Experiment, with Dr George Scott Williamson whom she married in 1950.

Innes Pearse was born in Purley. She studied medicine at the London Hospital for Women and became House Surgeon at the Great Northern Hospital in 1918. She worked with Dr Scott Williamson at the Royal Free Hospital from 1920 to 1925. They began working together in Peckham in 1926.

Dr Pearse wrote a new book about the Peckham Experiment shortly before she died. *The Quality of Life: The Peckham approach to Human Ethology* was published posthumously. See Pearse Street and Williamson Court. [17, 494, 626]

INVERTON ROAD 1886 Inverton in Highland. [7, 283]

IRIS COURT, Brayards Road 2003 Name chosen by developer for no particular reason. [527]

ISIDORE CROWN MEDICAL CENTRE, 60 Chadwick Road was opened on 20 July 1998 and was named after Dr Isidore Wolfe Crown (1923-) who was born in Birmingham. He qualified as a doctor from King's College Hospital in 1947. As there was National Service then, he was conscripted to serve as a medical officer in the Royal Army Medical Corps and went to Victoria Hospital, Blackpool, as Casualty Officer and Orthopaedic House Surgeon. In 1948 he was posted to Germany where he was the Medical Officer of the garrison until he was demobilised in 1950 with the rank of Captain.

He worked in Colindale, Newport (Mon.) and Battersea before starting up his own single-handed medical practice at 105 Bellenden Road in 1953. He worked there until he retired in

1998. By then the practice had four doctors. New purpose-built premises in Chadwick Road, named Isidore Crown Medical Centre, were officially opened by Tessa Jowell MP, Britain's first Minister of State for Public Health, in October 1998.

Dr Crown has written five books – *Take One Anecdote Twice Daily*, *Repeat Prescription*, *No Side Effects* and *What a Laugh, Doc!* are about his patients; *Poles Apart* is a novel. [552]

IVY HOUSE See Stuart Arms.

IVYDALE ROAD 1882 Ivy<u>dale</u>: dale = valley between hills i.e. between Nunhead and Telegraph Hills. [7, 350]

IVYDALE SCHOOL Opened on 22 August 1892. See Ivydale Road. [340, 381, 425, 475]

J

JACK JONES HOUSE, 12 Reedham Street Jack Jones (1913-2009), general secretary of the Transport and General Workers' Union from 1969 until 1978, opened this accommodation for pensioners on 2 July 1987. He died in Cherrycroft (q.v.) on 21 April 2009 aged ninety-six. [95, 109, 110, 111, 112, 113, 114, 115, 116, 607]

JARVIS HOUSE, Oliver Goldsmith Estate 1955 Jarvis in *The Good Natur'd Man* by Oliver Goldsmith. [1, 2, 93]

JAY OPTICIANS, Aylesham Centre, Rye Lane Leslie Stuart Isaac Jay started in Peckham as an Opthalmic Optician in 1930, trading as Leslie S. Jay (Opticians) Ltd. on the first and second floors of 5 Central Buildings, Rye Lane. He had a uniformed commissionaire standing by the entrance promoting the practice. Leslie Jay died in April 1976. Since June 1987 the firm has traded as Jay Opticians. [228]

J. F. AYRE, Master Bakers, 131/133 Evelina Road John Frederick Ayre opened the bakery business on its present site in 1955. He was known as Fred the Bread. The Ayre family's baking tradition goes back seven generations to the early 1800s. [224]

JOCELYN STREET 1996 Reuse of a former street name. Jocelyn Street (1876) was formerly Queen's Place and Smith Street. It was closed in 1954. [7, 21, 458, 459]

JOE RICHARDS HOUSE, 100 Queen's Road, was opened on 26 June 1998 by the Rt. Hon. Harriet Harman, MP, Secretary of State for Social Security and Minister for Women. It was named after Joe Richards who was an active member of Equinox's (previously Drink Crisis Centre) management committee for six years. He was a primary school teacher who became a head teacher during the latter years of his teaching career. He died on 8 October 1996 aged seventy-eight. [477]

JOHN CARTER HOUSE, 25 Commercial Way In June 1968 John Carter became Senior General Foreman for the North Peckham Project, which was a small unit of Southwark Council responsible for building the North Peckham Estate. After the completion of the estate, John Carter was involved in many other projects for Southwark. At the time of his death in February 1981 he was the Contracts Manager for Southwark Construction. In view

of the high esteem in which John Carter was held by his colleagues, management and Members of the Council, it was decided in the late Autumn of 1981 to designate the office complex 'John Carter House' as a fitting memorial to the man and his work. [174]

JOHN DONNE SCHOOL, Wood's Road Opened as Wood's Road School in 1881. John Donne (1573-1631) was born in London, the son of an ironmonger. He was brought up in the Roman Catholic faith and matriculated early at Oxford to avoid taking the oath of supremacy.

Before entering Lincoln's Inn as a law student in 1592 he travelled on the continent. In 1596 he sailed as a volunteer with the Earl of Essex and on his return became private secretary to Sir Thomas Egerton, keeper of the Great Seal. This appointment was ended by his marriage to Ann More, niece of Egerton's wife.

John Donne visited Peckham quite often after his marriage because his wife's sister was married to Sir Thomas Grymes of Peckham.

George, the poet's second son, was born at Peckham and was baptized on 9 May 1605 in St Giles's Church.

After Mrs Ann Donne's death in 1617, Sir Thomas and Lady Grymes showed a warm and unceasing interest in the motherless family.

John Donne became Dean of St Paul's Cathedral in 1621 and continued in that capacity until his death. He frequently preached before Charles I. His sermons placed him among the greatest orators of his century.

Among his more important poems is the satirical 'Progresse of the Soule.' His best known poems include 'Hymn to God the Father', 'Death, be not proud' and 'Go and catch a falling star'.

John Donne was buried in St Paul's Cathedral. [17, 349]

JOHN HARRIS HOUSE, Reedham Street 1994 Sir John (H.) Harris (1874-1940) was a member of Peckham Quaker Meeting House in Hanover Street (now Highshore Road). The front is preserved as part of the Royal Mail Delivery Office. John Harris became Secretary to the Anti-Slavery and Aborigines Protection Society.

While engaged in social work in the City, he felt called to work in the Congo. He travelled widely in that country, obtaining first-hand information of the conditions of native labour at the beginning of the rubber boom. It was the cruelties which he saw perpetrated on the Africans in connection with the trade that led him to devote his life to welfare of the black people.

He travelled extensively in Europe and America trying to get forced labour and slavery abolished throughout the world.

John Harris was a keen politician. He was an unsuccessful Parliamentary candidate in Camberwell in 1922. He was MP for North Hackney 1923-4.

As a Quaker, he was deeply concerned about peace. From the foundation of the League of Nations he attended every meeting of the Assembly. He was knighted in 1933. [17]

JONES & HIGGINS, Rye Lane The co-founder of Peckham's former best known store, Edwin Jones, J.P. (1837-1916) came to London from Wales when he was a young man. He and George Randall Higgins became apprentices to an old-established business at the princely sum of £12 per year. By 1867 the two young men had saved enough money to open a

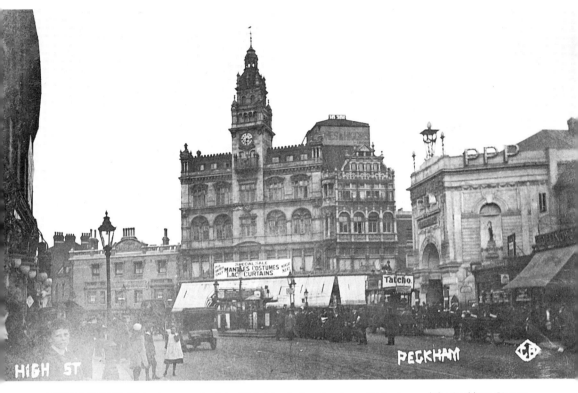

JONES & HIGGINS This photograph of the High Street, showing Jones & Higgins and the Peckham Picture Playhouse, was taken between 1911 and 1915.

small draper's shop at No. 1 Coburn Terrace, later known as No. 3 Rye Lane. Their first week's takings were £13. 19. 4*d*. In the early days Mr Jones and Mr Higgins slept under the counters of the shop to save lodging fees.

Edwin Jones worshipped with his wife at Peckham Wesleyan Church (demolished in 1972) and was a pewholder, if not a member of that church. He represented Peckham as a Progressive on the London County Council.

Jones & Higgins department store closed down on 7 June 1980 and re-opened two days later as The Houndsditch in Peckham. It was demolished in 1985. The Aylesham Centre (q.v.) was built on the site.

George Randell Higgins, J.P. (1844-1920) came from Oxfordshire to seek his fortune in London. He and Edwin Jones opened their own shop at the corner of Rye Lane.

The firm expanded quite rapidly, and in 1896 it was converted into a limited liability company. By 1923 it was employing 1,000 staff. Randell Higgins' son, and then his grandson, succeeded him in the business, which continued in the family until 1954 when it was taken over by Great Universal Stores.

Portraits of George Randell Higgins and Edwin Jones, painted by W. F. Measom, were presented to the South London Art Gallery on 12 October 1933. The unveiling ceremony was performed by Viscount Borodale, MP. [17, 572 (p. 17)]

JOSEPH MEWS, rear of 22 Inverton Road 2009 Named by the developer, Ms S. Kus. Joseph is the name of her eldest son. [614, 629]

JOWETT PARK, Commercial Way See Jowett Street.

JOWETT STREET 1938 (Middle Street) Benjamin Jowett (1817-93) was master of Balliol College, Oxford. He was born in the parish of Camberwell on 15 April 1817 [3, 6, 8]

J. SAINSBURY, Moncrieff Street John James Sainsbury (1844-1928) opened his first shop at 173 Drury Lane in 1869. Prior to houses being demolished to make way for the store which opened in 1982 and closed on 13 March 1993, Sainsbury's had a shop at 61-63 Rye Lane. This was opened on 6 November 1931. When it closed on 27 November 1982 it was Sainsbury's last old-type shop where staff served customers over the counter. [41, 259, 260, 261, 262, 263, 396]

K

KAPUVAR CLOSE, Alpha Street 2006 Named after the owner's daughter. [549]

KAREN COURT, 25–27 Peckham Hill Street *c.* 1955 Origin not traced. [322]

KELLIE'S (formerly Adam and Eve), 14 Peckham High Street (P) Renamed by its Irish owner who wanted an Irish-sounding name. Kellie's became Mantis in 2001. It was one of a group of pubs named after insects. In 2004 it became L'ile Boulay Nightclub. In 2005 the name was changed to Mbalax Nightclub. [184, 275, 492]

KELLY AVENUE Sir Gerald Kelly (1879-1972) was a portrait painter who was connected with the South London Gallery. His father was vicar of St Giles's, Camberwell. [473, 484]

KELVINGTON ROAD 1894 Possibly a misspelling of Kilvington in Nottinghamshire or North Yorkshire. [1, 5, 7]

KEMBLE COURT, Gloucester Grove Estate 1976 Kemble in Gloucestershire. [2, 5]

KENDRICK COURT, Wood's Road 1998 Councillor Ron Kendrick (*d.* 1997) was a Liberal Democrat Councillor (1990-94). [522, 523, 626]

KENNET HOUSE, Sumner Estate 1951 Kennet and Avon Canal. [1, 2, 177]

KENT WAY, Camden Estate 1976 Close to where Kent Cottages stood. [2, 7, 400]

KENTISH DROVERS, 71-79 Peckham High Street 2000 Reuse of a name for a pub that had been on the opposite side of the road next to Jones & Higgins' departmental store. [184]

KENTMERE HOUSE, Tustin Estate 1965 Kentmere in Cumbria. [2, 5]

KESTON ROAD 1879 Presumably Keston in the London Borough of Bromley. [1, 5, 7]

KETLEY HOUSE, Sumner Estate 1953 Ketley Canal. [1, 2, 69]

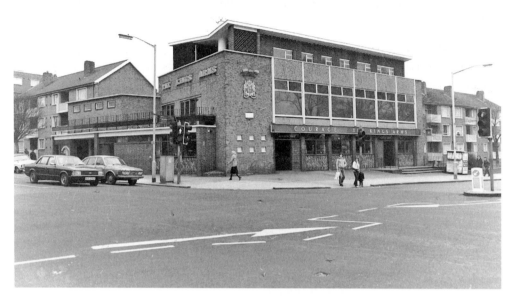

KINGS ON THE RYE The King's Arms, seen here in 1982, was converted into apartments.

KILMESTON WAY, North Peckham Estate 1971 Kilmeston in Hampshire. [2, 5]

KIMBERLEY AVENUE 1936 (Selborne Terrace, Stanley Terrace; Kimberley Road from 1867 and 1872 respectively) Probably named in honour of John Wodehouse (1826-1902) who was created the first Earl of Kimberley in 1866. [1, 4, 6, 7, 8, 10]

KINCAID ROAD 1883 Probably after Sir John Kincaid (1787-1862) of the Rifle Brigade. He was severely wounded at Waterloo. [1, 4, 6]

KING ARTHUR CLOSE 1980–81 Built close to where King Arthur Street used to be. [21, 361]

KING JOHN, 45 Peckham High Street (P) There is a tradition that King John killed a stag while hunting at Peckham. The pub closed in 1997 and was converted into flats in 2000. [3, 184, 476]

KINGFISHER HOUSE, Pelican Estate 1964 Kingfisher. [1, 2, 120]

KING'S ARMS See Kings on the Rye.

KING'S GROVE 1938 (King's Road; prior to 1872 Somerset Villas and Brooklyn Villas) Association of ideas: King's Grove off Queen's Road. [1, 4, 7, 8]

KINGS ON THE RYE, 132 Peckham Rye (P) Formerly King's Arms. Blanch (1875) wrote: 'John Barleycorn is proverbially loyal, and therefore ... we have "The King's Arms" (Peckham Rye)'. The pub was converted into apartments which opened in 2000 as Rye Apartments. [3, 11, 184, 291, 292]

KINGSBURY HOUSE, 777 Old Kent Road Foundation stone laid by Mary Smith on 18 January 1973. Kingsbury Securities were the first owners; they went into liquidation. [397, 442]

KINSALE ROAD 1907 Kinsale near Cork (association with Peckham unknown). [1, 7]

KIRKWOOD NATURE GARDEN Opened 2000 and described as 'Peckham's hidden gem' in *Peckham and Nunhead Through Time*. See Kirkwood Road. [611, 612]

KIRKWOOD ROAD 1868 (Henry's Cottages, Sunnyside Cottages, Chichester Terrace, Melrose Cottages) Kirkwood; place and house 4½ miles S.S.W. of Lockerbie, Dumfries and Galloway in Scotland. [1, 5, 7, 27]

KNOTTINGLEY HOUSE, Sumner Estate 1951 Knottingley Canal. [1, 2, 108]

L

LA COSTA SMERALDA, 57 Nunhead Lane A coast in Sardinia meaning the emerald coast. The owners are from Sardinia. See Edinburgh Castle. [615]

LABURNUM CLOSE, Brimmington Estate 1979 A laburnum tree stood in the Close until it was cut down in about 1990. [2, 377]

LAGAN HOUSE, Sumner Estate 1953 Lagan Navigation from Belfast to Lough Neagh. [1, 2, 42]

LAMBROOK HOUSE, Clifton Estate 1969 Lambrook in Somerset. [2, 5]

LANBURY ROAD 1987 Origin not traced. [7]

LANCEFIELD HOUSE, Nunhead Estate 1950 Mr Lancefield was one of the principal coachmasters in the parish of Camberwell at the beginning of the nineteenth century. [1, 2, 3]

LANDPORT WAY, North Peckham Estate 1971 Landport, a district of Portsmouth. [2, 5]

LANE WARD See Rye Lane.

LANVANOR ROAD 1877 Origin not traced. [7]

LASBOROUGH COURT, Gloucester Grove Estate 1975 Lasborough in Gloucestershire. [2, 5]

LATONA ROAD 1879 Latona is Latin for Leto who was a Titaness, the daughter of Coeus and Phoebe, the mother of Apollo and Artemis. [7, 336]

LATTER-RAIN OUTPOURING REVIVAL BETHANY, Copleston Road This black pentecostal church took over Church House, built in 1902 for St Saviour's, in 1984. The Latter-Rain Outpouring Revival was established in London in 1965 by Bishop Olive V. Parris, D.D., Ph.D., a former Salvation Army officer in the West Indies. The origin of the name goes back to the day the Lord spoke to her, as a young evangelist, that there would be an 'outpouring of the latter rain which will be more glorious than the former rain'. [266, 267]

LAUSANNE ROAD 1874 (part of Cemetery Road, Carlton Terrace, Rose Villas, Stanley Villas, Laburnham Villas, Clifton Villas, Leicester Villas, Clarendon Villas, Lausanne Villas) Lausanne in Switzerland. [1, 7]

LAWN PLACE, Camden Estate 1976 Lawn Houses used to be in Peckham Road. [2, 3]

LEAH HOUSE, 55a Chadwick Road 1991 Workshop of clothing manufacturer Leah Leisurewear. The girl's name Leah was chosen at random for registration at Companies House. [238, 343]

LEDBURY ESTATE 1965-69 See Ledbury Street. [2]

LEDBURY STREET 1863 Ledbury in Herefordshire. [1, 5, 7]

LEEDS HOUSE, Sumner Estate 1937 Leeds and Liverpool Canal. [1, 2, 108]

LEO STREET 1879 (Charles Street, Charles Cottages, Linden Terrace, Carleton Terrace) A humorous allusion to Washington Lyon, a Camberwell Vestryman who lived in Asylum Road. Lyon was still living at the time the street was named so approval of 'Lyon Street' was withheld. Leo Street School, now Grenier Apartments (q.v.) opened on 10 April 1899. [1, 3, 7, 10, 475]

LEONTINE CLOSE, Bells Gardens Estate 1980 Leontine in *The Good Natur'd Man* by Oliver Goldsmith. [2, 93, 400]

LEWES HOUSE, Friary Estate 1937 Franciscan community at Lewes in East Sussex. [1, 37, 308, 361]

LEYTON SQUARE PARK Leyton Square Garden, as it was originally called, was opened in 1901. Probably named after Leyton in East London. [1, 4]

LIDDLE WARD Alice Gertrude Liddle, a Councillor for eighteen years, who died in King's College Hospital on 2 December 1975, her seventy-third birthday. She was first elected as a member of the Metropolitan Borough of Camberwell for Clifton Ward in May 1953. Subsequently Miss Liddle was re-elected in 1956, 1959 and 1962.

After the amalgamation of the boroughs in 1965, she was elected as Councillor for Brunswick Ward of the London Borough of Southwark. For about thirty-five years Miss Liddle worked as agent and later as secretary for the Peckham branch of the Labour Party. [319, 320]

LIDGATE ROAD The Peckham Partnership chose to reuse the name of a former Peckham road. The 1874 road was named after a village in Suffolk. [1, 483]

LIME TREE HOUSE, Dundas Road A lime tree is in the garden. [496]

LIMERICK HOUSE, Sumner Estate 1939 Limerick Canal in Ireland. [1, 2]

LIMES WALK, Linden Grove 1970-71 Lime is the British name for the linden trees of the genus *Tilia*. [2, 26]

LIMESFORD ROAD 1884 In company with Linden Grove which borders the north side of Nunhead Cemetery. Linden = another name for lime tree. [7, 350]

LINACRE CLOSE 1997 Origin not traced.

LINDEN GROVE 1889 (Linden Terrace, Lyel Terrace, Clifton Villas, Oxford Villas, Cambridge Villas, Tresco Terrace) A grove of lime trees. Twenty-four lime trees were planted to lead from the main entrance gates of Nunhead Cemetery to the chapel. [1, 4, 7, 145]

LINDEN GROVE ESTATE 1947-1980 See Linden Grove. This estate began to be demolished in 2001. [2, 184, 499, 500]

LINDLEY ESTATE 1950-69 John Lindley (1799-1865), botanist and horticulturist. All blocks of flats are named after botanists in honour of Peter Collinson, the Quaker botanist of Peckham. [1, 2, 6, 17, 608]

LINWOOD WAY, North Peckham Estate 1971 Linwood in Hampshire. [2, 25]

LISFORD STREET 1876 (Bath Place, Elizabeth Street) Origin not traced. [7]

LISMORE HOUSE, Linden Grove Estate 1948 Lismore, Scottish island known as the Great Garden. [1, 2, 179]

LISS WAY, North Peckham Estate 1971 Liss in Hampshire. [2, 5]

LISTER HEALTH CENTRE, 1 Camden Square Joseph Lister (1827-1912) who became Lord Lister of Lyme Regis. He was Professor of Clinical Surgery at King's College (1877-93). Lister Health Centre was officially opened on 2 February 1978 by Sir John Donne, chairman of the South-East Thames Regional Health Authority. [6, 71, 72, 73, 74]

LISTER PRIMARY CARE CENTRE opened on 11 March 2002 at 101 Peckham Road, SE15. [506]

LIVESEY, Tustin Street This residential home for elderly people was named after the Livesey family who were great benefactors to the area that became the London Borough of Southwark. Mr Thomas Livesey, manager and secretary of the South Metropolitan Gas Company (1839-42), was a warm friend and liberal patron of local charities. His son, Sir George Livesey who became chairman, was instrumental in establishing the Working Men's Club and was donor of the Livesey Library in 1890. See Ullswater House. [49]

LIVESEY MUSEUM, 682 Old Kent Road Opened on 30 March 1974 by poet laureate Sir John Betjeman. Erected in 1890 as the second public library in Peckham; the gift of Sir

LIVESEY Councillor Lucy Brown opened Livesey on 25 October 1969.

LIVESEY MUSEUM A statue of Sir George Livesey was moved from the gasworks in the Old Kent Road to the courtyard of the Livesey Museum.

George Livesey. George Livesey (1834-1908) was the son of Thomas Livesey (1807-71) who was employed by the Gas Light and Coke Company from 1821. In 1842 Thomas Livesey became secretary of the South Metropolitan Gas Company and lived close to their works in the Old Kent Road.

George Livesey started working for the S.M.G.C. in 1848, became his father's assistant, and in 1862 was made engineer to the company. On his father's death in 1871, George Livesey became secretary of the company. He became chairman of the board of directors in 1885. He introduced a scheme whereby the employees shared in the profits of the company. He was knighted in 1902.

The Liveseys built up the S.M.G.C. to what was to become the second largest gas undertaking in the country, providing consumers with supplies of the highest standard. George Livesey effected improvements in almost every branch of the industry, and with his ability to utilize better and more economical methods of construction, he saw the development of the water sealed holder brought to its zenith.

George Livesey was buried in Nunhead Cemetery. His grave and memorial can be seen on the left hand side of the path leading from the main entrance to the derelict chapel. [17, 382, 567, 572]

LIVESEY PLACE 1926 (Elizabeth Cottages) Sir George Livesey. See Livesey Museum. [1, 8, 17]

LOANDA HOUSE, Linden Grove Estate 1948 Loanda, former name of Luanda, seaport capital of Angola, SW Africa. The three oldest blocks on this estate – Linden, Lismore and Loanda – all bear the name of harbours. [1, 2, 219]

LODER STREET 1874 (York Grove North and Clifton Cottages) Probably in honour of James Loader, Camberwell Vestryman (1863). [1, 7, 128]

LONDON AND BRIGHTON, 154 Asylum Road (P) Close to former London, Brighton and South Coast Railway line. [4, 21]

LONDON WILDLIFE GARDEN CENTRE, Marsden Road Opened on 25 June 1989 by the London Wildlife Trust in a disused Southwark Council yard. This is now known as the Centre for Wildlife Gardening. [184, 399, 625]

LONGHOPE CLOSE, Gloucester Grove Estate Longhope in Gloucestershire. [5]

LORD DENNING COURT, Grummant Road 1998 Lord Denning, a former Master of the Rolls. [538, 539]

LORD LYNDHURST, 53 Lyndhurst Way (P) This pub was converted into residential accommodation after closing in 2000. See Lyndhurst Grove. [3, 184, 294]

LORDS COURT, St Mary's Road The person who chose the name did so because of what she had been told about the history of Queen's Road i.e. that it was mainly divided into courtyards occupied by Lords. [562]

LUGARD ROAD 1877 (Gurdon Road) Rt. Hon. Sir Edward Lugard (1810-98). Entered army 1828; General, 1872; served Afghan War, 1842; Sikh War, 1845-46; Punjab Campaign, 1848-49; Persian War, 1856-57; Under-Secretary War Department, 1861-71. [1, 4, 7, 10, 32]

LULWORTH ROAD 1877 Lulworth in Dorset. [1, 5, 7]

LYDNEY CLOSE, Gloucester Grove Estate Lydney in Gloucestershire. [5]

LYMPSTONE GARDENS, Lindley Estate 1963-69 Lympstone in Devon. [1, 2, 5]

LYNBROOK CLOSE, Gloucester Grove Estate 1974 Lydbrook in Gloucestershire. (Spelling may have been changed to avoid confusion with nearby Lydney Close.) [5, 400]

LYNDHURST GROVE 1877 (Grove Terrace and Andover Terrace) John Singleton Copley (1772-1863), who was created Baron Lyndhurst. A lawyer, he was Solicitor General 1819-24, Attorney General 1824-26 and Lord Chancellor in 1827. [1, 6, 10]

LYNDHURST GROVE SCHOOL opened on 15 January 1883. See Lyndhurst Grove. Housing now occupies the site. [184, 475]

LYNDHURST SQUARE 1843 See Lyndhurst Grove. [144]

LYNDHURST WAY 1938 (Lyndhurst Road) See Lyndhurst Grove. [1, 4, 8]

LYNN HOUSE, Friary Estate 1937 Franciscan community at Lynn in Norfolk. [1, 5, 14, 37, 361]

M

MACFARLANE GROVE 2004 Walter McGlaughlan Macfarlane (1911-97) was born and brought up in Glasgow. He became a member of the British Communist Party at an early age and remained so until his death. He moved to the London County Council's newly built Rye Hill Estate, Peckham Rye, in 1938, and was actively involved in running the estate's tenants' association, editing its newsletter, and eventually became president of the association. Being a Scotsman, and living so close to Nunhead Cemetery, he was intrigued by the large monument erected to the memory of the Scottish Political Martyrs, and wanted to know more about this link between his country and his adopted 'parish'. His research took him to Australia, where the unfortunate advocates of universal suffrage were transported after being tried and found guilty of sedition in 1793. Wally published his findings in *The Story of the Scottish Martyrs* published by the Friends of Nunhead Cemetery in 1983.

On a glorious sunny Sunday in September 1993, representatives of all political parties met at Nunhead Cemetery to remember the Scottish Martyrs. A large crowd assembled and were led through the cemetery gates by a lone piper who played a lament. The event was addressed by, among others, Councillor Cecile Lothian J.P., Mayor of Southwark, and Wally Macfarlane who, through the Friends of Nunhead Cemetery, conceived the event. Wally summed up his address by saying that at the previous General Election the lowest recorded poll was that of Peckham, in whose local cemetery a monument was placed in memory of a handful of men who championed the right of all of us to vote.

Wally died in February 1997, aged eighty-six, and was cremated at Honor Oak Crematorium. An atheist, his secular send off included readings from the works of his hero, Robert Burns. [529, 530, 531, 573, 626]

MACHELL ROAD 1877 Probably James Octavius Machell (1837-1902), owner and manager of racehorses. Three of his own horses won the Grand National Steeplechase in 1873, 1874 and 1876. [1, 6, 7]

MAGDALENE CLOSE 1981 Proximity to St Mary Magdalene School. Mary Magdalene was a disciple of Jesus. [127, 361]

MAISMORE ARMS, 104 Peckham Park Road (P) See Maismore Street. Thomas Milner House (q.v.) stands on the site of this former pub demolished in 2002. [184, 628]

MAISMORE STREET 1910 (Maismore Terrace and William's Cottages) Maismore Terrace. Maismore Square is shown on Dewhirst's 1842 map. [7, 143]

MALLARD HOUSE, Pelican Estate 1956 Mallard [1, 2, 120]

MAN OF KENT, 2 Nunhead Green (P) Traditionally the description of a man born to the east of the River Medway, while those born to the west of it claim the title of Kentish Man. Probably chosen in contrast to the local commemoration of the Maid of Kent. See Barton Close. [295, 340]

MANATON CLOSE 1980 Built partly on the site of Manaton Road (1868). Probably named after Manaton in Devon. [1, 7, 21, 361]

MANOR COURT, 43 Talfourd Road 1960 There was no particular reason why this name was chosen. [322, 337]

MANOR GROVE 1879 (Hall's Cottages, Whittmee's Cottages, Victoria Place) Hatcham Manor. [1, 7, 61]

MARCUS HOUSE, Peckham High Street 1933 Built by Church Army Housing Ltd. A good benefactor to this housing scheme was a person called Marcus. [242, 243, 244]

MARLBOROUGH HEAD, 74 Marmont Road (P) Marmont Road used to be Marlborough Road. This former pub, which closed in 2000, bacame St George's Lodge. It is owned by St Georges Letts, Property Consultancy and Lettings, 55 St George's Road, SE1. [7, 184, 544].

MARMONT ROAD 1882 (Marlborough Road) Probably Auguste Frédéric Louis Viesse de Marmont (1774-1854), Marshal of France. [7, 26]

MARNE HOUSE, Sumner Estate 1954 Marne Canal in France. [1, 2, 26]

MARSDEN ROAD 1884 (Harrison Villas, Lee Villas, Elizabeth Villas, Ferndale Villas, Carisbrooke Villas, Branscombe Villas, Stanley Villas) George William Marsden (1812-93) lived at 113 Camberwell Grove. He was elected vestry clerk of Camberwell in 1852. [1 ,3, 7, 10, 135]

MARTOCK COURT, Clifton Estate 1967 Martock in Somerset. [2,5]

MATTINGLEY WAY, North Peckham Estate 1971 Mattingley in Hampshire. [2,5]

MAXTED ROAD 1876 (Blenklow Terrace, Woodlands Terrace, Winster Terrace, Bonsall Terrace, Hazelwood Terrace, Clarendon Street) Probably Maxted Street, a Kent hamlet. [1, 5, 7, 501]

MAXDEN COURT, Maxted Road 1962 Variation on name of road. [172]

MAYA CLOSE was named after the ancient Maya culture. The name was chosen by the developer. [494]

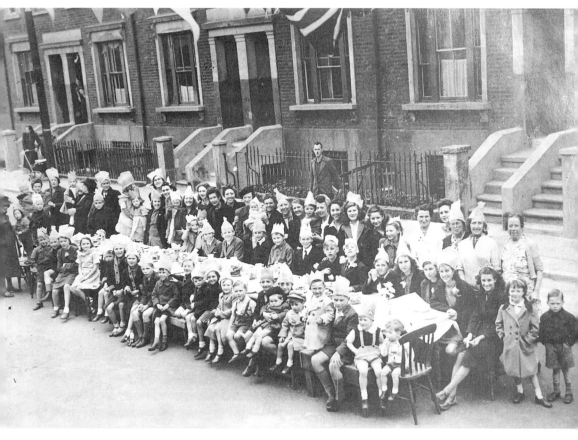

MARMONT ROAD A street party was held in Marmont Road in 1945 to celebrate victory in the Second World War. This is the photograph that should have appeared in *Peckham and Nunhead Through Time* on page 29.

MAYFAIR COURT, Fenwick Road 1963 Private estate named by the builders whose offices were in Mayfair. [1]

McCABE'S TAVERN, 107 Sumner Road (P) Mathew McCabe, owner from 31 March 1992. [307]

McDERMOTT ROAD Bryen McDermott, landowner *c.* 1830. McDermott Road Nature Garden became McDermott Grove in 2000. [1, 10, 184, 542]

McKENZIE COURT 300 Ivydale Road, 2008 Commemorates Able Seaman Albert McKenzie (1898-1918) who won a Victoria Cross. He lived in Shorncliffe Road, off the Old Kent Road. He is included in *Camberwell Old Cemetery* by Ron Woollacott. [564]

McKERRELL ROAD 1878 (Wadham Road) McKerrell was the maiden name of Lady Claude Champion de Crespigny. She was the second daughter of Robert McKerrell. Sir Claude married Georgiana Louisa Margaret McKerrell on 19 September 1872. [1, 3, 7, 47, 148]

MEDINA HOUSE, Rye Hill Estate 1959 River Medina, Isle of Wight. [1, 2, 5]

MEETING HOUSE LANE An old name marked on Rocque's map of 1744. The original meeting house of the congregation that later became known as Hanover Chapel was situated in this lane. [1, 3, 4, 10, 67]

MELON ROAD 1906 (Martins Road, Melon Place, Britannia Place, Britannia Cottages, Britannia Terrace, Melon Cottages) Site of a seventeenth century melon ground, on part of Basing Manor. Sir Thomas Gardyner, who lived at Basing Manor House, sent King Charles I some melons. [1, 3, 7, 10]

MERIDIAN COURT, Gervase Street The developer was Meridian Time Development Ltd. [594]

MERSEY HOUSE, Sumner Estate 1939 Mersey and Irwell Navigation. [1, 2, 77]

MERTTINS ROAD 1886 Origin not traced. [7]

MILFORD WAY, Camden Estate 1976 Milford Cottages were demolished when the Camden Estate was built. [2, 7, 400]

MILLBROOK HOUSE, Friary Estate 1952 Millbrook Priory, Bedfordshire. [1, 308]

MISSION PLACE 1936 (Blue Anchor Lane) Orchard Mission, opened in 1906. [8, 129]

MITCHELDEAN COURT, Gloucester Grove Estate 1976 Mitcheldean in Gloucestershire. [2, 5]

MONCRIEFF ESTATE 1978 See Moncrieff Street. [2]

MONCRIEFF PLACE See Moncrieff Street. Part of Moncrieff Street, between Rye Lane and the Peckham Premier Cinema, now the Peckham Multiplex, was renamed Montcrieff Place in February 1997. [463]

MONCRIEFF STREET 1871 (Cambridge Terrace) Sir Alexander Moncrieff (1829-1906), colonel and engineer. He was a designer of gun mechanisms. The street was named in the year that he was elected a Fellow of the Royal Society. [1, 4, 6, 10]

MONKLAND HOUSE, Camden Estate 1949 Monkland Canal, Scotland. [1, 8, 42]

MONTAGUE SQUARE 1981-82 Origin not traced. [361]

MONTEAGLE WAY 1979 Lord Monteagle (1790-1866), patron of the Metropolitan Beer and Wine Society. He laid the first stone of the Society's asylum at Nunhead Green in 1852. [2, 3, 6, 180]

MONTPELIER, 43 Choumert Road (P) Choumert Road used to be Montpelier Road. [7, 296]

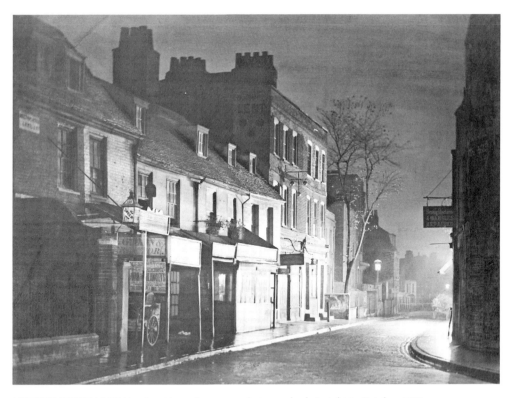

MEETING HOUSE LANE Meeting House Lane was photographed at night in October 1910.

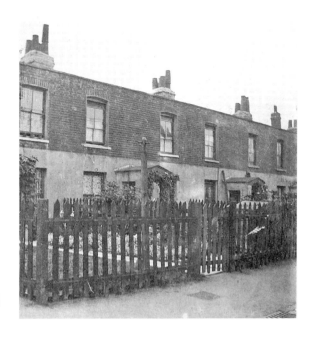

MELON ROAD How different Melon Road looks today!

MONTPELIER, 99 Queen's Road (P) *c.* 1853 On the corner of Montpelier Road. The former pub was demolished and flats were built on the site. [144, 184, 206]

MONTPELIER ROAD 1875 (Wellington Villas) Montpellier (sic.) in France was seat of an ancient university and medical school and virtually the only malaria-free cultural centre on the Mediterranean. It was a favourite destination for young British aristocrats and their tutors doing the Grand Tour of Europe during the seventeenth and early eighteenth centuries. By the early nineteenth century, when the British streets were built, Montpellier was no longer favoured by well-heeled British tourists who were transferring their affections to Nice and Monte Carlo, but the aristocratic association persisted and, the speculative builders and developers who 'ran up' the new terraces and streets for their middle class clients naturally chose an upmarket name with aristocratic pretensions.

What is unclear is why invariably the street name is misspelt, 'Montpelier' (one L), unless the builders were trying to save a little on the cast iron of the street signage. [1, 7, 318]

MOODY ROAD 1997 Harold Arundel Moody (1882-1947) came to London in 1904 from Jamaica. He studied medicine at King's College and qualified as a doctor. See Dr Harold Moody Park. Dr Moody's former home at 164 Queen's Road was the first building in SE15 to have an English Heritage blue plaque erected on it. [17, 184, 460, 574]

MORNING STAR, 231 Rye Lane (P) The planet Venus when visible in the East before sunrise. The Morning Star became The Nags Head in 2000. It was named after the make-believe Peckham pub featured in BBC TV's *Only Fools and Horses*. [210, 507, 508, 509]

MORTLOCK CLOSE, Cossall Estate 1977-78 Before the Cossall Estate was built, Mortlock Gardens (1869) stood where part of Cossall Park is today. Part of Harder's Road used to be known as Mortlock Terrace. [1, 7, 21]

MOTHER GOOSE NURSERY SCHOOL, 34 Waveney Avenue The way a mother goose looks after her goslings prompted the use of this name for a nursery school. [221, 222]

MURDOCK STREET 1938 (Alexander Street) William Murdock (1754-1839), engineer and inventor of coal-gas lighting. [1, 6, 8, 10]

MUSCHAMP ROAD 1877 Muschamp family, prominent in Camberwell and Peckham from the beginning of the sixteenth century to the 1670s when their estates were bought by Sir Thomas Bond. There is a memorial to Thomas Muschamp in St Giles's Church, Camberwell. [1, 3, 7, 10, 130]

N

NAGS HEAD (P) See Morning Star.

NAILSWORTH COURT, Gloucester Grove Estate 1976 Nailsworth in Gloucestershire. [2, 7]

NAYLOR ROAD 1863 (Exon Terrace, Pembroke Cottages, Milford Grove, Milford Cottages) Elizabeth Caroline Naylor, of 15 The Gardens, who leased six houses in Naylor Road in 1877. [4, 7, 137]

NAZARETH GARDENS 1994 Built in the former grounds of Nazareth House. [3, 420, 426]

NELL GWYN NURSERY SCHOOL, Staffordshire Street 1935 Nell Gwyn, whose real name was Eleanor Gwyn (1650-87), was a mistress to Charles II. She was born in Hereford.

Nell's first public occupation was that of an orange seller in the Theatre Royal. She later became an actress.

There is a local legend that she played in the theatre in the High Street, Peckham, though no proof has been found. However, a comedy in three acts was published in 1799 called *The Peckham Frolic or Nell Gwyn*.

Charles II is believed to have been a frequent visitor at the Peckham home of Sir Thomas Bond so it is not beyond the bounds of possibility that the King saw Nell Gwyn perform in the Peckham Theatre.

She was buried in St Martin-in-the-Fields.

The school moved in 1994 from Staffordshire Street to Meeting House Lane. [17, 354]

NEVILLE CLOSE, Bells Gardens Estate 1980 Miss Constance Neville in *She Stoops to Conquer* by Oliver Goldsmith. [2, 23, 93, 400]

NEW JAMES COURT, Nunhead Lane 1966 Built on part of the site of New James Street. [181, 361]

NEW JAMES STREET ESTATE 1957-78 See New James Court. [2]

NEWENT CLOSE, Gloucester Grove Estate 1972 Newent in Gloucestershire. [2, 9]

NEWLANDS The last part of Nunhead to be built on towards the end of the nineteenth century. [340]

NIGEL ROAD 1872 Possibly *The Fortunes of Nigel* by Sir Walter Scott. [1, 7, 23]

NILE TERRACE The Battle of the Nile (1798). [10, 131]

NORTH PECKHAM ESTATE 1950-72 See Peckham. [2]

NORTHFIELD HOUSE, Friary Estate 1934 North Field was a plot of land that bordered the Peckham Manor. [1, 2, 122]

NORTHLEACH COURT, Gloucester Grove Estate 1976 Northleach in Gloucestershire.[2, 5]

NUNHEAD The origin of the name Nunhead is shrouded in mystery. It was mentioned in a deed dated March 1583 in which Edgar Scot sold to Thomas and William Patching a fifth part of the manor of Camberwell Buckingham, including certain estates 'lying at Nunn-head'. There is no evidence to link the name Nunhead with the famous 'Nun of Kent', Elizabeth Barton (?1506-34), whose outspoken criticism of Henry VIII's marriage with Anne Boleyn led to her being executed for treason at Tyburn. However, the name may be connected with the nunnery of St John the Baptist at Halliwell (Shoreditch), which acquired various lands in Camberwell and Peckham in the late twelfth century. These later formed the manor of Camberwell Friern. The name None Head is shown on John Rocque's map of the area dated 1741-45. [516]

NUNHEAD CEMETERY Consecrated by the Bishop of Winchester on 29 July 1840. See Nunhead. [289]

NUNHEAD CRESCENT 1894 (William's Terrace). See Nunhead. [1, 7]

NUNHEAD ESTATE 1950-56 See Nunhead. [2]

NUNHEAD GREEN See Nunhead. Camberwell Vestry bought Nunhead Green in 1868 for £1,000 on condition that it remained open to the public in perpetuity. [4]

NUNHEAD GROVE 1889 (Nunhead Terrace, Daniel's Cottages, Montague Villas, Florence Villas) See Nunhead. [7]

NUNHEAD HILL 200 feet above sea level. See Nunhead. [340]

NUNHEAD LANE 1889 (Beaufort Terrace, Philbrick Terrace, James Place, Belle Vue Terrace, Osborne Villas, Percy Terrace, Cambridge Terrace, Elm Place, Adelaide Terrace, Renfrew Terrace, York Place) See Nunhead. [7, 10]

NUNHEAD PASSAGE See Nunhead.

NUNHEAD CEMETERY The main entrance and the Anglican chapel in Nunhead Cemetery were photographed in 1982.

NUTBROOK STREET 1876 (Parson's Villas, Colville Terrace, Roseley Terrace, Eccleston Terrace) Local field name. [1, 7, 10]

NUTCROFT ROAD 1875 Local field name. [1, 4, 7]

NUTT STREET 1873 (Charles Street) Joseph Nutt, Surveyor of Highways 1700-75. [1, 7]

O

OAK COURT, North Peckham Estate 1994 Oak Tree. [443, 444]

OAKDALE ROAD 1980 (Ivydale Road) Renamed in company with Hollydale Road and its former name. [180]

OAKDENE, Acorn Estate 1962 Oak tree. Dene means vale. [1, 2, 19]

OGLANDER, Oglander Road (P) 1883 See Oglander Road. [609]

OGLANDER ROAD 1877 (Colville Grove, Wildash Road, Leyton Terrace, Oglander Terrace, Frederick Terrace, Thompson Villas, Frenchwood Villas, Withernsea Villas, Avenham Villas, Walton Villas, Fern Villas, Myrtle Villas, Oak Villas, Ash Villas, Elm Villas, Birch Villas) Sir John Oglander (1585-1655), diarist. He married Sir Thomas Grymes of Peckham's sister, Frances, on 4 August 1606. [1, 4, 6, 7, 10]

OLD CANAL MEWS, off Nile Terrace 2002. The Grand Surrey Canal was a short distance away. [20]

OLD JAMES STREET 1966 Possibly William James, Surveyor to Dulwich College property, early nineteenth century. [1, 361]

OLD KENT ROAD The road leading from London to Kent, dating back to the Romans. [1, 4, 10]

OLD NUN'S HEAD, 15 Nunhead Green (P) 1934 A signboard outside the Old Nun's Head Tavern, Nunhead Green, purports to tell the story of the pub which gives the area its name. It should be noted, however that some of the information on the sign is based on a popular local legend.

The Myth:

Local families whose connection with Nunhead goes back a long way, some of whom have lived in Nunhead since the 1860s, were brought up to believe that the Old Nun's Head occupies the site of a nunnery. Unfortunately, no evidence has been found to support this theory.

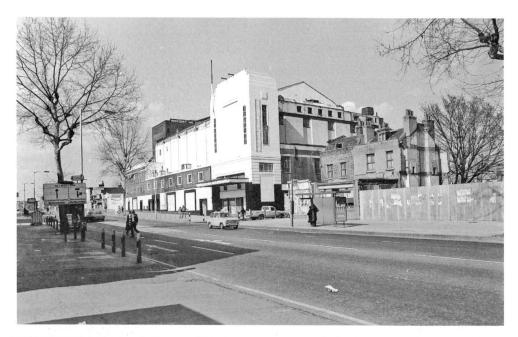

OLD KENT ROAD The Astoria cinema, which closed in 1968, was still a landmark in the Old Kent Road in 1980; it was demolished in 1984.

In 1925 Leopold Wagner, author of *More London Inns and Taverns,* perpetuated the myth (possibly based on the local stories) by suggesting that the nuns used a secret subterranean passage in the cellar of the nunnery as a means of escape during the Reformation. Wagner also claimed that when Henry VIII's soldiers sacked the nunnery, the Mother Superior was arrested and beheaded, and her severed head was placed on a pike-staff in the middle of the green. He went on to invite readers to examine the remains of the tunnel by arrangement with the landlord of the tavern. Wagner's book makes fascinating reading but lacks notes or references.

The Facts:

Despite a sign erected over the Old Nun's Head Tavern in the nineteenth century claiming it was first licensed in the age of Henry VIII, the first recorded mention of a licensed establishment at Nunhead was in 1690, during the reign of William and Mary. However, the first documentary evidence of the name Nunhead appears in a deed of 1583, when Edgar Scot sold his part of the Manor of Camberwell Buckingham, including his estate at 'Nunn-Head' to Thomas and William Patching. Nun's Heads make uncommon place names and usually meant a messuage, which is a piece of land with a dwelling house and outbuildings attached. In the seventeenth century there were three such messuages in the City of London bearing the name 'Nun's Head' or 'Nunn's Head'. Our Nun's Head, which was then in the County of Surrey, appears to be the only surviving tavern sign.

The present pub, built in 1934, occupies the site of a much earlier building. In the eighteenth century it included a skittle alley and a tea garden among its attractions, and

according to William Hone (1780-1842), writer and bookseller, it was a popular resort among 'smoke dried London artisans' *The Epicure's Almanac,* an 1815 guide to eating and drinking establishments in London and its suburbs, promised that a rural dinner with vegetables fresh from the garden may be had at the Nun's Head in the summer.

In the 1830s, Sarah Dyer (*c.* 1782-1851) was the tavern keeper. In Sarah's lifetime Nunhead was still a pleasant Surrey hamlet surrounded by meadows and market gardens. The development of Nunhead as a residential suburb of London began after the consecration of Nunhead Cemetery in 1840. Edward Hazel was landlord of the Old Nun's Head from 1908 to 1933. The building was demolished and a new one was built in the 'Mock Tudor' style in 1934.

<div align="right">Ron Woollacott [44, 436, 576]</div>

OLIVER GOLDSMITH ESTATE 1930-59 See Goldsmith Road. [2, 17]

OLIVER MEWS, Highshore Road Percy Lane Oliver (1878-1944) was born at St Ives, Cornwall. His family moved to south east London in 1883. After leaving school Percy Lane Oliver worked for Camberwell Borough Council and continued to do so until he retired.

He was a founder member of the Camberwell Division of the Red Cross in 1910. *The Shell Book of Firsts* records that the first blood donor panel was set up in 1921 by Percy Lane Oliver. An oil painting of him hangs in the entrance hall of the Haematology Out Patients Department of King's College Hospital. Next to the portrait is the inscription:

<div align="center">'Voluntary Blood Donation Service
1921-1971'</div>

From King's College Hospital in 1921 Mr Percy Lane Oliver of the Red Cross in Camberwell received an urgent call for a blood donor. This showed him the need for Voluntary Blood Donor Panels at a time when these were unknown. By the Second World War he had created a network covering the whole country. His was the first Blood Transfusion Organisation. It gave impetus to the formation of the National Service in this country and inspired the creation of similar panels throughout the world.'

Mr Oliver moved to 210 Peckham Rye in 1926 where he and his wife ran the growing blood donor service. The telephone was never left unattended. As their landlord objected to all the activity, they moved to 5 Colyton Road in 1928. From here Percy Oliver and his colleagues developed their important work and blood transfusion services spread throughout the world. At an international conference in Rome in 1935 a tribute was paid by the Belgian delegate to Percy Oliver's Red Cross Service for pioneering this form of social service. Again in 1948 at Turin it was referred to as the world's most senior service.

In 1979 a Greater London Council blue plaque was unveiled at 5 Colyton Road which states:

<div align="center">Percy Lane Oliver
1878-1944
Founder of the First Voluntary Blood Donor Service
lived and worked here</div>

<div align="right">[17, 184, 497]</div>

ONDINE ROAD 1876 (Rutland Villas, Mount Villas, Aden Villas, Pine Villas, Crescent Villas, Dartmouth Villas, Tiverton Villas, Buxton Villas, Salisbury Villas, Bexley Villas, Brookwood Villas, Argyle Villas, Lorne Villas, Luton Villas, Charlton Villas, Hatherley Villas, Belmont Villas, Clarence Villas, Ryde Villas, Ventnor Villas, Merton Villas, Camden Villas, Florence Villas, Clifton Villas, Rosedale Villas, Taunton Villas, Brighton Villas, Shanklin Villas, Lonsdale Villas, Pevensey Villas, Westbury Villas, Clyde Villas, Clevedon Villas, Wellington Villas, Marlborough Villas, Litchurch Villas) Ondine, or Undine, the water nymph in *Undine* by Fouqué (Friedrich Heinrich Karl), Baron de la Motte (1777-1843), German poet. *Undine* was published in 1811 and adapted as a play by Jean Giraudoux (*Ondine*, 1939). [1, 7, 23, 132]

OPHIR TERRACE 1901 (York Terrace, Acacia Terrace) Ophir, a region celebrated in ancient times for its fine gold and frequently mentioned in the Old Testament. Its position has been the subject of much dispute. [7, 26]

ORMSIDE STREET 1874 (St James's Street, Grove Cottages, Stafford Place, St Thomas's Terrace, Alpha Cottages, Oxford Place, St Ann's Place, Sarah's Place) Great Ormside in Cumbria. [1, 5, 7]

OSPREY HOUSE, Pelican Estate 1957 Osprey. [1, 2, 120]

OXENFORD STREET 1902. Playwright John Oxenford (1812-77) who was born in Camberwell. [1, 3, 7, 10]

P

PAGE 2, formerly Edinburgh Castle, 57 Nunhead Lane The owner had a bar in North London called Chapter One so he made a link between the two pubs. This pub became The Village Inn in 2008. It is now La Costa Smeralda (q.v.). [184, 537]

PAINSWICK COURT, Gloucester Grove Estate 1976 Painswick in Gloucestershire. [2, 5]

PALM COURT, North Peckham Estate 1994 Palm tree. [443, 444]

PALYNS HOUSE, 270 Consort Road 1980 George Palyn, Master of the Girdlers Company in 1595. In 1610 he gave money by Will to found his Almshouse Charity. [28, 453]

PARKSIDE NEIGHBOURHOOD HOUSING OFFICE, 27 Bournemouth Road 1991 Bournemouth Road neighbourhood forum decided to change the name of the neighbourhood office to Parkside to reflect the number of parks in the area and the greener aspect of Peckham. [237]

PARKSTONE ROAD 1866 Parkstone in Poole. [4, 5, 7]

PATCHWAY COURT, Gloucester Grove Estate 1976 Patchway in South Gloucestershire. [2, 5]

PATTERDALE ROAD 1965 Patterdale in Cumbria. [2,5]

PEAR COURT, North Peckham Estate 1994 Pear tree. [443, 444]

PEARSE STREET 2004 Dr Innes Pearse (1889-1978) was co-founder of the Peckham Experiment with Dr George Scott Williamson whom she married in 1950. See Innes Street and Williamson Court. [17, 626]

PECKHAM Old English *Peac-ham* – village by a hill. We cannot be sure which hill – Nunhead Hill, Telegraph Hill or Honor Oak Hill (One Tree Hill)? Manorial and other evidence strongly suggests that it was Nunhead Hill. Here stood the original Manor of Bredinghurst which may be identified with 'lands of Pecheham' belonging to Bishop Maminot at the time of the Domesday Survey. Peckham was called Pecheha in the Domesday Book. [3, 44, 133, 368, 369]

PECKHAM CHRISTIAN CENTRE See Howbury Mission.

PECKHAM CHRISTIAN FELLOWSHIP, Consort Road Ichthus used the former St Paul's Church opened in 1907. St Paul (*d. c.* AD 65) was an apostle of Jesus Christ. [284, 287]

PECKHAM GROVE 1867 (Cambridge Terrace) See Peckham. [7]

PECKHAM HIGH STREET The high or principal street. The High Street, Peckham, became Peckham High Street in 1935. See Peckham. [10, 577]

PECKHAM HILL STREET 1939 (Hill Street and originally Lord's Lane) Mrs Martha Hill bought the Peckham Manor House and estate in 1732 after the death of Lord Trevor. Mrs Hill passed the estate to her youngest brother, Isaac Pacatus Shard. The deed for this transaction is preserved in Southwark Local History Library, 211 Borough High St., SE1 1JA. [1, 8, 10, 17]

PECKHAM LODGE, 110 Peckham Road 2002 This hostel was the headquarters of the Amalgamated Union of Engineering Workers. [184]

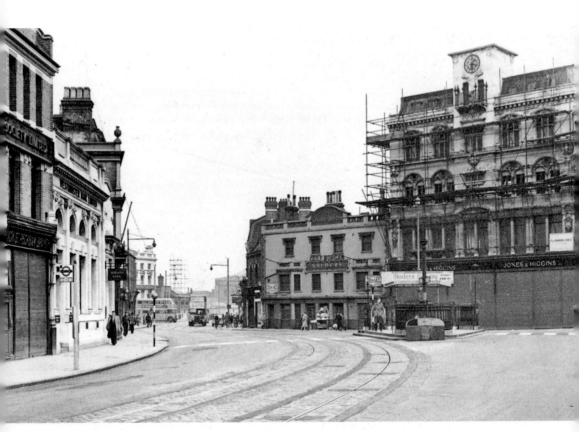

PECKHAM HIGH STREET In 1953 travellers along Peckham High Street could see the 1894 Jones & Higgins's tower being repaired after it was damaged during the Second World War. [572]

PECKHAM METHODIST CHURCH, Wood's Road 1974 John Wesley, founder of Methodism, was leader of a group of friends at Oxford who read the Bible and prayed regularly together. When the group's activities became known, derisive undergraduates called it various names including 'The Enthusiasts', 'The Bible Moths' and 'The Holy Club' but the name which stuck was the 'Methodists' (presumably given because of the curiously methodical way of life which they followed). [43, 142]

PECKHAM PARK PRIMARY SCHOOL, Friary Road Opened on 4 September 1876 as Lower Park Road School. The Infants School opened on 20 August 1888. See Peckham Park Road. [302, 475]

PECKHAM PARK ROAD 1870 (Park Road, Charles Place, Mary's Place, Leah Cottages, Nile Terrace, Cambridge Terrace, Lebanon Place, Sutherland Terrace, Eagle Place, Trafalgar Place, Clyde Cottages, Gloucester Cottages, Gloucester Place, Park Villas, Henry's Cottages, Villa Place, William Cottages, Maismore Place, Park Terrace, George Terrace, Edwin Place). Before the growth of the area in the nineteenth century this area was known as Peckham Park. W.H. Blanch in *Ye Parish of Camerwell* (1875) states that it was 'a park of considerable extent'. Park Road was formerly called Peckham Gap. [1, 3, 4, 7, 10, 190]

PECKHAM PARK ROAD BAPTIST CHURCH, Peckham Park Road Opened on 5 May 1951. See above and East Dulwich Baptist Church. [288]

PECKHAM ROAD 1892 See Peckham. [4, 7]

PECKHAM RYE See Peckham. Rye is Old English *ripe* meaning 'brook'. Peckham Rye is mentioned in documents as early as the fourteenth century. Peckham Rye is rhyming slang for tie. [3, 4, 10, 44, 133, 136]

PECKHAM RYE PARK, SE22 Opened on 14 May 1894. See Peckham Rye. [336]

PECKHAM RYE PRIMARY SCHOOL, Whorlton Road Opened on 7 January 1884. See Peckham Rye. Rye Oak Primary School (q.v.) now occupies the site. [184, 475]

PECKHAM RYE STATION 1865 Named Peckham Rye to distinguish it from Peckham Station (later renamed Queen's Road, Peckham). Listed grade II 2008. [3, 138, 578]

PECKHAM RYE TABERNACLE BAPTIST CHURCH, 55a Nigel Road 1963 See Peckham Rye and East Dulwich Baptist Church. Tabernacle was a provisional tent where the Lord met his people. (Exodus 33: 7-10). [127, 327]

PECKHAM SEVENTH DAY ADVENTIST CHURCH, 149-159 Ivydale Road Originally Waverley Park Methodist New Connexion Chapel opened in 1896. Used by Seventh Day Adventists since March 1986. A section of Adventists who, after the expected Second Coming of Christ failed to be realised in 1844, constituted themselves as a separate body. They observe the Old Testament Sabbath Saturday as the weekly day of rest and praise instead of Sunday. [4, 284, 312, 326]

Peckham Rye. Band Stand.

PECKHAM RYE A bandstand was moved from the Royal Horticultural Society's Garden in Kensington to Peckham Rye in 1889. It was partially destroyed by a land mine in the Second World War. As it was a danger to children it was blown up. [618]

PECKHAM SQUARE See Peckham. Opened on 29 September 1994 by the Members of Parliament for Peckham and Dulwich, Harriet Harman and Tessa Jowell. [428, 429, 430, 431]

PELICAN ESTATE 1956-1964 An eighteenth-century house called Pelican House stood where Pelican House is today. [1, 2, 3, 21, 143]

PELICAN HOUSE, Peckham Road See Pelican Estate. When Blanch wrote *Ye Parish of Camerwell* (1875) Pelican House had 'been built at least 200 years, and the pelicans, from which it derives its name, originally stood on brick pilasters at the entrance gates'. In 1989 the building on the site was renamed Winnie Mandela House. In 1995 Southwark Council changed Winnie Mandela House (q.v.) back to its original name. In 2008 apartments were opened in the new Pelican House. [1, 3, 21, 134, 184, 450, 451]

PENARTH STREET 1874 (Cross Street, John's Place) Penarth in The Vale of Glamorgan. [1, 5, 7]

PELICAN HOUSE The façade of Pelican House, seen here in 1979, has been incorporated in the apartments opened on the site in 2008.

PENCRAIG WAY, Ledbury Estate 1969 Pencraig in Herefordshire. [2, 5]

PENNACK ROAD 1887 Charles Pennack, builder, who married Susannah Tavener of Marylebone on 10 August 1846 at St Mary's, Lambeth. In 1851 he was living at 19 Smyrks Road, Newington. In 1861 he was residing at 1 Haywards Place, Upper Grange Road, Bermondsey. Also at this address were three younger brothers – John, George, and Henry, who were all carpenters. In 1871 Charles was a widower and was living with his brother John at 102 Upper Grange Road. John had married Eliza Tavener, sister of Charles' wife. [1, 7, 579]

PENNETHORNE ROAD 1883 Sir James Pennethorne (1801-71), architect. [1, 4, 6, 7]

PENTRIDGE STREET 1912 (St George's Street) Pentridge in Dorset. Robert Browning's great-grandfather lived in the parish of Pentridge. Robert Browning was born at Southampton Street, Camberwell, on 7 May 1812. [1, 5, 6, 7, 157]

PETERCHURCH HOUSE, Ledbury Estate 1966 Peterchurch in Herefordshire. [2, 5]

PHAROAHS, Peckham Road Reason for name not traced. This pub was very badly damaged by fire on 9 July 2004. Formerly the Walmer Castle (q.v.), the pub was built in the 1870s. In *Nunhead & Peckham Pubs Past and Present: A pub crawl through time* Ron Woollacott recorded that the champion boxer Chris Finnegan was 'mine host'. He shot to fame in 1968 when he won the Olympic middleweight gold medal in Mexico. After turning professional he became British and European light-heavyweight champion in 1972. [184, 509, 580, 581]

PHILIP ROAD 1868 (Philip Terrace and Girdler's Terrace) Philip Champion de Crespigny of Champion Lodge, Camberwell, proctor of the Courts of Admiralty and Arches. [1, 7, 47]

PHILIP WALK, Consort Estate 1978 See Philip Road. [2]

PILGRIM'S WAY PRIMARY SCHOOL, Tustin Estate, Manor Grove 1968 Close to the route used by pilgrims travelling to Canterbury in the middle ages. [372, 373, 374, 378, 379]

PILKINGTON ROAD 1868 (Keating Road) Sir Thomas Pilkington (*b.* 7 December 1773), father-in-law to Sir John Tyssen Tyrrell and grandfather of Mary Tyrrell. On 1 August 1797 at Great Waltham, Essex, he married Elizabeth Anne Tufnell. He was Sheriff of Yorkshire (1798-99). He died on 9 July 1811 aged thirty-seven. [7, 328, 329]

PINEDENE, Acorn Estate 1962 Pine tree. Dene means vale. [1, 2, 19]

PIONEER CENTRE, Frobisher Place St Mary's Road Opened in 1935 as The Pioneer Health Centre. Later it was The Frobisher Institute of Adult Education. [516, 521]

PIONEER STREET 1996 The Peckham Pioneer Health Centre and because of its close proximity to the Peckham Pulse, Britain's first healthy living centre. [458, 516]

PITT STREET Probably William Pitt the Younger (1759-1806) who was Prime Minister (1783-1801, 1804-06). [6, 190]

POLLARDS, 171 Rye Lane The firm was founded by William Waide Pollard (1866-1937) in 1892. Trading began in these premises in 1985 though the firm had previously had shops at 110 High Street and 165 Rye Lane. [271, 272, 273]

POMEROY ESTATE 1980–82 Pomeroy in Tyrone, Northern Ireland. [1, 2, 325]

PORTBURY CLOSE, Clifton Estate 1967 Portbury in North Somerset. [2, 5]

POTTER CLOSE 2002 Revd Canon George Potter is remembered as Father Potter of Peckham. He became Vicar of the neglected church of St Chrysostom, in Hill Street, in 1923. On the Sunday before he was inducted there were three people in the congregation and a collection of 6 ½*d.*

George Potter lived in the church hall until rats drove him out. He then took over a disused public house, 'The Eagle' in Bells Garden Road, as his vicarage.

In 1924 he founded the Brotherhood of the Holy Cross, wearing the habit of a grey cloak with a knotted cord. Other brothers were recruited.

After two years in the disused public house, the community moved to a factory building in the High Street. A few years later they moved to 60 Linden Grove.

Father Potter and his collegues looked after hundreds of delinquent boys over the years. He wrote about his experiences in two books called *Father Potter of Peckham* and *More Father Potter of Peckham.*

He died at 66 Linden Grove on 15 February 1960 aged 73. The funeral service, held at St Chrysostom's, was conducted by the Bishop of Southwark, Dr Mervyn Stockwood. [17, 582, 626]

POULNER WAY, North Peckham Estate 1971 Poulner in Hampshire. [2, 5]

PRIMROSE HOUSE, Oliver Goldsmith Estate 1930 Dr Charles Primrose, the central character in *The Vicar of Wakefield* by Oliver Goldsmith. [1, 2, 90]

PRINCE ALBERT, 111 Bellenden Road (P) Consort to Queen Victoria. This part of Bellenden Road used to be Victoria Road. [21]

PRINCE OF WALES, 14 Ruby Street (P) Very common sign (nearly 100 in Greater London alone) usually refers to Edward (1841–1910), eldest son of Queen Victoria. He became Edward VII in 1901. [295]

PRINCE OF WINDSOR, 888 Old Kent Road (P) Formerly Prince of Saxe-Cobourg. The rulers of Saxon Duchies abdicated after the First World War. Windsor is the family name of the present royal house of Great Britain. [26, 303]

PRIORY COURT, Cheltenham Road 1976 Built on the site of Priory Villas. [189, 361]

PURDON HOUSE, Oliver Goldsmith Estate 1954 Edward Purdon, a friend of Oliver Goldsmith's. Purdon was either editor of *Busy Body* or a contributor. *Busy Body* was a short-lived periodical published three times a week between 9 October and 3 November 1759. [1, 2, 93]

PYROTECHNISTS ARMS, 39 Nunhead Green (P) Close to the site of Brock's firework factory. [17]

Q

QUANTOCK MEWS, Choumert Grove Quantock Laundry occupied the site. The family who owned it came from the area of the Quantock Hills. [532, 533, 534]

QUARLEY WAY, North Peckham Estate 1971 Quarley in Hampshire. [2, 5]

QUAY HOUSE, 2c King's Grove The naming of Quay House sprang from the name of the design practice Quay 2c. The Quay name came from the evolving design of the 'beach huts' at the back of 2c King's Grove that were designed in 1998 and fit between the existing roof trusses that have kept in the main ground floor space. This coastal theme continued in the naming of Quay House and there are allusions to the coastline in some of the design features internally to the top flat, the silver wave roof etc. Architect Ken Taylor also liked the ambiguity of the word quay in that it could be mistaken as a 'key' to unlocking things. This actually sprang from thinking about naming, and talking about favourite bits of music, which in his case is 'Spanish Key' from the Miles Davis album *Bitches Brew*. [583]

QUEDGELEY COURT, Gloucester Grove Estate 1976 Quedgeley in Gloucestershire. [2, 5]

QUEEN, 101 Commercial Way (P) Queen Elizabeth I. [298, 306]

QUEEN ELIZABETH, 61 Asylum Road (P) *c.* 1840 Queen Elizabeth I. The pub was boarded up in February 2002. Meridian Court occupies the site. [144, 184, 208, 306]

QUEEN'S ROAD 1868 (Queen's Cottages, Barden Place, Pemell's Terrace, Gotha Place, Derby Place, Montpelier Terrace, Devonshire Terrace, Oriental Place, Alexander Terrace, Ebenezer Place, Alpha Place, Montague Terrace, Hatcham Place, Holloway Terrace, Caledonian Terrace, Wyndham Place, Belvidere Villas, Union Road, Union Terrace, Bath Place, St Mary's Terrace, Princess Terrace, Dennet Terrace, Laural Cottages, Queen's Terrace, Victoria Terrace). Originally known as Deptford Lane, the name was altered in honour of Queen Victoria who often passed along it on her way to the Naval School at New Cross (now Goldsmiths College). [1, 3, 4, 5, 10, 190]

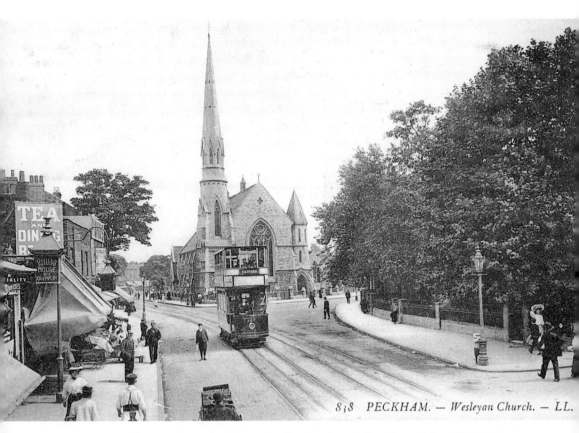

8;8 PECKHAM. — Wesleyan Church. — LL.

QUEEN'S ROAD Peckham Wesleyan Church was a landmark in Queen's Road from 1865 to 1972. [43]

QUEEN'S ROAD STATION Opened 13 August 1866. Originally Peckham Station. Renamed on 1 December 1866. [3, 138]

QUENINGTON COURT, Gloucester Grove Estate 1976 Quenington in Gloucestershire. [2, 5]

R

RADFORD COURT, Old Kent Road Tony Radford is a director of Infany Homes who bought the site. [593]

RADNOR ROAD 1938 (Radnor Street) Probably William Pleydell-Bouverie (1779-1869), third Earl Radnor, a distinguished whig politician. [1, 6, 8]

RAILWAY TAVERN, 66 Gibbon Road (P) Close to railway in Nunhead. Only the pub sign exists; flats occupy the site. [184]

RAUL ROAD 1882 Claude Raul Champion de Crespigny *b.* 19 September 1878. [1, 4, 7, 10, 47]

READING HOUSE, Friary Estate 1938 Franciscan community at Reading. [1, 2, 5, 14, 37, 308]

RECORD STREET 1895 Origin not traced. [7]

RED BULL, 116 Peckham High Street (P) W. H. Blanch (1875) wrote in *Ye Parish of Camerwell* 'The Red Bull' (High Street, Peckham) is an ancient public-house sign. Alleyn, founder of Dulwich College, says in a memorandum, October 3, 1617:- 'Went to "The Red Bull" and received for the Younger Brother (a play) but £3 6s. 4d.' [3, 295, 296]

RED COW, 190 Peckham High Street (P) Blanch (1875) wrote – Strange, or perhaps natural enough, the next house in the High Street to 'The Red Bull' is 'The Red Cow', and for 150 years at least both have lived in the same street upon the best of terms:

> 'The Red Cow
> Gives good milk now.'
> and of 'The Red Bull' it was said,
> 'If you want a good pull,
> Just step in at the Bull.' [3]

REDDINS ROAD 1873 Edmund Reddin, contractor to Camberwell Vestry, 1867. [1]

REEDHAM STREET 1887 (Norfolk Street, Laburnam Cottages, Somershall Terrace, Ararat Cottages, Arthur Cottages) Reedham in Norfolk. [1, 5, 7]

REGAL ROW, off Astbury Road 1994 Name taken from Southwark Council's Street Name Bank and has no local reference. [443, 444]

RELF ROAD 1872 Probably in honour of Camberwell Vestryman John Thomas Relph. [1, 7, 10, 255]

REVIEW, 131 Bellenden Road Opened May 2005. It made sense to call a bookshop 'Review'. It also made sense that if selling books didn't work then 'Review' would do nicely as a name for a shop selling just about anything else where some careful selection of products on offer would make the shop stand out from other shops of similar ilk. [631]

REYNOLDS ROAD 1891 (Pancras Road, Priory Villas, St Pancras Terrace) Jonathon C. Reynolds, Surveyor to Camberwell Vestry in the 1860s. [1, 3, 4, 7, 10, 128]

RICHLAND HOUSE, Oliver Goldsmith Estate 1954 Miss Richland in *The Good Natur'd Man* by Oliver Goldsmith. [1, 2, 90]

RISING SUN, 799 Old Kent Road (P) A common heraldic sign, referring to Edward III, Richard III and to many landed families. [295]

ROBERT COURT, Sternhall Lane 2008 Developer Robert Mulvey of Mulvey Developments (UK) Limited of Hainault, Essex. He was originally from County Leitrim, Ireland. He moved to England in 1986 and was a self-employed builder who started his own company in 1989. He developed an old derelict button factory at 1-6 Sternhall Lane. Previously six houses were on the site; they were bombed in the Second World War. Robert Court comprises eleven flats and two business units. Robert Mulvey wanted to name the development after his only daughter Claire, but Southwark Council refused permission because at 98 Peckham Rye is Claire Court (q.v.). [598]

ROBERT HART MEMORIAL SUPPLEMENTARY SCHOOL, 5-9 Hordle Promenade East Robert B. O. Hart (1913-84) was born in Guyana. He was a lawyer and teacher who taught in Britain for more than twenty years.

In the late 1970s he became secretary of the Caribbean Teachers' Association and in that position was instrumental in formulating a Teaching and Educational project designed to be supportive of and supplementary to mainstream education provision. As part of this project, a supplementary school was established on the North Peckham Estate. After the death of Robert Hart, the school was named after its founder. [385, 386]

ROBERT KEEN CLOSE 1978 Alderman Robert James George Keene (sic) who was on Camberwell Borough Council (1956-1965). He was a process engraver's etcher. [2, 269, 270]

ROCHDALE HOUSE, Sumner Estate 1938 Rochdale Canal. [1, 2, 77]

ROLLINS STREET 1881 Origin not traced. [622]

ROMAN WAY, Brimmington Estate 1982 Remains of Roman roads (Watling Street and London to Lewes road) lie nearby. [2, 16, 140]

ROSEMARY COURT 2009 See Rosemary Road. [614]

ROSEMARY GARDENS, Southampton Way 1960 See Rosemary Road. [333]

ROSEMARY ROAD 1872 (North Street, Chandos Terrace, Castle Terrace, Cambria Cottages, Cromwell Villas, Ebenezer Terrace, Branch Buildings, Denmark Terrace, Hesse Terrace, Before the North Peckham Estate was built Rosemary Road extended from the west end of what is now Commercial Way.) The Old Rosemary Branch public house stood at the corner of what are now Southampton Way and Commercial Way. It was first recorded in *c.* 1700. It is shown on Stockdale's map (1797). The grounds surrounding it were extensive; horse racing, cricket, pigeon shooting and all kinds of outdoor sports and pastimes were carried on. Rosemary was formerly an emblem of remembrance. 'There's rosemary, that's for remembrance,' say Ophelia. (*Hamlet*, Act IV, Scene 5). A new Rosemary Road was built off Sumner Road. [1, 3, 7, 10, 21, 143, 144, 184]

ROSENTHORPE ROAD 1894 Rosen<u>thorpe</u>: Thorpe = homestead or village. [7, 350]

ROSINA WHYATT MEMORIAL GARDEN, Highshore School, Bellenden Road The upkeep of the Memorial Garden was provided for by a fund given to the school by Miss Rosina Whyatt, Justice of the Peace, Alderman and Mayor (1954-55) of the Borough of Camberwell and for twenty-one years chairman of the managers of Highshore School. She died in August 1971 aged eighty-five. [314]

ROTHER HOUSE, Rye Hill Estate 1951 River Rother. [1, 2, 92]

ROUPEL HOUSE, Sumner Estate 1953 Roupel ship canal in Belgium. [1, 2, 183]

ROWAN COURT, North Peckham Estate 1994 Rowan tree. [443, 444]

ROYAL LONDON BUILDINGS, 644 Old Kent Road The Royal London Mutual Insurance Society Limited purchased the freehold in 1896. The offices were built around the turn of the twentieth century. [393, 394]

ROYSTON HOUSE, Friary Estate 1950 Austin Canons community at Royston in Hertfordshire. [1, 2, 5, 14, 37, 308]

RUBY STREET 1876 (Church Street, St Thomas Terrace, Bethwin Terrace, Church Place) Believed to be named after landowner's daughter. [1, 7]

RUBY TRIANGLE 1910 (Baker's Terrace and then The Triangle) See Ruby Street. [7]

RUDBECK HOUSE, Lindley Estate 1950 Oluf Rudbeck (*d.* 1702) Swedish botanist. [1, 2, 132]

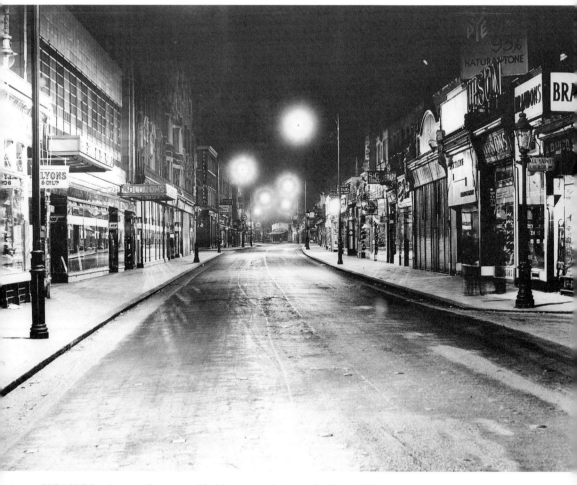

RYE LANE Rye Lane, with improved lighting, was photographed in *c.* 1936.

RUSSELL COURT, Heaton Road 1980 Russell Road (1872) – now Blackpool Road. [7, 21, 180]

RYE APARTMENTS opened in 2000 in the former King's on the Rye (q.v.) (formerly known as the King's Arms). [184]

RYE HILL ESTATE 1938-64 See Rye Hill Park. [2]

RYE HILL PARK 1901 (Portland Villas, Hillsboro', Hillside Villas) Built on hill overlooking Peckham Rye. [1, 7, 189]

RYE HOTEL, 31 Peckham Rye (P) Overlooks Peckham Rye. This pub was renamed The Rye in 2004. [184, 536]

RYE LANE 1868 (South Street) The lane leading to Peckham Rye (q.v.). [1, 4, 7, 10]

RYE LANE CHAPEL Opened on 18 November 1863. See Rye Lane. [3]

RYE OAK PRIMARY SCHOOL, Whorlton Road 2005 The school is close to Peckham Rye. Just as mighty oak trees grow from small acorns so the school aims to help their children develop to their full potential. The school uses the former Peckham Rye Primary School (q.v.). [595]

RYE PASSAGE 1936 (Back Alley) Passage leading from Troy Town to Peckham Rye. [8]

RYE ROAD 1909 See Peckham Rye. [1, 7]

RYEGATES, Brayards Estate 1960 Rycotts, Ricotes, Rigates or Ryegates: a plot of land in Dulwich sixteenth-seventeenth century. [1, 2, 3, 207]

RYEVIEW, 110 Peckham Rye Has a view across the northern end of Peckham Rye. [184]

S

SAFEWAY, Aylesham Centre In 1962 the American supermarket chain 'Safeway Stores Inc' entered the British market. In 1986 the Argyll Group PLC, whose main trading facia was Presto, showed an interest in Safeway Food Stores Ltd and the following year Safeway became part of Argyll. In due course the Presto store in the Aylesham Centre became Safeway. This was later bought by Morrisons. [184, 402]

SAINSBURY, J. See J. Sainsbury.

ST ALBAN'S R.C. PRIMARY SCHOOL, Peckham Road St Alban, the first English martyr. Building opened in 1888 as a pupil teacher centre. From 26 September 1906 until 1931 it was the County Secondary School, Peckham. From 1986 it was St Alban's R.C. Primary School. Since 1996 it has been St James the Great Catholic Primary School (q.v.). [162, 163, 338, 584]

ST ANDREW'S NURSING HOME, 64-66 Choumert Road Named after the builder, Andrew McCallion, a Scotsman. [480]

ST ANTONY'S CHURCH, Nunhead Consecrated on 12 October 1957 by the Bishop of Southwark, Rt. Revd Bertram Simpson. St Antony of Egypt, the first. Desert Father (c. AD 251-356). The building became the Lighthouse Cathedral – The Mega Church. [44, 184]

ST BRIAVELS COURT, Gloucester Grove Estate 1975 St Briavels in Gloucestershire. [2, 5]

ST FRANCIS R.C. SCHOOL, Friary Road St Francis of Assisi. [162, 299]

ST GEORGE'S CHURCH See Church of Saint George.

ST GEORGE'S LODGE, Marmont Road See Marlborough Head.

ST GEORGE'S TERRACE, Peckham Hill Street Close to the district of St George. [143]

ST GEORGE'S WAY 1936 (St George's Road) Proximity to St George's Church, Wells Way, built in 1822-24 and converted into flats. [1, 8, 10, 11, 184]

ST JAMES THE GREAT CATHOLIC CHURCH PRIMARY SCHOOL, Peckham Road Became the new name for St Alban's R.C. Primary School (q.v.) on 1 September 1996. The school was originally sited by a chapel called St Alban's in what was to become Burgess Park. When the park was developed the chapel, which was in the parish of English Martyrs, was demolished and the school was to close. However, the school building in Peckham Road became available and so the school moved there into the parish of St James the Great in 1986. [457]

ST JAMES THE GREAT CHURCH, Elm Grove 1904 James the Great (*d.* A.D. 44); apostle and martyr. Described in the Gospels as the son of Zebedee and the brother of John, James was one of the three witnesses of the Transfiguration of Christ and his agony in the garden of Gethsemane. He was also the first apostle to die for the Christian faith, being put to the sword at Jerusalem by King Herod Agrippa. [248, 249]

ST JAMES WALK, Camden Estate 1975 James's Grove and James's Street were nearby. [2, 155, 190]

ST JOHN'S AND ST CLEMENT'S SCHOOL, Adys Road The school moved into this building from North Cross Road, SE22, in 1994. St John was an apostle of Jesus. St Clement was Bishop of Rome. The former Adys Road School was built in 1883. [284, 435, 441, 471]

ST JOHN'S CHURCH, Meeting House Lane The parish church of St John, Bishop of Constantinople was consecrated by Mervyn Stockwood, Lord Bishop of Southwark on 11 June 1966. The new building replaced two former churches – St Chrysostom in Peckham Hill Street, demolished in 1963, and St Jude destroyed by enemy action in 1940. The former was named after St John Chrysostom who was elected Archbishop of Constantinople in 398. St John had been nicknamed 'Chrysostom' (meaning 'golden-mouthed') and it was thought appropriate that the new church should bear the saint's correct name rather than his nickname. [230, 231, 390, 391]

ST LUKE'S CHURCH, North Peckham Estate Consecrated on St Luke's Day, 18 October, 1954. Evangelist. According to tradition he was the author of the Third Gospel and of the Acts of the Apostles. [284, 309]

ST MARY MAGDALENE CHURCH, St Mary's Road Consecrated on 3 November 1962 by the Bishop of Southwark, the Rt. Rev. Mervyn Stockwood. Her Majesty Queen Elizabeth the Queen Mother attended the Opening Service. Mary Magdalene was a disciple of Jesus Christ. The present church replaced one destroyed in 1940. [127, 287, 290]

ST MARY MAGDALENE SCHOOL, Godman Road 1856 (boys) and 1894 (girls) See above. The school has been converted into apartments. The present school opened in 2001. [3, 127, 184, 585, 586]

ST MARY'S ROAD 1878 (Sophia Place, Lombardian Terrace, Lombardian Villas, New Villas, Ryde Villas) St Mary Magdalene Church was consecrated by the Bishop of Winchester on 7 May 1841. It was destroyed by a landmine on 21 September 1940. [1, 3, 4, 7, 10, 147]

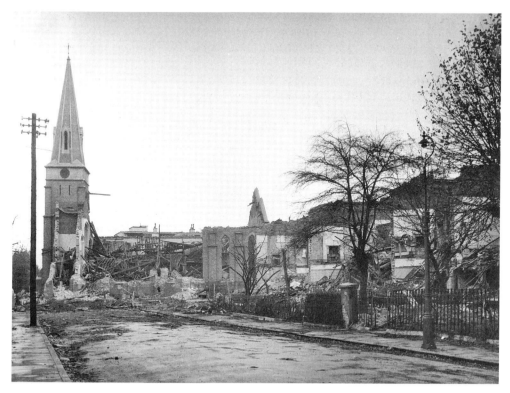

ST MARY MAGDALENE CHURCH St Mary Magdalene Church was destroyed by a land mine in 1940.

ST SAVIOUR'S CHURCH, Copleston Road (now the Copleston Centre) Consecrated on 22 February 1881. Saint is an adjective meaning holy i.e. Holy Saviour's. There was no St Saviour. [210, 211, 395]

ST SILAS CHURCH, Ivydale Road 1903 A prominent early Christian disciple. He was St Paul's companion on his first visit to Macedonia and Corinth. This Edwardian building was replaced by the Community Centre of St Antony with St Silas which was dedicated in 2003. [4, 284, 569]

ST THOMAS THE APOSTLE CATHOLIC CHURCH, Hollydale Road 1905 One of the twelve apostles, known as 'doubting Thomas'. [127, 357]

ST THOMAS THE APOSTLE COLLEGE, Hollydale Road 1965 See previous entry. [358]

SALISBURY TERRACE, Barset Estate 1981-82 Barset Road was formerly Salisbury Terrace. [2, 7]

SALLY MUGABE HOUSE, 69 Bellenden Road In 1993 this building was renamed after the wife of Zimbabwean President Robert Mugabe. Sally Mugabe died on 27 January 1992 aged

fifty-nine. She was seriously ill for the last eleven years of her life but refused to allow this to get in the way of her active support for community programmes which earned her the unofficial title 'Amau' – mother of the nation. She was patron of many projects involving child welfare and health, education, human rights and self-help for women. She made monthly visits to leprosy sufferers to ensure they had sufficient food and clothing, She went to Southwark in March 1987 and visited women's projects. She spoke on political changes in South Africa and their effect on women and children. Robert Mugabe visited the house in Bellenden Road on 18 May 1994. [281, 282, 411, 587]

SALLY O'BRIEN'S, formerly the Crown, Peckham High Street (P) In 1994 the governor of this Irish pub changed its name. A television advertisement for beer included an attractive young woman called 'Sally O'Brien'. The catch phrase was 'Sally O'Brien and the way she might look at you'. The pub was seen boarded up in early 2002 and occupied by Reed in 2004. [184, 432, 560]

SALVATION ARMY CITADEL, Gordon Road Opened in 1891, damaged by a bomb in 1940 and re-opened in 1960.

Minnie Lindsay Carpenter wrote in *William Booth* – 'During the early months of 1878, William Booth was engaged on the preparation of a report of the Mission. With him were his son Bramwell and George Railton. As he walked up and down the room discussing the proofs, they came to the question which headed it: "What is the Christian Mission?" "A volunteer army of converted working people" Railton had written. William Booth looked over the young man's shoulder and, picking up a pen, struck out the word "Volunteer", substituting "Salvation". Then he read aloud: "The Christian Mission is a Salvation Army ..." There was a moment of tense silence. The three men looked at each other and rose to their feet. A thrill passed from heart to heart. The Salvation Army! They felt they had suddenly burst upon a wonderful discovery; how great, was at the moment hid from their eyes.' From 1879 the Mission notepaper was stamped with the new title. [388, 389]

SAMUEL JONES COURT 2009 See Samuel Jones Industrial Estate. [614]

SAMUEL JONES INDUSTRIAL ESTATE The factory of the gummed paper firm Samuel Jones and Co. Ltd. used to stand in Southampton Way. Samuel Jones was born in 1818 and entered his father's stationery firm when he was thirteen. He succeeded to the business in 1845.

In 1868 Samuel Jones purchased 67 and 69 Peckham Grove and erected a small factory at the bottom at the bottom of his garden at number 67. These houses became the site of the factory.

Samuel was a religious man and wrote *The Pliable of the Nineteenth Century brought to the Bar of Eternal Truth*. An autograph copy is preserved in Southwark Local History Library, 211 Borough High Street, SE1 1JA.

Samuel Jones retired from his firm in 1874.

Samuel Jones and Co. Ltd. adopted the Camberwell Beauty as their trademark in 1912. This butterfly was first recorded in England in 1748 when two specimens were captured in Cold Harbour Lane near the village of Camberwell.

The 20 ft. mosaic of the Camberwell Beauty which rested at the top of the factory from the 1920s was moved to Southwark Council's public library in Wells Way in 1982. [17, 462]

SAMUEL STREET 1997 Samuel Jones' gummed paper factory, which was demolished in 1982. See above. [17, 462]

SANDGATE STREET 1908 (Caroline Street, Eliza Cottages or Place, part of Ruby Street) Sandgate in Kent. [1, 5, 7]

SANDISON STREET 1884 (Bedford Street, Victory Cottages) May be related to its former name. There is a place near Bedford called Sandy. [1, 7]

SANDLINGS CLOSE, off Pilkington Road 1995 Variation on Sanding which was a long-standing wedding tradition. Coloured sand was spread before the doors of the bride, her friends and wellwishers, and elegant scrolls, hearts, lovers' knots and posies were laid on it in white sand. [448]

SANTANDER, 97 Rye Lane See Abbey.

SARAWAK COURT, Consort Road 2008 Sarawak is one of two Malaysian states that share the island of Borneo. Crisscrossed with rivers and blessed with lush rainforest, the place is dotted with one of the world's most elaborate cave systems and is home to some of Asia's most intriguing wildlife including Orang Utans and Birds of Paradise. Over two million people live in Sarawak and the population is as diverse as the geography that surrounds them. More than forty ethnic groups, each with their own language, culture and lifestyle, live together including Malays, Kayan, Chinese, Melanau and Penan. The state has historically enjoyed harmonious race relations and despite its infamy as the home of headhunting, it's now renowned for its people's hospitality and warmth. [558]

SARNESFIELD HOUSE, Ledbury Estate 1965 Sarnesfield in Herefordshire. [2, 5]

SARTOR ROAD 1863 Mr J. A. Dunn, who was a tailor, made an application for this road to be made on the estate of the Tailors' Labour Agency Freehold Land Society. Sartor is Latin for tailor. [1, 7, 23, 252, 253]

SASSOON GALLERY was named after Ben Sassoon, the owner, who also owns Bar Story. [550]

SASSOON HOUSE, St Mary's Road 1932 This five-storey block of twenty flats was a gift of Mrs Meyer Sassoon to the Pioneer Housing Trust in memory of her only son, R.E. Sassoon. It was designed by Maxwell Fry and opened by Sir Samuel Hoare. During the First World War, which began when Reginald Ellice Sassoon was twenty-one, he obtained a commission in the Irish Guards, rose to Captain and gained the Military Cross. After the war he entered the family business, being a director of the two Elias David Sassoon companies as well as of Arnhold & Company Limited and the Eastern Bank. He bought a string of horses and began to ride them regularly in races under the National Hunt rules. In January 1933, while taking part in a steeplechase at Lingfield, he fell and sustained serious injuries. He died a few days later in a London nursing home. A race was instituted by his friends in his memory. [2, 144, 176, 342, 546]

SAUL COURT, Gloucester Grove Estate 1976 Saul in Gloucestershire. [2, 5]

SAVANNAH CLOSE 2002 One of the road names based on African or Caribbean influences to connect with many people who live in Peckham. [630]

SCAFFOLD HOUSE, Consort Road Office of D & R Scaffold Group. [184]

SCIPIO STREET 1879 (George Street) John Francis Scipio, Camberwell Vestryman. [1, 3, 7]

SCYLLA ROAD 1872 (Sherlock Road, Nunhead Passage (part), Scylla Gardens, Monks Cottages, Francis Place, Scylla Terrace, Winter's Buildings, Percy Cottages) HMS *Scylla* was the ship commanded by Captain Augustus James de Crespigny. He was renowned for his bravery in rescuing fellow sailors from drowning. He served under Nelson and Collingwood. He died on board HMS *Scylla* on 24 October 1825 and was buried in Port Royal, Jamaica, where there is a memorial to him. [1, 7, 47, 148]

SELDEN ROAD Origin not traced.

SENATE STREET 1866 Origin not traced. [7]

SHAKESPEARE COURT, 22A Peckham Rye 1990 Dramatist and poet William Shakespeare (1564-1616). [6, 2, 15]

SHANKLIN WAY, North Peckham Estate 1971 Shanklin on the Isle of Wight. [2, 5]

SHANNON COURT, Garnies Close 1972 River Shannon, longest river in Ireland. [26, 361]

SHARDS SQUARE (formerly Shard Square) The Shards of Peckham were a family of considerable note in the latter part of the eighteenth century and a large portion of Peckham once belonged to them. [1, 3, 20]

SHARPNESS COURT, Gloucester Grove Estate 1976 Sharpness in Gloucestershire. [2, 5]

SHARRATT STREET 1881 Origin not traced. [622]

SHEFFIELD HOUSE, Bellenden Road 1933 Built by Church Army Housing Ltd. A good benefactor to this housing scheme was a lady living in Sheffield. [1, 171, 242, 243, 244]

SHELLEY CLOSE, Gordon Road 1989 Poet Percy Bysshe Shelley (1792-1822). [6, 201]

SHERGAR (formerly Prince Albert), 119 Consort Road (P) Race horse Shergar won the Derby in 1981. Proprietor Joseph Beattie chose the name as he was a racing fan. Shergar became The Spotted Frog on 19 December 1997. The name was chosen by the seven-year-old daughter of one of the pub's customers. She entered the competition to find a new name for the pub and found the name in a story book. The pub's name was changed to The Frog on the Green in 2005. It is now the Frog on the Green Deli. [184, 274, 467]

SHURLAND GARDENS, Willowbrook Estate 1962 Shurland in Kent. [2, 283]

SIDMOUTH ARMS, 102 Bird-in-Bush Road (P) *c.* 1860 Early nineteenth century Prime Minister Henry Addington, Viscount Sidmouth. [489]

SIDMOUTH HOUSE, Lindley Estate 1965 Sidmouth in Devon. [1, 2,5]

SIDMOUTH ROAD, Camden Estate 1976 Sidmouth Terrace was demolished when the Camden Estate was built. [2, 7, 400]

SILKIN MEWS, Fenham Road 2006 Lewis Silkin (1889-1972) was Labour Member of Parliament for Peckham from 1936 to 1950. Clement Attlee appointed him Minister of Town and Country Planning at the end of the Second World War. He therefore had an important influence on every aspect of the third Labour Government's rebuilding policy. He was responsible for steering through Parliament the New Towns Act of 1946, the Town and Country Planning Act of 1947; and the National Parks and Access to the Countryside Act of 1949.

As MP for Peckham he had a large following in South London. He founded the solicitors firm of Lewis Silkin and Partners.

In 1950 he was raised to the peerage as Baron Silkin of Dulwich. He was Deputy Leader of the Opposition in the House of Lords from 1955 to 1964. He was the father of the Rt. Hon. Samuel Silkin, who was MP for Dulwich from 1964 until 1983. He was also the father of the Rt. Hon. John Silkin, who became MP for Deptford in 1963. [17, 555, 628]

SISTER MABEL'S WAY 1984 Probably Sister Mabel who founded Sister Mabel's Free Dispensary for Sick Animals of the Poor of South London. She was Mabel Strangeways Hounsell, a niece of the Earl of Ilchester. She went to Camberwell to work as a housekeeper to Dr Jarvise who practised at 325 Southampton Street. In 1921, ten years after going to Camberwell, the need for a free dispensary for animals was felt to be acute. No such service existed and people could not afford to pay the fees of veterinary surgeons. An outbuilding was fitted up and pets were treated by a veterinary surgeon while Sister Mabel treated the owners. She died in October 1927. The Dispensary was moved to 1 Camberwell Station Road. [2, 166, 167]

SKENFRITH HOUSE, Ledbury Estate 1965 Skenfrith in Monmouthshire – close to Herefordshire border. [2, 5]

SMITH, W.H. See W. H. Smith.

SOAMES STREET 1873 (Gloucester Terrace, Soames Villas, Soames Terrace, Lavington Terrace) Soames Villas and Soames Terrace, [1, 6, 7]

SOJOURNER TRUTH ASSOCIATION, 161 Sumner Road Now called Sojourner at Peckham. Uses former St Luke's Primary School built in 1847. Sojourner Truth (*c.* 1797-1883), American abolitionist. She was born a slave and belonged to several owners before working on a farm in New York State (1810-26). Here she had at least eight children by a fellow slave Thomas,

but in 1827 she fled to another farm owned by the Van Wagener family. She successfully fought a legal battle to obtain the freedom of her son, illegally sold to an Alabama planter, and after receiving her own freedom moved to New York as Isabella van Wagener.

During the next fifteen years she worked in the city, becoming involved with various visionary groups, until in 1843 she was commanded by voices to leave and take the name Sojourner Truth. She spoke at revival meetings in the Eastern states, and in 1847 met leading abolitionists in Northampton, Massachusetts. In 1850 she went west, selling her biography, *The Narrative of Sojourner Truth*, drawing huge crowds by her dramatic lectures on slavery and, increasingly, on the suffrage issue. She eventually settled in Battle Creek, Michigan, worked for union causes, was received by Abraham Lincoln in 1864, and became a worker for the Freedman's Relief Association. Her last campaigns were for land grants and a 'Negro state', and she encouraged Negro emigration to the Midwest. When she finally retired in 1875 she continued to receive visitors from all over the USA. [3, 144, 403, 406, 407, 408, 464]

SOLOMON'S PASSAGE 1850s Israel Solomon, market gardener. He lived In Pineapple Lodge overlooking Peckham Rye. [180]

SOMERTON ROAD 1892 Site of house called Somerton Lodge. [1, 7, 10]

SOUTH RIDING, 6 Everthorpe Road 1882 (3 Placquett Terrace) Named by Marian and John Beasley when they bought the house in 1972. Marian was born in the South of England (Lewisham) and John at Hornsea in the East Riding of Yorkshire. The house name linked their birthplaces. After choosing the name they learnt that Winifred Holtby had written a book called *South Riding*. While staying in Hornsea, Winifred Holtby wrote about the Peckham Pioneer Health Centre. [7, 247, 405, 588]

SOUTHWARK COUNCIL Peckham has been part of the London Borough of Southwark since 1965 when the Metropolitan Boroughs of Bermondsey, Camberwell and Southwark amalgamated. From 1900 Peckham was in the Metropolitan Borough of Camberwell.

The earliest reference to Southwark is in the Burghal Hidage where it is given in the Southern Division as Suthringa Geweorche, a name referring to the defence work of the 'Surrey Folke'. The Burghal Hidage was a list of burhs with the measure in hides of each territory. It was compiled in 920. [16, 133, 401]

SPIKE, Gordon Road This former workhouse, opened in 1879, was commonly known as 'The Spike'. The word was first recorded in 1866. In 1906 Bart Kennedy wrote in *Wander Pictures*: 'The homeless men who go along the road call the casual ward the spike ... It means that when you have come to the very end of things you are impaled' [210, 213, 214]

SPRINGALL STREET 1875 Mr Springall was a builder active locally in the 1870s. [1, 8, 10]

SPRINGTIDE CLOSE, Staffordshire Street 1995 Relating to tides. Name taken from Southwark Council name bank. [448]

SRI CHINMOY PEACE GARDEN, next to Thomas Calton Centre, Alpha Street Sri Chinmoy opened the peace garden named after him on 15 July 1991.

He was born in 1931 in Shakpura, East Bengal (now Bangladesh). In 1944, after both his parents had died, he entered the Sri Aurobindo Ashram, a spiritual community near Pondicherry in South India. In 1964 he moved to New York City to share his inner wealth with sincere seekers in the West. His work aimed to promote peace between communities and nations.

Sri Chinmoy died on 11 October 2007. [412, 438, 589, 590]

STAFFORDSHIRE STREET 1937 (Stafford Street) The Earls of Stafford were Lords of the Manor of Camberwell in the fifteenth and sixteenth centuries. [1, 3, 8]

STANBURY ROAD 1877 Possibly John Stanbury (*d.* 1474), Bishop of Hereford. [1, 6, 7]

STANESGATE HOUSE, Friary Estate 1950 Cluniac nuns community at Stanesgate in Essex. [1, 2, 14, 25, 37]

STANTON STREET 1876 (Royal Place, Cowley Place) Possibly Revd Dr Vincent Henry Stanton (1846-1924), Regius Professor of Divinity, University of Cambridge 1916-22. Fellow of Trinity College, 1872. *Trinity in Camberwell: A History of the Trinity College Mission in Camberwell 1885-1985* states: 'As Dr Stanton explained to the College at a meeting on May 18th 1885, "They applied to the Wilberforce Missioner, Mr Grundy, and to others, as to parishes which were in need, and went down and saw some which he pointed out to them, and amongst others, St George's Camberwell. That parish seemed in the greatest need of the kind of work they were to do, and so they selected it". [7, 202, 348]

STAR OF INDIA, 26 Gordon Road (P) Has as its sign a replica of the medallion of that British order of chivalry known as 'The Most Exalted Order of the Star of India'. Instituted by Queen Victoria in 1861, as a reward for services in and for India, the motto of the Order is 'Heaven's Light our Guide'. The pub closed in 1997 and housing was built on the site [184, 294]

STATION COURT, Gibbon Road Close to Nunhead Station. [184]

STATION WAY 1935 (Station Arcade, Railway Approach) Leads to Peckham Rye Station. [8]

STAVELEY CLOSE, Brimmington Estate 1978-80 Staveley in Derbyshire [2, 5]

STEPHEN LAWRENCE HOUSE, 203 Southampton Way 1997 Eighteen-year-old Stephen Lawrence was murdered by white youths in a racially-motivated attack while he was standing at a bus stop in Eltham on 22 April 1993. [468, 628]

STERNHALL LANE Sternhall House, one of the lesser mansions in Peckham Rye. [1, 10]

STOPES STREET 1997 Dr Marie Stopes (1880-1958). [472]

STOURBRIDGE HOUSE, Sumner Estate 1938 Stourbridge Canal. [1, 2, 69]

STRAKER'S ROAD The Straker family lived in a large house on Peckham Rye called 'Sunnyside'. Samuel Straker (*d.* 1874) was a Camberwell Vestryman. [1, 10, 81, 180]

STRICKLAND COURT, East Dulwich Road Estate 1954 Revd W. J. Strickland, Vicar of St John's, Goose Green, 1888-1900. [1, 2, 398]

STUART ARMS, 40 Stuart Road (P) See Stuart Road. Stuart Arms became the Ivy House in 1998. [591]

STUART ROAD 1901 (Salisbury Villas, Kenilworth Villas, Ledbury Villas, Seymour Villas, Hilda Villas, Malvern Villas, Stuart Villas, Melbourne Cottages) Stuart Villas. [1, 7]

STUDHOLME STREET 1875 Studholme in Cumbria. [1, 4, 7, 25]

STURDY ROAD 1866 Built on land belonging to Daniel Sturdy. [1, 7, 10]

SUMMERSKILL CLOSE 2001 Edith Clara Summerskill (1901-80) was born in London and qualified as a doctor at the age of twenty-three.

She married Dr E. Jeffrey Samuel. At the time of their marriage in 1925 he was a medical officer at Peckham House. This was a private mental hospital (on the site of The Harris Academy at Peckham in Peckham Road) which provided accommodation for paying patients. However, as the treatment of mentally ill people improved, the London County Council used some of the accommodation for the care of those who were poor and mentally ill.

In her memoirs *A Woman's World*, Edith Summerskill wrote: 'I was a frequent visitor to the hospital – indeed it provided a background for our courting – and we never failed to join in the Christmas festivities for many years after my husband had left.'

Dr Edith Summerskill entered Parliament in 1938 as MP for West Fulham. In 1949 she had what she liked to call 'her finest hour' when she introduced legislation to ensure that all milk sold for human consumption conformed with specified standards of purity.

Dr Summerskill campaigned vehemently against professional boxing and held that there was much medical evidence to support her view that punches to the head could cause permanent damage to the brain.

She was created a life peeress in 1961. Among her successes in the Lords were the Married Women's Property Act 1964 entitling wives to a half share in any joint savings of a marriage; and the Matrimonial Homes Act 1967 which ensured the right of a wife to occupy a dwelling house which had been a matrimonial home.

The obituary of Baroness Summerskill in *The Times* declared: 'She will rank high among women pioneers of the Labour Party.' [17, 614]

SUMNER AVENUE 1889 See Sumner Road. [7]

SUMNER ESTATE 1937-54 See Sumner Road. [2]

SUMNER HOUSE (formerly Peckham Manor School) See Sumner Road. Sumner Road School opened on 10 January 1876 and was remodelled in 1921-23. [217,475]

SUMNER NURSERY SCHOOL, Marne House, Sumner Estate Opened in September 1954 and was the first purpose-built nursery school to provide part-time education for London 'under fives'. See Sumner Road. [359]

SUMNER ROAD 1869 (Willow Brook Road (part), Crab Tree Shot Road, Sumner Street, Charles Street, Sumner Terrace, Winchester Place) Charles Richard Sumner (1790-1874), Bishop of Winchester. [1, 3, 4, 6]

SUNWELL CLOSE, Cossall Estate 1978 Close to former Sunwell Street (1866). [1, 2, 7, 21]

SURE WAY CHRISTIAN CENTRE, Sumner Road Used a former Primitive Methodist Chapel erected in 1874; Pentecostal since 1921. A pastor chose Sure Way because Christians believe that following Jesus is the best way to live. The chapel is now the New Testament Church of God: Anapausis Centre. [3, 4, 122, 184, 409]

SURREY CANAL ROAD 1987 Where the Grand Surrey Canal used to be. [619, 628]

SURREY CANAL WALK The Peckham branch of the Grand Surrey Canal was filled in during 1972 and later made into a linear park leading to Burgess Park. The 750th tree was planted early in 1976. [16, 334]

SURREY ROAD 1897 Close to the original boundary between Surrey and Kent. [1, 7]

SURREY VIEW TAVERN, 135-137 Commercial Way (P) Used to overlook Peckham branch of the Grand Surrey Canal. The pub closed in 1997 and was converted into a café. [21, 184, 296]

SURREY CANAL WALK Surrey Canal Walk is where the Peckham branch of the Grand Surrey Canal ran from 1826 until 1971.

SWAN, 59 Peckham Park Road (P) In use as a tavern sign since the fourteenth century, either as a direct allusion to the majestic bird or to a coat of arms which featured it. The sign remains fairly popular, with some thirty examples in Greater London. [295]

SWISS TAVERN, 44 Lausanne Road (P) Name association with Lausanne in Switzerland.

SYCAMORE PARK, Staffordshire Street 1997 A sycamore tree grows on this site. [184, 465]

SYLVAN GROVE 1901 Sylvan means 'of the woods; having woods; rural' but no record exists of the number of trees planted in the Grove. [1, 19]

SYLVAN TERRACE See Sylvan Grove.

SYMONS CLOSE 2004 Cornishman Vivian Symons (1913-1976) was educated at St Catherine's College, Oxford, where he obtained his M.A. After becoming a clergyman he went to Biggin Hill, Kent, where St Mark's needed a new church. Insufficient money was available for such a project.

At that time All Saints, in Davey Street, Peckham, was a redundant church and permission was granted for it to be demolished.

The Moving Church, brief history and guide to the Parish Church of St Mark, states: 'August 12th, 1952, saw the Vicar (or to give him his then correct title, Perpetual Curate, for Biggin Hill could not become a Parish until it had a permanent church), driving down the Old Kent Road in an old Morris lorry, given by a London builder, on his way to start dismantling All Saints. From that day he spent every available hour, sometimes with a small band of voluntary and inexperienced helpers, but more often than not on his own. It was a full-time job, yet in addition there was the work of his district to attend to as well as being Chaplain to the RAF Station. Day after day, lorry load after lorry load, the work went on, each time everyone becoming more proficient at a job at first new and strange to them. Begrimed with the disturbed dust of ages, in his "dog collar" and overalls, the Reverend Vivian Symons became a familiar figure in the Camberwell district except, perhaps, to one Londoner who, seeing such a dusty parson having a cup of tea in the local café, exclaimed in loud sotto voice, "Cor! Now I've seen everything!"'

The complete dismantling of All Saints took three years and four months and all that was left was a clean level site. In Biggin Hill 125,000 bricks and 200 tons of stonework and all the roof timbers were stored on open land behind the Vicarage. Building the new church with the bricks and other material from Peckham began in 1958.

On 25 April 1959 the bells rang out for the first time for the consecration of the church by the Lord Bishop of Rochester.

The Revd Vivian Symons was buried at Saint Botolph, Chevening, the local church of the late Lord Stanhope who did so much to encourage him in the fulfilment of the project of 'The Moving Church'. [17, 628]

T

TALFOURD PLACE 1884 (Hillsborough Villas, William's Terrace, Denman Cottages) Sir Thomas Noon Talfourd (1795-1854), judge and author. [1, 3, 6, 7]

TALFOURD ROAD 1873 (Hatfield Villas, Pollock Villas, Derby Villas, Rock Terrace, Amesbury Terrace, Alexandra Villas, Surrey Villas, Paradise Villas, Osborne Villas, Pembroke Villas, Melrose Villas) See Talfourd Place. [1, 10]

TAMARIND HOUSE, 5 Hereford Retreat 1980 Tamarind – an evergreen tree cultivated in India and other tropical countries. [26, 188]

TAPPESFIELD ESTATE 1964-66 See Tappesfield Road. [2]

TAPPESFIELD ROAD 1877 Henry Tappesfield, sixteenth century London merchant, married Susan Muschamp of Peckham. [1, 3, 7, 10]

TERN HOUSE, Pelican Estate 1957 Tern. [1, 2, 120]

THALIA COURT, Rye Lane 2006 The niece of Phil Purkiss, Development Manager, Servite Houses, W6. Thalia is a Greek name for Greek Mythology. [602, 603]

THAMES COURT, Daniel Gardens 1972 River Thames. [5, 361]

THE DUKE, 57 Nunhead Lane Renamed in 2008. Link between a former name, Edinburgh Castle (q.v.) and Duke of Edinburgh. [563]

THE GROVE NURSERY SCHOOL See Grove Nursery School.

THE MARKET Choumert Road 1-6 The Market is between Rye Lane and Choumert Road. It appears that a market has existed here since the late 1870s. [433]

THE RYE See Rye Hotel.

THOMAS CALTON COMMUNITY EDUCATION CENTRE, Alpha Street (formerly Choumert Road School, 1893) Thomas Calton was a city goldsmith. Henry VIII granted him Dulwich manor in 1545. [3, 159, 160]

THOMAS MILNER HOUSE, 75 Bird-in-Bush Road 2003 Built on the site of Maismore Arms (q.v.). Thomas Milner M.D. (1719-97) was the son of Dr John Milner and was born at Peckham. In 1759 he was elected physician to St Thomas's Hospital. He moved to Maidstone in 1762 where he had a large practice. He used to walk to the parish church every Sunday bearing a gold-headed cane, followed in linear succession by the three unmarried sisters who lived with him.

In 1783 he published in London 'Experiments and Observations on Electricity', a work in which he describes some of the effects which an electrical power is capable of producing on conducting substances, similar effects of the same power on electrical bodies themselves, and observations on the air, electric repulsion, the electrified cup, and the analogy between electricity and magnetism.

He died in Maidstone and was buried in All Saints' Church there. [17, 184, 628]

THORN TERRACE, Nunhead Grove Origin not traced.

THORNBILL HOUSE, 160 Glengall Road 1984 Thornbill, bird belonging to the Hummingbird family. [161, 181]

THRUXTON WAY, North Peckham Estate 1971 Thruxton in Hampshire. [2, 5]

TILBURY CLOSE, Willowbrook Estate 1963 Tilbury in Essex. [2, 5]

TILLING HOUSE, Nunhead Estate 1950 Thomas Tilling (1825-93) was born on his father's farm at Hendon and from an early age had a passion for horses. When he was twenty-one he owned a grey mare, Kitty, and took her to London and there invested his small capital of £30 in a carriage. This he hired out for weddings and for the various functions carried out by a job-master. He quickly built up a prosperous business.

In 1851 the Great Exhibition was held in Hyde Park. Tilling cashed in on this event by putting his first omnibus on the road and naming it *The Times*. This was a four-horse omnibus for businessmen; it plied between Peckham and Oxford Circus (four journeys a day for 1s. 6d. all the way). His was the fastest on the route. He was the first proprietor to refuse to pick up passengers from various places and take them to the bus starting point, nor would he wait until his bus was full before the driver started. Punctuality was one of the secrets of his success. His vehicles worked to a strict timetable – hence the name *The Times*.

Tilling introduced the bus season ticket; and on certain journeys the regular businessmen had their allotted seats, and rugs were provided, for all of which they paid a fixed monthly fare.

In 1864 he horsed the fire engine of the Surrey Volunteer Fire Brigade, based in Hill Street. As the Brigade had no funds, Tilling generously horsed the engine without charge for the first six months.

Tilling's headquarters were at Winchester House in the High Street. Thomas Tilling's firm continued after his death. In 1904 the first double-decker motor omnibus in the world was run by his firm. Its inaugural trip was on 8 September and the motor omnibus ran

from Peckham to Oxford Circus – the same route used by *The Times* horse drawn omnibus in 1851.

Thomas Tilling's grave can be seen in Nunhead Cemetery. [1, 2, 17]

TILSON CLOSE 2000 Named after the former Tilson Road which commemorated Sir Thomas Tilson who was elected as a member of the School Board for London in 1870. [495, 628]

TIMBERLAND CLOSE 1995 Timber was transported along the Peckham branch of the Grand Surrey Canal close to where these houses were built. [449, 592]

TONBRIDGE HOUSE, Willowbrook Estate 1963 Tonbridge in Kent. [2, 5]

TORRIDGE GARDENS, Rye Hill Estate 1958 River Torridge. [1, 2, 92]

TORTINGTON HOUSE, Friary Estate 1950 Austin Canons community at Tortington in West Sussex. [1, 2, 5, 14, 37, 308]

TOWER MILL ROAD 2002 Stands close to where a windmill stood in the nineteenth century. [3, 628]

TRAFALGAR, 47 Sumner Road (P) W.H. Blanch in *Ye Parish of Camerwell* (1875) refers to national glory in winning the Battle of Trafalgar being represented by 'The Trafalgar'. The Trafalgar changed its name to Hector's. [3, 184]

TRAFALGAR AVENUE 1936 (Trafalgar Road) Battle of Trafalgar. A house at the corner of the Old Kent Road, built by John Rolls in 1780, became the Lord Nelson public house after Nelson's death. [1, 8, 10]

TRAFALGAR AVENUE This 1977 photograph shows Trafalgar Bridge (left) and the Golden Eagle Tavern (right) in Trafalgar Avenue.

TROY TOWN In 1904 A. B. Gibson painted a back view of Troy Town showing St Andrew's Mission Church in Waghorn Street built in 1903.

TRENT HOUSE, Rye Hill Estate 1938 River Trent. [1, 2, 92]

TRESCO ROAD 1878 Tresco in the Isles of Scilly. [1, 7]

TRINITY COLLEGE CENTRE, 1 Newent Close 1983 Trinity College in Cambridge which started the Trinity College Mission in 1885. [202]

TROY TOWN In 1875 W. H. Blanch wrote in *Ye Parish of Camerwell:* 'a small cluster of cottages off Peckham Rye actually bears the imposing title of Troy Town!' Troy Town is a Cornish expression for a labyrinth of streets, a regular maze. [1, 3, 58]

TUKE SCHOOL, 4 Wood's Road 1970 Daniel Hack Tuke (1827-95), a physician who specialised in the field of mental health. [6, 185, 186, 187]

TULSI HOUSE, 59-61 Carlton Grove used to be the Clarkson Arms. Tulsi is the daughter of Alshep Patel, the developer. She was born very soon after the completion of the development in December 1989. [599]

TUSTIN ESTATE 1965 See Tustin Street. [1, 2]

TUSTIN STREET 1874 (Manor Street, York Place) The Tustin family owned and ran a colour and oil works in the road – Jesse Tustin (1814–99) and his sons Charles (1842-1912) and William (1844-93). [1, 7, 180]

TUTSHILL COURT, Gloucester Grove Estate 1975 Tutshill in Gloucestershire. [2, 5]

TYRRELL ARMS, 25 Nunhead Lane (P) 1960s Mary Tyrrell, wife of Sir Claude William Champion de Crespigny. She was the second daughter of Sir John Tyssen Tyrrell, MP. They married on 22 August 1843. The pub closed in 2000 and was demolished in January 2001. [184, 328, 329, 340]

TYRRELLS COURT 2002. Built on the site of Tyrrell Arms. [184]

U and V

ULLSWATER HOUSE, Tustin Estate Livesey Court, a residential home for elderly people, was converted into a hostel for homeless families in 1992 and named Ullswater House. Named after Ullswater in Cumbria. [5, 278, 279, 280]

UNWIN CLOSE 1965 On the site of former Unwin Road (1873) which was probably laid out by Unwins, builders active in South London from *c.* 1860. [2, 4, 10]

UNWIN ESTATE 1963-65 See Unwin Close. [2]

VERMEER GARDENS 1997 Dutch Artist Jan Van Delft Vermeer (1632-1675). [183,565]

VERVAIN HOUSE, 7 Hereford Retreat 1980 Vervain – a hummingbird. [161, 188]

VICARAGE COURT, Inverton Road Built on the site of St Silas' Vicarage. [191]

VIVIAN SQUARE, Consort Estate 1978-81 Close to the site of Vivian Road (1876). Sir Richard Hussey (1775-1842), 1st Baron Vivian, married Eliza, daughter of Philip Champion de Crespigny on 14 September 1804. [1, 2, 6, 7, 21, 25]

W and Y

WAGHORN STREET 1876 Before the cutting of the Suez Canal Thomas Waghorn (1800-50) established a reliable overland link between Port Said and Suez as part of a steamer route from Europe to India. Coal was carried by camel train across the desert. [1, 6, 7, 10]

WAGNER STREET 1873 (Cross Street, Coles Buildings) Probably German composer Richard Wagner (1813–83). [1, 7, 26]

WAITE STREET 1868 John Waite, tenant of local lands in *c.* 1830 as shown on the Tithe Map. [1]

WAKEFIELD HOUSE, Oliver Goldsmith Estate 1930 *The Vicar of Wakefield*, a novel by Oliver Goldsmith published in 1766. [1, 2, 23, 93]

WALES CLOSE 1999 In 1864 His Royal Highness the Prince of Wales, who succeeded Prince Albert as patron of the Licensed Victuallers Asylum, now Caroline Gardens, unveiled a statue erected by voluntary contributions to the memory of the Society's late illustrious patron. [3]

WALKFORD WAY, North Peckham Estate 1971 Walkford in Dorset. [2, 5]

WALKYNSCROFT, Brayards Road Estate 1960 A plot of land on the Dulwich Manor. [1, 2, 80]

WALMER CASTLE, 102 Peckham Road (P) Walmer Castle near Deal in Kent. This became Pharoah's (q.v.) in 2002 and was closed in the same year. It was badly damaged by fire on 9 July 2004. [5, 184]

WARBURTON COURT, East Dulwich Road Estate 1954 Revd T. A. Warburton, Vicar of St. John's, Goose Green, 1876–88. [1, 2, 82, 398]

WARMLEY COURT, Gloucester Grove Estate 1976 Warmley in South Gloucestershire. [2, 5]

WARWICK COURT, Choumert Road Possibly Alderman Alfred Warwick. See Warwick Gardens.

WAGHORN STREET People lived in prefabs in Waghorn Street in 1981.

WARWICK GARDENS Warwick Gardens was a popular park in 1981 – as it is today.

WARWICK GARDENS, Lyndhurst Way Alderman Alfred Charles Warwick (?-1951) who was Mayor of Camberwell (1935-36). He first went on to Camberwell Borough Council in 1919. The park was opened in 1963 by the Deputy Mayor of Camberwell, Councillor Edgar Reed, a member of the London County Council for Camberwell. [54, 55, 56, 57]

WARWICK GARDENS HOUSE, 93-99 Azenby Road See Warwick Gardens.

WARWICK PARK SCHOOL, Peckham Road See Warwick Gardens. The school was established in September 1983 by the amalgamation of Peckham, Peckham Manor, Silverthorne and Thomas Calton Schools. The main complex on Peckham Road (formerly Peckham School) was built in 1958 on the site of a mental asylum called Peckham House. The Harris Academy at Peckham now occupies this site. [17, 126, 184]

WATER MEWS, Linden Grove 1995 Close proximity to Nunhead Reservoirs. [452]

WATLING STREET 1998 The name of the Roman road which ran close to where the Old Kent Road is today. [516, 628]

WATTS STREET 1998 George Watts, an early benefactor of the South London Gallery. [473, 628]

WAVENEY AVENUE 1897 River Waveney. [1, 7, 92]

WAVENEY HOUSE, Rye Hill Estate 1940 See Waveney Avenue. [2]

WAVERLEY ARMS, 202 Ivydale Road (P) On Waverley Park Estate. [4]

WAVERLEY WARD *Waverley*, the first of the novels of Sir Walter Scott, published in 1814. Waverley Park estate was developed by Edward Yates. [4, 23, 367]

WELLAND HOUSE, Rye Hill Estate 1938 River Welland. [1, 2, 92]

WENTWORTH CRESCENT, Bells Gardens Estate 1980 All the blocks of flats on this estate were said to be named after characters in Oliver Goldsmith's works. *Wentworth* is not in the index to the *Collected Works of Oliver Goldsmith*. [2, 93, 400]

WESTONBIRT COURT, Gloucester Grove Estate 1976 Westonbirt in Gloucestershire. [2, 5]

WHISTLER MEWS 1998 James A. M. Whistler, an artist who was connected with the South London Gallery. [473, 628]

WHITE HORSE, 20 Peckham Rye (P) 1930s This sign has been in use since the fifteenth century and remains very frequent because of its widespread heraldic usage. A galloping white horse refers heraldically to the House of Hanover, and dates from the accession of George I in 1714. [295, 340]

WHITMINSTER COURT, Gloucester Grove Estate 1978 Whitminster in Gloucestershire. [2, 5]

WHITTEN TIMBER LTD, Eagle Wharf, Peckham Hill Street The founder of the business was Mr W. H. Whitten who commenced trading in 1919 from his home by selling second-hand timber, doors, windows, etc. from London County Council schools that were being replaced by more modern buildings. His business prospered and in 1921 he moved to Canal Head to begin trading in softwoods. The firm moved to their present premises in May 2002. Area 10 Project Space occupies the firm's previous premises. [164, 184, 596]

WHORLTON ROAD 1888 Probably Whorlton in North Yorkshire. [1, 5, 7]

W. H. SMITH, The Aylesham Centre, Rye Lane William Henry Smith (1792-1865), son of the firm's founder, Henry Walton Smith who established a tiny 'newswalk' in 1792 in Little Grosvenor Street, London. [316, 317]

WICKWAY COURT, Gloucester Grove Estate 1976 Wickwar (sic) in South Gloucestershire. [2, 5]

WILKINSON HOUSE, Dewar Street Sir George Wilkinson (1885-1967), Lord Mayor of London (1940-41). He was the first chairman of the London Homes for the Elderly. The foundation stone was laid by Sir Dennis Truscott in 1957 and the building was completed in 1958. It was opened by Her Majesty, Queen Elizabeth, The Queen Mother. The building is now called Cherrycroft because cherry trees grow in the grounds. [50, 51, 52, 53, 554]

WILLIAM BLAKE HOUSE 22 Elm Grove 2001 Poet and artist William Blake (1757-1827) was born in Soho. He visited Peckham Rye when he was about eight or ten years old. There he had his first vision, of a 'tree filled with angels, bright angelic wings bespangling every bough like stars'. However, when he related this experience to his father, young William Blake escaped a thrashing only because of his mother's intercession.

After studying at the Royal Academy he began to produce water colour figure subjects and to engrave illustrations for the magazines. His first book of poems was *Poetical Sketches*. His mystical and prophetical works included *The Marriage of Heaven and Hell*. Among the most important of his paintings is *The Canterbury Pilgrims*. At his death Blake was employed on the illustrations to Dante.

A biography of William Blake was written by John Middleton Murray (1889-1957) who was born at 20 Ethnard Road, Peckham. [17, 628]

WILLIAM MARGRIE CLOSE, Moncrieff Estate 1978 William Margrie (1871-1960) was known as the Sage of Peckham. Soon after the First World War, Mr C. G. Ammon, MP nominated him as a school manager. One of the four schools to which he was appointed was Gloucester Road School, which he had attended as a boy. In 1930 he founded the London Explorers Club.

He was a prolific writer. Among his publications about the Peckham area was *My Heart's Right There – Seventy Colourful Years in a London Borough*. William Margrie was very fond of the district in which he lived and once wrote: 'I have no very urgent desire to go to Heaven;

Peckham is good enough for me.' He died in his sleep at Sage Cottage, 24 Nigel Road, a Victorian terraced house which still stands. [2, 17]

WILLIAMSON COURT, Peckham Rye 2004 The famous Peckham Experiment was begun by Dr George Scott Williamson (1884-1953) and Dr Innes Pearse. George Scott Williamson was born in Scotland. In 1906 he obtained his M.D. and M.R.C.S. at the University of Edinburgh. During the First World War he served in France and was a prisoner of war in Germany for nine months.
 After the War he worked in various London hospitals. In 1926 he and Dr Innes Pearse began what became known as the Peckham Experiment. Their work was started in a house at 142 Queen's Road. In 1935 a new building known as the Pioneer Health Centre was opened in St Mary's Road. Until 1950 this unusual building housed the world famous scientific investigation into the nature and cultivation of health. See Innes Street and Pearse Street. [626]

WILLOWBROOK ESTATE 1962-76 See Willowbrook Road. [2]

WILLOWBROOK ROAD 1892 (Birkbeck Place, Bangor Crescent, Willowbrook Terrace, Amelia Terrace, Elizabeth Terrace) It is believed there was a brook nearby at one time. Withee Brook Field is shown on a 1739 map. A field name in the Trevor/Hill/Shard estate was Withey Brooke Shott. [1, 7, 198, 410]

WILLOWBROOK URBAN STUDIES CENTRE See Willowbrook Road. Opened on 2 November 1985 by Coun. Geoff Williams, Chair of Southwark Council's Planning Committee. [245]

WILLOWDENE, Acorn Estate 1962 Willow tree. Dene means vale. [1, 2, 19]

WILLSBRIDGE COURT, Gloucester Grove Estate 1976 Willsbridge in South Gloucestershire. [2, 5]

WILMOT CLOSE, Bells Gardens Estate 1980 Miss Arabella Wilmot in *The Vicar of Wakefield* by Oliver Goldsmith. [2, 93, 400]

WINCHCOMBE BUSINESS CENTRE 1989 See Winchcombe Court. [192]

WINCHCOMBE COURT, Gloucester Grove Estate 1976 Winchcombe in Gloucestershire. [2,5]

WINDERMERE POINT, Tustin Estate 1965 Windermere in Cumbria. [2, 5]

WINDSOR COURT, Chadwick Road 1987 Extracted at random from the Outer London telephone directory. [201]

WINDSPOINT DRIVE, Ledbury Estate 1969 Wynds Point in Herefordshire. [2, 283]

WINGFIELD MEWS 2003 See Wingfield Street. [628]

WINGFIELD STREET 1876 (Hadfield Terrace, Whittington Terrace) Wingfield in Derbyshire. Hadfield and Whittington are both in Derbyshire. [1, 7]

WINNIE MANDELA HOUSE, Peckham Road (formerly Pelican House) Anti-apartheid campaigner Winnie Mandela. The building reverted to its original name of Pelican House after Mrs Mandela received much negative publicity. [141, 149, 150, 151,152, 156, 184, 305, 437]

WISHING WELL INN, 77-79 Choumert Road (P) Named by tile proprietor Mike McCann after the wishing well at Kingscourt, County Cavan, Ireland. Mr McCann was born in that county. A wishing well was removed from outside the pub [184, 268]

WITCOMBE POINT, Clifton Estate 1970 Great Witcombe in Gloucestershire. [2, 5]

WITHINGTON COURT, Gloucester Grove Estate 1977 Withington in Gloucestershire. [2, 5]

WIVENHOE CLOSE 1979 Wivenhoe Hall in Essex, the home of Sir Claude William Champion de Crespigny. [10, 329, 361]

WODEHOUSE AVENUE 1997 Author P. G. Wodehouse. [460, 473]

WOOD DENE, Acorn Estate 1963 The flats on this estate are associated with trees. See Acorn Estate. [2]

WOOD'S ROAD 1866 (Edward Terrace) Charles Wood, landowner in *c.* 1830. Wood's Road School (now John Donne School) opened on 29 August 1881 and was remodelled in 1902. [1, 7, 10, 475]

WOODSTAR HOUSE, 6 Hereford Retreat 1980 Woodstar – a hummingbird. [161, 188]

WOODSTOCK SCHOOL, Adys Road When the school was opened in April 1963, it was in premises in Marlborough Road and so the name Marlborough was considered. As this name had already been used, the name Woodstock was chosen as having an association with Marlborough. (See Blenheim Grove.) Woodstock School moved to Ruby Street in June 1966. In 1979 the school moved temporarily to Camberwell. The school then moved to Adys Road in September 1985. It took over what latterly had been Thomas Calton Lower School. What was originally Adys Road School since 1994 has been St John's and St Clement's School. [184, 197]

WOOLWORTHS, 91 & 93 Rye Lane Frank Winfield Woolworth (1852-1919). An American entrepreneur who with his brother C. S. Woolworth (1856-1947) built up a chain of shops. The store closed on 30 December 2008. [227, 610]

WROXTON ROAD 1877 Wroxton in Oxfordshire. [1 , 5, 7]

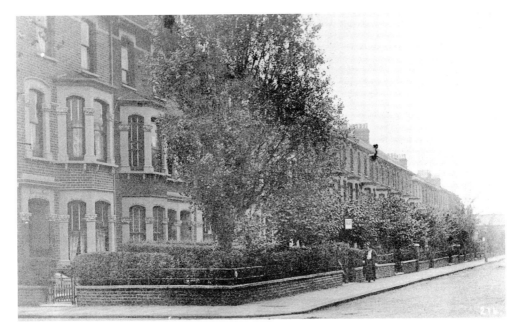

YORK GROVE York Grove featured on a postcard in *c.* 1906.

YARNFIELD SQUARE, Clifton Estate 1970 Yarnfield in Wiltshire, transferred from Somerset in 1895. [2, 199, 200]

YORK GROVE 1898 George, who was created Duke of York in 1892. He became King George V in 1910. [1, 7, 26]

KEY TO SOURCES
AND FURTHER READING

1. *Camberwell Place and Street Names and their Origin* by L. S. Sherwood. Camberwell Borough Council, 1964.
2. List of property owned by Southwark Council administered by the Camberwell, Dulwich and Peckham housing offices, 1987.
3. *Ye Parish of Camerwell* by W. H. Blanch. E. W. Allen, 1875.
4. *Victorian Suburb* by H. J. Dyos. Leicester University Press, 1966.
5. *Bartholomew Gazetteer of Places in Britain* compiled by Oliver Mason. John Bartholomew, 1986.
6. *Dictionary of National Biography*.
7. *List of the Streets and Places within the Administrative County of London*. London County Council, 1929.
8. *Names of Streets and Places in the Administrative County of London*. London County Council, 1955.
9. *The Gazetteer of England* by Oliver Mason. David & Charles, 1972.
10. *The Streets of London: A dictionary of the names and their origins* by S. Fairfield. Papermac, 1983.
11. *The Buildings of England LONDON 2: SOUTH* by Bridget Cherry and Nikolaus Pevsner. Penguin, 1983.
12. Property Brochure Camberwell District J. O'Brien January 1982.
13. Property Brochure Dulwich District J. O'Brien January 1982.
14. Property Brochure Peckham District J. O'Brien November 1982.
15. North Peckham Project. London Borough of Southwark. (S.C. P711. 5 NOR).
16. *The Story of Peckham* by John D. Beasley. London Borough of Southwark, 1983.
17. *Who Was Who in Peckham* by John D. Beasley. Chener Books, 1985.
18. *The Canals of South Wales and the Border* by Charles Hadfield. David & Charles, 1967.
19. *The Concise Oxford Dictionary* edited by J. B. Sykes. Oxford University Press, 1983.
20. Old Ordnance Survey Maps: Old Kent Road 1914. The Godfrey Edition.
21. Old Ordnance Survey Maps: Peckham 1914. The Godfrey Edition.
22. *The Place-Names of Dorset* by A. D. Mills. English Place-Name Society, 1980.
23. *The Oxford Companion to English Literature* edited by Margaret Drabble. Oxford University Press, 1985.
24. *The Canals of South and South East England* by Charles Hadfield. David & Charles, 1969.
25. Office of Population Censuses and Surveys Census 1981 Index of Place Names. H.M.S.O., 1985.
26. *Everyman's Encyclopaedia* edited by D. A. Girling. J. M. Dent, 1978.
27. *Gazetteer of Scotland* revised by R. W. Munro. Johnston and Bacon, 1973.

28. The Girdlers Company.
29. *Who's Who in Shakespeare* by Peter Quennell and Hamish Johnson. Weidenfeld and Nicolson, 1973.
30. *The Canals of South Wales and The Border* by Charles Hadfield. David & Charles, 1967.
31. *The Canals of South West England* by Charles Hadfield. David & Charles, 1985.
32. *Who Was Who 1897-1916*. Adam & Charles Black, 1967.
33. *South London Press* 31 January 1986 – Letter from Cllr. Tony Goss.
34. Peckham Society Newsletter Spring 1986.
35. *Looking Back: Photographs of Camberwell and Peckham 1860-1918*. Peckham Publishing Project, 1979.
36. *Acorn wharf 1855-1955: The Story of R. May & Son Limited*. R. May & Son Ltd., 1955.
37. *English Monastic Life* by Abbot Gasquet. Methuen, 1904.
38. Plaque inside Ammon.
39. *Who Was Who 1951-1960*. Adam & Charles Black, 1961.
40. *The New Century Cyclopedia of Names* edited by Clarence L. Barnhart. Prentice-Hall, 1954.
41. *The Peckham Society News* Spring 1993.
42. *British Canals: An Illustrated History* by Charles Hadfield. David & Charles, 1984.
43. *Building Together: The Story of Peckham Methodist Church* by John D. Beasley. Peckham Methodist Church, 1985.
44. *Centenary Viewpoint St Antony's Nunhead 1878-1978* edited by Roger Smith. St Antony's Church, Nunhead, 1978.
45. *'I Think of My Mother' Notes on the Life and Times of Claudia Jones* by Buzz Johnson. Karia Press, 1985.
46. *South London Record No. 2 1987*. South London History Workshop, 1987.
47. *Burke's Peerage, Baronetage, Knightage 1897*. Harrison, 1897.
48. *Armorial Families: A Directory of Gentlemen of Coat-Armour* compiled and. edited by Arthur Charles Fox-Davies. Hurst and Blackett, 1929.
49. *Southwark Civic News* July 1969.
50. London Homes for the Elderly (pamphlet).
51. *The Daily Telegraph* 27 August 1962.
52. *South London Press* 24 September 1974.
53. *Who Was Who 1961-1970*. Adam & Charles Black, 1972.
54. *South London Observer* 26 April 1951.
55. *South London Observer* 16 July 1959.
56. *South London Press* 8 November 1963.
57. *Metropolitan Borough of Camberwell Twenty-Second Report of the Council from 1st April 1935 to 31st March 1936*.
58. *Southwark Civic News* July 1971.
59. *The Times* 4 April 1960.
60. Southwark Collection Calendar of Deeds.
61. *The Victoria History of the Counties of England: Surrey* edited by H. E. Malden Constable, 1912.
62. *Retracing Canals to Croydon and Camberwell*. Living History Publications and Environment Bromley, 1986.
63. *South London Press* 19 August 1983.
64. *The New Encyclopaedia Britannica*. 1986.
65. *Palace of the People* by Graham Reeves. Bromley Library Service, 1986.

66. *Burke's Peerage* edited by Peter Townend. Burke's Peerage, 1963.
67. *Hanover Chapel (Congregational) Bellenden Road, Peckham, London, SE15 celebrates 300 years of Christian witness*. 1957.
68. *A Shell Guide: Staffordshire* by Henry Thorold. Faber and Faber, 1978.
69. *The Canals of the West Midlands* by Charles Hadfield. David & Charles, 1985.
70. *The King's England The Lake District Cumberland Westmorland* by Arthur Mee. Hodder and Stoughton, 1967.
71. *Joseph Lister* by Richard B. Fisher. Stein and Day, 1977.
72. *King's College Hospital Gazette* February 1978.
73. *The Story of King's College Hospital* by David Jenkins and Andrew T. Stanway. King's College Hospital, 1968.
74. *South London Press* 7 February 1978.
75. *Stately Homes, Museums, Castles and Gardens in Britain 1987* edited by Penny Hicks. Automobile Association, 1986.
76. *Islington Elfrida Rathbone Association Annual Report* 1986/87.
77. *The Canals of North West England* (volume 1) by Charles Hadfield and Gordon Biddle. David & Charles, 1970.
78. *St Giles, Camberwell, Surrey Eleventh Annual Report of the Vestry 1867*.
79. The Copleston Centre.
80. *The History of Dulwich College* by William Young. 1889.
81. *St Giles, Camberwell, Surrey Seventh Annual Report of the Vestry 1863*.
82. List of vicars of St John's, Goose Green, supplied by Mary Boast.
83. Letter from The Tilt Estate Co. dated 17 November 1987.
84. *South London Observer* 4 August 1960.
85. Letter dated 19 November 1987 from Mrs Margaret Bruce, daughter of Arnold Dobson.
86. Obituary of Arnold Dobson in *Contact* (published by Dulwich Labour Party), 1980.
87. *South London Advertiser* 5 April 1974.
88. Extract from an article in Southwark Local History Library (PC 929.4B) written by W. J. A. Hahn.
89. Undated letter in Southwark Local History Library from W. J. A. Hahn (Chief Librarian, Camberwell Public Libraries) – PC 929.4.
90. *Everyman's Dictionary of Fictional Characters* by William Freeman. J. M. Dent, 1973.
91. *Who's Who of British Members of Parliament* (Volume IV 1945-1979) edited by M. Stenton and S. Lees. Harvester Press, 1981.
92. *English River-Names* by Eilert Ekwall. Oxford, 1928.
93. *Collected Works of Oliver Goldsmith* ed. by Arthur Friedman. Oxford, 1966.
94. *The Oxford Companion to Classical Literature* compiled and edited by Sir Paul Harvey. Oxford, 1974.
95. *Who's Who 1987*. A & C Black, 1987.
96. *St Giles, Camberwell, Surrey, Nineteenth Annual Report of the Vestry 1874-75*.
97. *Southwark Civic News* July 1979.
98. *South London Press* 3 September 1982.
99. *South London Press* 17 August 1984.
100. *Cyclopedia of Classified Dates* by Charles E. Little. Funk and Wagnalls, 1900.
101. *St Luke's Lads' Club*. pub. 1912.
102. *A Tour of Camberwell* by Olive M. Walker. H. H. Greaves, 1954.
103. *South London Press* 31 May 1985.

104. *The Inquirer* 25 April 1885.

105. *The Inquirer* 2 May 1885.

106. *Camden Parish Magazine* April 1892 (p. 61).

107. Minutes of meeting of trustees of Camden Chapel held on 17 June 1796.

108. *The Canals of Yorkshire and North East England* (Volume 1) by Charles Hadfield. David & Charles, 1972.

109. *Southwark Sparrow* September 1987.

110. *South London Press* 30 June 1987.

111. *News on Sunday* 5 July 1987.

112. *Labour Weekly* 10 July 1987.

113. *T &G Record* August 1987,

114. *Bellenden News* August/September 1987.

115. *South London Press* 14 July 1987.

116. Letter from Jack Jones to the author dated 11 July 1987.

117. *Southwark Civic News* March 1981.

118. *Kentish Mercury* 19 December 1958.

119. *The Parks and Woodlands of London* by Andrew Crowe. Fourth Estate, 1987.

120. *A Dictionary of Birds* ed. by Bruce Campbell and Elizabeth Lack. T. & A.D. Poyser, 1985.

121. *Shorter Oxford Dictionary*. Clarendon Press, 1977.

122. *London South of the Thames* by Sir Walter Besant. Adam & Charles Black, 1912.

123. Letter dated 23 March 1988 from Margaret Sawyers, Co-ordinator, Black Elderly Group Southwark.

124. *Social and Economic Effects on Gloucester Road Primary School* by Pamela Knowler, 1970.

125. *A view of Dulwich, Peckham and Camberwell around 1300* by R. J. Warhurst, 1985.

126. South West Quadrant Review Facts and Figures. ILEA.

127. *The Westminster Dictionary of the Bible* by John D. Davis. Collins' Clear-Type Press. 1944.

128. *1863-64 St Giles, Camberwell, Surrey Eighth Annual Report of the Vestry.*

129. *The Orchard Mission's 50th Annual Report, 1937.*

130. *St Giles: The Parish Church of Camberwell* by Mary Boast. Friends of St Giles Church, 1987.

131. *Nelson's War* by Peter Padfield. Hart-Davis, MacGibbon, 1976.

132. *Imperial Dictionary of Universal Biography* edited by John Francis Waller. William Mackenzie, 1857-63.

133. *The Concise Oxford Dictionary of English Place-Names* by Eilert Ekwall. Oxford, 1974.

134. *Metropolitan Borough of Camberwell Official Guide*. Ninth edition, 1955.

135. *G. W. Marsden: A Memoir* by Edward Foskett. Privately printed, 1896.

136. *A Dictionary of Rhyming Slang* by Julian Franklyn. Routledge & Kegan Paul, 1975.

137. Deed 9380 – Southwark Local History Library.

138. *The Forgotten Stations of Greater London* by J. E. Connor and B. L. Halford. Forge Books, 1978.

139. *Nunhead Notables* by Ron Woollacott. Friends of Nunhead Cemetery, 1984.

140. *Roman Ways in the Weald* by Ivan D. Margary. Phoenix House, 1965.

141. *Nelson Mandela* by Mary Benson. Penguin, 1986.

142. *Methodism* by Rupert E. Davies. Epworth Press, 1963.

143. *Map of the Parish of St Giles Camberwell, delineating its ecclesiastical and parochial districts*, 1842. By J. Dewhirst, civil engineer.

144. *The Architecture of Peckham* by Tim Charlesworth. Chener Books. 1988.

145. *Nunhead Cemetery: An Illustrated Guide*. Friends of Nunhead Cemetery. 1988.

146. *Old Surviving Firms of South London* by Steven Harris. 1987.

147. St Mary Magdalene, Peckham – brochure prepared for opening of church consecrated on 3 November 1962.

148. Supplement to the Camberwell Society Newsletter No. 38 July 1977.

149. *South London Press* 24 January 1989.

150. *Deptford and Peckham Mercury* 26 January 1989.

151. *Governing London* 26 January 1989.

152. *Dulwich, Peckham and Walworth Comet* 1 February 1989.

153. *Southwark Sparrow* 6 February 1989.

154. *Kelly's London Suburban Directory 1884.*

155. Ordnance Survey Map (1st edition).

156. *Winnie Mandela: Part of My Soul* by Anne Benjamin. Penguin, 1985.

157. *Robert Browning and His World: The Private Face (1812-1861)* by Maisie Ward. Cassell, 1968.

158. *Brewer's Dictionary of Phrase and Fable* by Ivor H. Evans. Cassell. 1983.

159. *The Great North Wood: A brief history of ancient woodlands from Selhurst to Deptford* by L. S. C. Neville. London Wildlife Trust, Southwark Group, 1987.

160. *Dulwich Discovered* by William Darby. Published by the author, 1974.

161. *Finding Birds Around the World* by Peter Alden and John Gooders. Andre Deutsch, 1981.

162. *Every Man's Book of Saints* by C. P. S. Clarke. A. R. Mowbray, 1948.

163. Letter dated 17 April 1989 from Mrs Kate McGuinness, Headteacher, St Alban's R.C. Primary School.

164. *Timber Trades Journal* 12 February 1977.

165. Letter dated 29 June 1987 from A. C. L. Hall, Librarian, Dulwich College.

166. *Daily Chronicle* 4 September 1926.

167. *South London Observer* 30 December 1954.

168. *The Oxford Encyclopedia of Trees of the World*. Consultant Editor: Bayard Hora. Oxford University Press, 1981.

169. *Berkshire* by Ian Yarrow. Robert Hale, 1974.

170. Letter dated 20 June 1989 from John McNicol, Managing Director, Groveside Homes, 89-91 Hartfield Road, Wimbledon, SW19 3TJ.

171. Letter dated 23 June 1989 from D.J. Forge, Area Housing Manager, Church Housing Association.

172. *Supplement to Names of Streets and Places in the Former Administrative County of London for 1955-1966.* Greater London Council, 1967.

173. *Lockerbie and its Story: the town's history – and other articles* by Revd John C. Steen, n.d.

174. Letter dated 16 March 1989 from Mrs Nancy Hammond, Southwark Personnel and Management Services, John Carter House, 25 Commercial Way, SE15 6DG.

175. *Medieval Religious Houses in Scotland* by Ian B. Cowan and David E. Easson. Longman, 1976.

176. *The Story of the London Boroughs: Camberwell*. E. J. Burrows, 1936.

177. *The Canals of South West England* by Charles Hadfield. David & Charles, 1985.

178. *Kelly's London Suburban Directory 1888 Southern Suburbs.*

179. *The New Shell Guide to Scotland* edited by Donald Lamond Macnie and Moray McLaren. Ebury Press, 1977.

180. Street names in Nunhead: list compiled by Ron Woollacott. 1989.

181. Old Ordnance Survey Maps. East Dulwich and Peckham Rye, 1914. Godfrey Edition.

182. *1871-72 St Giles Camberwell Surrey Sixteenth Annual Report of the Vestry.*

183. *Encyclopaedia Britannica*, 1951.
184. Author's observations.
185. Letter from Miss P. Davy, headmistress, Tuke School dated 8 August 1986.
186. *Southwark Civic News* October 1970.
187. Tuke Junior Training School SLHL 371.92.
188. Letter dated 21 March 1989 from Joan Khachik, Estate Office, Hyde Housing Association.
189. *Old Ordnance Survey Maps Brockley 1868*. Alan Godfrey Maps.
190. Map of an estate situate at or near Peckham in the Parish of St Giles Camberwell and County of Surrey. The freehold property of Charles Shard Esq. Surveyed April 1831.
191. Ordnance Survey Map. 1914.
192. *South London Press* 8 December 1989.
193. Letter from the Bishop of Croydon dated 8 January 1990.
194. Letter from the Bishop of Croydon to the African Refugee Housing Action Ltd. dated 20 October 1989.
195. Press release from ARHAG Housing Association Ltd. dated 6 December 1989.
196. *Who's Who 1989*. A. & C. Black, 1989.
197. Letter dated 9 July 1987 from Mr M. J. Gavin, headmaster, Woodstock School.
198. A Survey of the whole Manor of Frerne, and part of the Manor of Buckingham and Kennington, in the Parish of Camberwell the Estate of Joseph Windham Ash Esq. taken in 1739.
199. Letter dated 10 April 1990 from David Bromwich, Local History Librarian, Somerset County Council.
200. Letter dated 10 June 1966 from Hubert Bennett, Superintending Architect of Metropolitan Buildings, Greater London Council.
201. Notes provided in 1990 by Mrs Joy Broadbent, Engineering and Public Works Department, Southwark Council.
202. *Trinity in Camberwell: A History of the Trinity College Mission in Camberwell 1885-1985* by Lawrence Goldman. Trinity College Cambridge, 1985.
203. *Southwark a London Borough* by Mary Boast. Southwark Council, 1975.
204. Minutes of Proceedings of the Metropolitan Board of Works 1869.
205. Proceedings of the Royal Society Volume 82, 1909.
206. Monthly Notice of the Royal Astronomical Society Volume 69, 1909.
207. *The Story of Dulwich* by Mary Boast. London Borough of Southwark, 1990.
208. Southwark Engineering and Public Works: Numbering of Buildings notice dated 29 January 1987.
209. Letter dated 30 May 1990 from Margaret Reynolds, Sales Supervisor, Balfour Beatty Homes, Leatherhead, Surrey.
210. *The Oxford English Dictionary* Second Edition. Prepared by J. A. Simpson and E. S. C. Weiner. Clarendon Press, 1989.
211. *St Saviour's Parish News* November 1977.
212. Plan of the South Common Fields, Peckham, Surrey 1830.
213. *A Dictionary of the Underworld* by Eric Partridge. Routledge & Kegan Paul, 1968.
214. Date on the workhouse in Gordon Road which became Camberwell Reception Centre and later Camberwell Resettlement Unit.
215. Letter dated 23 November 1990 from M. Baker, Southwark Engineering and Public Works Department.
216. *Nature Conservation in Southwark* by John Archer et al. London Ecology Unit, 1989.

217. Adult Education Southwark 1990/91.
218. Letter dated 29 November 1990 from R. W. Standley, Chairman, Newgate Press Ltd., Colour Lithographers.
219. *Chambers World Gazetteer* edited by David Munro. Chambers, 1988.
220. Letter dated 22 November 1990 from R. A. Roffey, Archivist, Co-operative Wholesale Society Ltd.
221. Information obtained by telephone on 19 December 1990 from a member of staff of Mother Goose Nursery.
222. *The Local* 11 December 1990.
223. Plaque inside Helena Day Nursery.
224. *South London Press* 21 December 1990
225. Letter dated 3 January 1991 from Karen Ody, Comet Group plc.
226. *South London Press* 27 November 1987.
227. *The Hutchinson Paperback Dictionary of Biography* edited by Michael Upshall. Arrow Books, 1990.
228. Letter dated 27 December 1990 from Brian M. Jay.
229. Letter dated 19 February 1976 from A. W. Whitehead (Director), Parma Agency Ltd.
230. *The History of St John (Chrysostom) with St Andrew, Peckham* by Leslie Mole.
231. *The Penguin Dictionary of Saints* by Donald Attwater. Penguin, 1983.
232. Tithe Map and Camberwell Schedules, 1837. Tithe Commissioners.
233. *South London Observer* 9 March 1961.
234. *South London Press* 17 June 1977.
235. Letter dated 28 March 1991 from M. Baker, Head of Support Services, for Director of Engineering and Public Works, London Borough of Southwark.
236. London County Council Minutes of Proceedings July-December, 1931.
237. *Southwark Sparrow* 16 August 1991.
238. Letter dated 17 October 1991 from Leah Leisurewear.
239. Information provided by Argos Distributors Limited.
240. *South London Press* 21 January 1992.
241. B & Q Brochure.
242. *Church Army Review* June 1933.
243. *South London Observer* 13 May 1933.
244. *South London Press* 12 May 1933.
245. Letter from Judy Woodman, Chair of Management Committee of Willowbrook Urban Studies Centre dated 14 October 1985.
246. Argos New Store Opening Peckham.
247. *South Riding* by Winifred Holtby. William Collins, 1936.
248. Letter from St James' Catholic Church dated 1 March 1976.
249. *The Oxford Book of Saints* by David Hugh Farmer. Oxford University Press, 1987.
250. *South London Press* 16 September 1988.
251. Note from Robin Thomas, Managing Director, Abbey Rose & Co. Ltd. received in February 1992.
252. Minutes of Proceedings of the Metropolitan Board of Works 1863.
253. *Post Office London Directory 1892 Volume 2 Trades and Professional*.
254. *Camberwell and Neighbourhood* by Douglas Allport, 1841.
255. *1888-89 St Giles Camberwell Surrey Thirty-Third Annual Report of the Vestry.*

256. *South London Press* 24 November 1987.
257. *South London Press* 3 March 1992.
258. *A Latin Dictionary* by Charlton T. Lewis & Charles Short. Oxford University Press, 1966.
259. *JS 100 The Story of Sainsbury's* edited by James Boswell. J. Sainsbury, 1969.
260. *Daily Mail* 25 November 1982.
261. Photograph from an unnamed and undated magazine with caption – *50 years on – Peckham's Rye Lane branch on its opening day on November 6, 1931.*
262. *JS Journal* September 1983.
263. *The first 120 years of Sainsbury's 1869-1989.*
264. *St Mary Magdalene Magazine* June 1906.
265. *St Mary Magdalene Peckham Parish Church Magazine Centenary Number 1841-1941* May 1941.
266. Letter from the Revd C. L. Green dated 25 March 1992.
267. The Latter-Rain Outpouring Revival Constitution & Beliefs.
268. Information provided by Mike McCann on 31 March 1992.
269. Notes in Southwark Local History Library.
270. Borough of Camberwell Minutes of Proceedings of Council Volume 62 (May 1962-April 1963).
271. Letter from L. C. Pollard dated 18 April 1992.
272. *South London Press* 13 March 1992.
273. *Newham/Docklands Recorder* 23 January 1992.
274. Information provided on 28 April 1992 by Mrs Mary Beattie.
275. Information provided on 28 April 1992 by Mrs Stewart-Paver.
276. Halfords New Superstore Opens this Saturday in the Old Kent Road!
277. Letter dated 24 June 1992 from David Warburton, Marketing Executive, Halfords.
278. *Southwark and Bermondsey News* 16 July 1992.
279. *South London Press* 17 July 1992.
280. *Southwark Sparrow* 17 July 1992.
281. *South London Press* 3 July 1992.
282. *Southwark and Bermondsey News* 1 July 1992.
283. Ordnance Survey Landranger Gazetteer on microfiche, 1989.
284. *The Oxford Dictionary of the Christian Church* edited by F. L. Cross. Oxford University Press, 1963.
285. *East Dulwich Baptist Church: An abridged history of the Church.* 1973.
286. *Christ Church Evangelical Free Church 1880-1980.*
287. *St Mary Magdalene, Peckham.*
288. *100 Years of Service!* Peckham Park Road Baptist Chapel, 1953.
289. *Nunhead Cemetery, London: A History of the Planning, Architecture, Landscaping and Fortunes of a Great Nineteenth-century Cemetery* by James Stevens Curl.
290. *Who's Who 1992.* A & C Black, 1992.
291. *Ghosts of London* by Jack Hallan. Wolfe, 1975.
292. *The Architects' Journal* 30 May 1957.
293. Letter dated 17 February 1954 from the Chief Librarian and Curator for Camberwell.
294. *Stories of Inns and Their Signs* by Eric R. Delderfield. David & Charles, 1974.
295. *A Dictionary of Pub Names* by Leslie Dunkling and Gordon Wright. Routledge & Kegan Paul, 1987.
296. Cassell's Map of the Suburbs of London, 1870.
297. *Inns and their Signs: Fact and Fiction* by Eric R. Delderfield. David & Charles, 1975.
298. Pub sign.

299. Centenary of the Capuchin Franciscan Church of our Lady of Seven Dolours, 1966.

300. *A Catholic Dictionary* by William E. Addis et al. Routledge & Kegan Paul, 1960.

301. Plaque in The Aylesham Centre.

302. *Peckham Park Schools* edited by Vera K. A. Conway. Peckham Park School, 1989.

303. *English Inn Signs* by Jacob Larwood and John Camden Hotten. Blaketon Hall, 1985.

304. *Nunhead Resident* Issue no. 10.

305. *Winnie Mandela: Mother of a Nation* by Nancy Harrison. Victor Gollancz, 1985.

306. *Elizabeth Tudor: Portrait of a Queen* by Lacey Baldwin Smith. Hutchinson, 1976.

307. Information obtained from an employee of McCabe's Tavern on 21 October 1992.

308. *English Medieval Monasteries 1066-1540* by Roy Midmer. Heinemann, 1979.

309. Pictorial display on the history of St Luke's Church deposited in Southwark Local History Library.

310. *A key to the door: the Abbey National story* by Berry Ritchie. Abbey National, 1990.

311. Note from Erica Harper, Press Office, Abbey National plc, in October 1992.

312. *Life and Labour of the People in London* by Charles Booth. (Third Series: Religious Influences. Outer South London.) Macmillan, 1902.

313. Information obtained from Bishop B. A. Pitt on 5 September and 28 October 1992.

314. Memorial inside Highshore School.

315. Information obtained in October 1992 by Heather Cragg from a resident of Brookstone Court who moved there a few months after it opened. Building work began in 1938 and finished in 1940.

316. *First with the News: The History of W. H. Smith 1792-1972* by Charles Wilson. Jonathan Cape, 1985.

317. *New Technology New Markets: W. H. Smith through Two Centuries.* Designed by Carroll, Dempsey and Thirkell. W. H. Smith Group PLC, 1992.

318. Dr Iain Stevenson in *The Guardian* on 1 July 1991.

319. *Southwark Civic News* January 1976.

320. Map of London Borough of Southwark: Proposed Wards 1978.

321. *Kelly's London Suburban Directory for 1896.*

322. Information held on microfiche by Southwark Planning.

323. *Collins English Dictionary* edited by Patrick Hanks. Collins, 1986.

324. *The London Encyclopaedia* edited by Ben Weinreb and Christopher Hibbert. Papermac, 1988.

325. *The Times Index-Gazetteer of the World.* Times Publishing, 1965

326. *The Mercury* 26 March 1986.

327. Information provided in November 1992 by Mr Mence of Peckham Rye Tabernacle Baptist Church.

328. *Complete Baronetage* edited by George Edward Cokayne. Alan Sutton, 1983.

329. *A Genealogical and Heraldic Dictionary of the Peerage and Baronetage of the British Empire* by Sir Bernard Burke. Harrison, 1868.

330. *The Gentleman's Magazine* September 1761.

331. *The London Magazine* August 1761.

332. *Obituary prior to 1800* compiled by Sir William Musgrave. Harleian Society, 1899-1901.

333. Letter dated 13 November 1992 from Colin Brand, Park Services Manager, Southwark Council.

334. *South London Press* 6 February 1976.

335. *The Street Names of England* by Adrian Room. Paul Watkins, 1992.

336. *Peckham Rye Park 1894-1994* by John D. Beasley. South Riding Press, 1994.

337. Letter dated 24 November 1992 from Ord, Carmell & Kritzler.

338. *The Honor Oak School Golden Jubilee 1906-1956.*

339. Information obtained from a local resident.

340. *A Historical Tour of Nunhead and Peckham Rye* by Ron Woollacott. Special Limited Edition produced by the author, 1992.

341. *London Inns and Taverns* by Leopold Wagner. George Allen & Unwin, 1924.

342. *The Wonderful Story of London* edited by Harold Wheeler. Odhams Press, 1937.

343. Information obtained on 2 December 1992 from Mrs Anderson of Leah Leisurewear.

344. Letter dated 27 November 1992 from Carol Harrison, Environmental Services Department, Southwark Council.

345. Memo dated 30 November 1992 from David Solman, Development Department. Southwark Council.

346. Celestial Church of Christ Constitution.

347. *Divine Spiritual Message* by Revd Pastor Founder and Prophet S. B. J. Oshoffa.

348. *Who Was Who 1916-1928.* Adam & Charles Black, 1967.

349. *The Builder* 24 September 1881.

350. Notes on Waverley Park Estate written by Ron Woollacott who suggests that the names are probably romantic compositions. None appears elsewhere in London.

351. *The Story of Congregationalism in Surrey* by Edward E. Cleal. James Clarke, 1908.

352. *The Baptist Churches of Surrey* edited by Arthur H. Stockwell. Stockwell, *c.* 1910.

353. *A Cure of Delinquents: The Treatment of Maladjustment* by Robert W. Shields. Heinemann, 1962.

354. *The Mercury* 8 August 1985.

355. *De Laune Gazette* No. 1 Vol. 1 (22 November 1894).

356. *A Century Awheel 1889-1989: A History of the De Laune Cycling Club* by Mike Rabbetts.

357. *The Catholic Directory of England and Wales 1992.* Gabriel Communications Ltd., 1992.

358. Information obtained on 17 December 1992 from Joan Bond, former librarian of St Thomas the Apostle School.

359. Letter dated 20 October 1977 from Miss G. M. Cronin, Headmistress, Sumner Nursery School.

360. Information obtained in 1977 from the headmaster of Bredinghurst School.

361. Computer print-out of properties in SE15 managed by Southwark Council (1993). Some dates are slightly different from those recorded in [2].

362. *Achievement: A short history of the London County Council* by W. Eric Jackson. Longmans, 1965.

363. *Regiments and Corps of the British Army* by Ian S. Hallows. Arms & Armour Press, 1991.

364. Foundation stone at Howard Court.

365. *South London Press* 25 March 1938.

366. Notes provided on 21 October 1977 by A. G. Larter, Headmaster, The Highshore School.

367. *Exploring the Urban Past: Essays in urban history* by H. J. Dyos edited by David Cannadine and David Reeder. Cambridge University Press, 1982.

368. *Anglo-Saxon England 2* edited by Peter Clemoes. Cambridge University Press, 1973.

369. *The Place-Names of Surrey* edited by A. Mawer and F. M. Stenton. Cambridge University Press, 1934.

370. *Gazetteer of the British Isles.* John Bartholomew, 1971.

371. Letter dated 4 January 1993 from Robert F. Tennant, Divisional Organiser, Reference and Information Services, North Yorkshire County Council.

372. ILEA letter dated 6 February 1968 in the possession of Pilgrim's Way School.

373. *Evening News and Star* 27 May 1968.

374. *Evening News and Star* 30 May 1968.
375. Information provided on 6 January 1993 by Esther Hothersall, Head, The Grove Nursery School.
376. *ILEA Contact* 28 February 1975.
377. Information provided on 9 January 1993 by Lisa Evans, a resident of Laburnum Close.
378. *The Mercury* 27 March 1969.
379. Information on the history of Pilgrim's Way School provided on 7 January 1993 by Dave Boalch, Headteacher.
380. Opening of the New Buildings of Highshore School on 30 January 1970.
381. *Southwark Sparrow* 24 May 1991.
382. Brochure to mark the opening of Livesey Museum.
383. Foundation stones of former Nunhead Baptist Church, Gautrey Road.
384. Information provided on 21 January 1993 by the wife of His Eminence Revd Dr Prince J. Blackson.
385. Letter dated 18 January 1993 from Cecily Haynes-Hart, Project Co-ordinator, Robert Hart Memorial Supplementary School.
386. Information provided on 23 January 1993 by Cecily Haynes-Hart.
387. *The Apostolic Faith: Its Origin, Functions, and Doctrines.* The Apostolic Faith, Oregon, USA.
388. *The Salvation Army Nunhead Corps Centenary Brochure 1884-1984.*
389. *William Booth* by Minnie Lindsay Carpenter. Wyvern, 1957.
390. *Saint John's Church, Peckham and its inheritance* by Les Mole.
391. *St John Chrysostom Archbishop of Constantinople* by Les Mole.
392. Letter dated 1 February 1993 from Ron Woollacott.
393. *We the Undersigned... : A History of the Royal London Mutual Insurance Society Limited and its times 1861-1961* by W. Gore Allen. Newman Neame, 1961.
394. Letter dated 3 February 1993 from Miss M. J. Salmon, Property Division, Royal London Asset Management.
395. *S. Saviour's Church, Denmark Park. Jubilee, 1881-1931.*
396. *South London Press* 29 January 1993.
397. Plaque at Kingsbury House.
398. *St John's, East Dulwich Church and Parish* by Mary Boast. St John the Evangelist, 1991.
399. Information obtained on 14 February 1993 from Dawn Eckhart, Project Manager.
400. Information obtained from the Environmental Services Department, Southwark Council.
401. London Borough of Southwark Official Guide.
402. Safeway Company History.
403. *Sojourner Truth* by Peter Kraas. Chelsea House Publishers, 1988.
404. Letter dated 19 February 1993 from Mr J. A. Selkend, Woodhall Developments Ltd.
405. House deeds of 2 Everthorpe Road.
406. Information received in February 1993 from Sojourner Truth Association.
407. *The Macmillan Dictionary of Women's Biography* compiled and edited by Jennifer Uglow. Macmillan, 1989.
408. *Her name was Sojourner Truth* by H. Pauli. 1962.
409. Information provided on 24 January 1993 by a member of Sure Way Christian Centre.
410. Information provided by Stephen C. Humphrey, author of *A Guide to the Archives of Southwark Local Studies Library (1992).*
411. *Southwark Sparrow* 14 May 1993.

412. *South London Press* 14 May 1993.
413. *Southwark News* 3 November 1994.
414. *South London Press* 11 November 1994.
415. *Deptford & Peckham Mercury* 24 November 1994.
416. Letter dated 19 April 1994 from R. J. Bruty, Chief Engineer, Traffic Group, Southwark Environmental Services.
417. *Southwark News* 4 November 1993.
418. Letter dated 12 September 1994 from Carol Quamina, Southwark Environmental Services.
419. *Camille Pissarro at Crystal Palace* by Nicholas Reed. London Reference Books, 1987.
420. *Peckham and Nunhead Churches* by John D. Beasley, South Riding Press, 1995.
421. Letter dated 14 November 1994 from Olivier Holmes, Chair, Deanery Lodge.
422. Deanery Lodge Annual Report 1993.
423. *The Guardian* 12 November 1993.
424. Letter dated 13 August 1993 from Diana Garnham, 4 Glengall Terrace.
425. Date on outside wall of Ivydale School.
426. *South London Press* 4 November 1994.
427. *South London Press* 12 November 1993.
428. *The Peckham Society News* Winter 1994.
429. *Southwark News* 1 June 1994.
430. *South London Press* 7 October 1994.
431. Media Information provided by Southwark Council on 29 September 1994.
432. Information provided on 7 December 1994 by barman.
433. *The Peckham Development Handbook* by Bill Marshall. Southwark Challenge Partnership Management Board, 1994.
434. *The Best Butter in the World: A History of Sainsbury's* by Bridget Williams. Ebury Press, 1994.
435. *St. John's Parish Magazine* September 1994.
436. *Daily Express* 16 July 1994.
437. *Southwark News* 3 June 1993.
438. *Southwark Sparrow* 19 March 1993.
439. Information obtained on 12 December 1994 from Haymerle School.
440. Schools and Day Nurseries in Southwark. September 1994.
441. Information provided on 12 December 1994 by Gill Frost.
442. Information provided on 16 May 1994 by Norman Royce, architect.
443. Letter dated 4 January 1995 from Carol Quamina, Southwark Council Regeneration & Environment Department.
444. Information provided on 9 January 1995 by Carol Quamina.
445. Ordnance Survey Map 1894-96.
446. Information provided on 31 January 1995 by Carol Quamina.
447. Cross Close was one of a number of names suggested by John Beasley.
448. Information provided in August 1995 by Ray Collins, Southwark Council Regeneration & Environment Department.
449. Information provided on 31 October 1995 by Carol Quamina, Southwark Council Regeneration & Environment Department.
450. *Southwark News* 21 December 1995.
451. *South London Press* 22 December 1995.
452. Kimberley Reeves, Southwark Council Regeneration and Environment Department on 24 June 1996.

453. Plaque on Palyns states: 'These houses built in 1980 replace six almshouses built in 1852 in Montpelier Road Peckham which themselves replaced the original six almshouses founded in 1609 in Pesthouse Row, St. Luke's, Finsbury as a result of a bequest from George Palyn Citizen and Girdler.'

454. Letter dated 25 July 1996 from Carol Quamina, Regeneration & Environment Department, Southwark Council.

455. Letter dated 7 November 1995 from Ray Collins, Southwark Council Regeneration & Environment Department.

456. Date is on wall of Beehive.

457. Information provided on 5 October 1996 by Mrs Gill Frost, a governor of St. James the Great Catholic Primary School.

458. Letter dated 2 October 1996 from Ray Collins, Regeneration & Environment Department, Southwark Council.

459. Information provided in August 1997 by Ray Collins, Regeneration & Environment Department, Southwark Council.

460. Information provided on 16 September 1997 by Ray Collins, Regeneration & Environment Department, Southwark Council.

461. Letter dated 2 January 1997 from Pat Kent, Regeneration & Environment Department, Southwark Council.

462. Letter dated 6 October 1997 from Ray Collins, Regeneration & Environment Department, Southwark Council.

463. Information provided on 13 October 1997 by Ray Collins, Regeneration & Environment Department, Southwark Council.

464. *ILEA Contact* 26 June 1981.

465. Brochure on Sycamore Park produced by Tower Housing Association.

466. *The history and antiquities of the County of Surrey* by Owen Manning and William Bray. John White, 1804.

467. Information obtained on 22 December 1997 from The Spotted Frog.

468. *Whitaker's Almanack 1994*. J. Whitaker, 1993.

469. *Southwark News* 27 November 1997.

470. Ann Bernadt April 12th 1948 – December 18th 1996 – A celebration of her life.

471. Plaque on outside wall of former Adys Road School.

472. Letter dated 7 March 1997 with accompanying information from Ray Collins, Regeneration & Environment Department, Southwark Council.

473. Letter dated 29 July 1997 from Ray Collins, Regeneration & Environment Department, Southwark Council.

474. Information provided on 30 March 1998 by Nick Burton, Groundwork Southwark.

475. Education Service Information (London County Council, 1937).

476. Information provided on 5 June 1998 by WPC Sally Williams.

477. Information pack prepared for the opening of Joe Richards House.

478. Letter from Karen Burgess, Patient Services Manager, Lambeth Southwark & Lewisham Health Authority sent in July 1998.

479. *Repeat Prescription* by Isidore Crown (Keter Classics, 1996).

480. Information provided on 6 July 1998 by Mrs Khoja, Manager of St Andrew's Nursing Home.

481. Information provided on 28 January 1999 by Kimberley Reeves, Regeneration & Environment Department, Southwark Council.

482. Roads at Peckham Partnership Developments.

483. *The Standard Street Guide to London* (Geographers' Map Co, n.d. 224 pages price 6d).

484. *The Concise Dictionary of National Biography*. The Softback Preview, 1993.

485. *South London Press* 11 May 1999.

486. Letter dated 18 July 2000 from Ian Ogden, Lead Officer, Street naming & Numbering, Southwark Council.

487. *South London Press* 17 October 2000 (p. 41).

488. *Peckham Rye Park Centenary* by John D. Beasley. South Riding Press, 1995.

489. Newsletter of the East Peckham Consortium (No 3 July 2000).

490. Beasley, John D., *Transport in Peckham and Nunhead* (South Riding Press, 1997).

491. *SAVO News* February 2001.

492. Man from Mantis on 16 March 2001.

493. Information provided by Ian Ogden on 25 April 2001.

494. Information provided in April 2001 by Ian Ogden (Southwark Council).

495. Tilson Close was originally planned to be Tilson Mews. Information provided by Ian Ogden (Southwark Council) in April 2001 and October 2003.

496. Edna and John Spicer, residents of this sheltered accommodation run by Hyde Housing, on 30 May 2001.

497. *Peckham Society News* No. 78 (Winter 1999/2000).

498. Letter from M. N. Siddiqi of L. E. Estates Ltd dated 13 July 2001.

499. *South London Press* 4 September 2001.

500. *Southwark News* 6 September 2001.

501. Plan of Eligible Freehold Building Land at Peckham, Surrey for sale by auction by Mr W.H. Collier at the Victoria Tavern, Choumert Road on Monday 13th October 1873.

502. Various press reports including *Southwark News* on 29 November 2001.

503. Letter dated 24 December 2001 from Ian Ogden, Lead Officer, Street Naming & Numbering Section, Development Control, Southwark Council.

504. *The Guardian* 5 January 2002.

505. Letter dated 30 April 1999 from A.K. Brunwin, Laing Homes Limited to the London Borough of Southwark Street Naming and Numbering Section.

506. Information provided on 26 April 2002 by a member of staff at Lister Primary Care Centre.

507. *Peckham Society News* No. 82 (Winter 2000/2001).

508. *South London Press* 14 November 2000.

509. *Nunhead & Peckham Pubs Past and Present* by Ron Woollacott (Magdala Terrace Nunhead Local History Publication, 2002).

510. Information provided by Paul Gilby of Gilby Construction in May 2002.

511. *Peckham Society News* No. 87 (Spring 2002).

512. Letter dated 15 August 2002 from Chris Chambers of Anchor Trust.

513. *A Historical Tour of Nunhead & Peckham Rye* by Ron Woollacott. (Maureen and Ron Woollacott, 1995).

514. *Peckham Society News* No. 89 (Autumn 2002).

515. *Peckham Society News* No. 73 (Autumn 1998).

516. *The Story of Peckham and Nunhead* by John D. Beasley (London Borough of Southwark, 1999).

517. Information provided on 6 January 2003 by Veronica Alden.

518. Letter dated 10 January 2002 from Simon Cocks, Assistant Development Manager, Laing Homes.

519. *Collins Dictionary of the English Language* (William Collins Sons & Co. Ltd., 1986).
520. Information provided on 17 January 2003 by Ian Ogden of Southwark Council.
521. *South London Press* 10 September 1976.
522. Information provided by Ian Ogden, Southwark Council, on 22 April 2003.
523. *Southwark News* 6 November 1997.
524. A person who attended The Peckham Society AGM on 27 April 2003.
525. Information provided by Martin Berry Partnership on 7 May 2003.
526. *The Guardian* 27 September 2003.
527. Information provided by Ian Ogden (Southwark Council) on 21 October 2003.
528. *East Dulwich: An Illustrated Alphabetical Guide* by John D. Beasley. South Riding Press, 1998.
529. Information provided by Ian Ogden (Southwark Council) in November 2003.
530. *The Scottish Martyrs: The Story of the Political Reformers of 1793-4* by Wally Macfarlane. Friends of Nunhead Cemetery, 1983.
531. Inscription in Wally Macfarlane (sic) Room in Parkside Neighbourhood Offices, Bournemouth Road.
532. Information provided by Ian Ogden (Southwark Council) on 12 December 2003.
533. *Kelly's Directory of Peckham Nunhead and Camberwell*. Kelly's Directories, Ltd., 1922.
534. *Peckham and Nunhead Remembered* compiled by John D. Beasley. Tempus Publishing, 2000.
535. Carol Thompson of 29 Soames Street on 9 September 2004. She worked for the Colmore Group.
536. *Southwark News* 9 September 2004.
537. Information provided on 23 July 2005 by Dick Daly.
538. Information provided on 19 August 2005 by Ian Ogden, Southwark Council.
539. *Whitaker's Almanack 1979*.
540. Information provided by Barrett Homes on 28 October 2005.
541. Letter from John Todd in *Peckham Society News* No. 102.
542.' Cheese and Chancery – The legacy of Bryen McDermott' by Richard Olney (2006).
543. *South London Press* 24 January 2006.
544. Note dated 29 January 2006 from Mr A. Patel of St Georges Letts.
545. Information provided on 28 January 2006 by Ian Ogden of Southwark Council.
546. *The Sassoon Dynasty* by Cecil Roth (Robert Hale, 1941).
547. *Southwark News* 13 July 2006.
548. *South London Press* 18 July 2006.
549. Ian Ogden, Southwark Council, on 29 August 2006.
550. Information given by Ben Sassoon to John Beasley on 11 June 2007.
551. Email from Brian Turton to Sue Hill dated 15 June 2007.
552. *Peckham and Nunhead Biographical Dictionary* being written by John D. Beasley. The unfinished book can be seen in Southwark Local History Library.
553. Letter dated 17 July 2007 from Ian Ogden (Southwark Council – Regeneration and neighbourhoods).
554. Letter dated 5 September 2007 from Joyce Mabena, General Manager, Cherrycroft.
555. Information provided by Ian Ogden (Southwark Council) on 8 October 2007.
556. Letter dated 17 January 2008 from Charles Barclay.
557. A drawing of Gordon's Brewery was published in *The Building News* on 12 January 1877.
558. Letter dated 17 June 2008 from Michael Smith, Presentation Housing Association.
559. Outreach – Newsletter of Peckham Methodist Church No. 1 June 2003.

560. *Peckham Society News* No. 87 Spring 2002.
561. acme: Supporting art & artists since 1972 (summer 2006).
562. Chandra Mohan of the Family Housing Association in July 2008 managed to track down a former colleague who suggested the name and the reason for doing so.
563. Information provided by a member of staff of The Duke on 6 August 2008.
564. *Peckham Society News* No. 112 (Summer 2008).
565. Information provided by Ian Ogden of Southwark Council on 27 August 2008.
566. Email dated 4 September 2008 from Phil Bale, chair, EQRA.
567. *Southwark Remembered* by John D. Beasley (Tempus Publishing, 2001).
568. Letter from Harinville Ltd in June 1995.
569. *Nunhead with Peckham Rye & Neighbourhood* by Ron Woollacott (Magdala Terrace, Nunhead, Local History Publication, 2008).
570. *An Index of London Schools and their records* by Cliff Webb (Society of Genealogists Enterprises Ltd, 2007).
571. *Southwark Sparrow* 21 May 1993.
572. *The Peckham Society News* No. 108 (Summer 2007).
573. Article on Wally Macfarlane written by Ron Woollacott.
574. *The Peckham Society News* No. 113 (Autumn 2008).
575. Date is on the top of the pub.
576. *The Peckham Society News* No. 109 (Autumn 2007).
577. *South London Press* 18 October 1935 (quoted in *The Peckham Society News* No. 110 p. 12).
578. *The Peckham Society News* No. 111 (Spring 2008).
579. Letter dated 20 October 1994 from Charles A. Pennack of Great Baddow, Essex.
580. *The Peckham Society News* No. 95 (Autumn 2004).
581. *The Peckham Society News* No. 102 (Winter 2005/6).
582. Letter dated 3 May 1993 from the Revd Kenneth Leech.
583. Letter dated 11 November 2002 from Ken Taylor.
584. *The Peckham Society News* No. 92 (Summer 2003).
585. Plaques at the Victorian St Mary Magdalene School in Godman Road.
586. *The Peckham Society News* No. 83 (Spring 2001).
587. *South London Press* 24 May 1994 and a member of staff at Sally Mugabe House.
588. *The Peckham Society News* No. 78 (Winter 1999-2000).
589. *The Peckham Society News* No. 110 (Winter 2007/8).
590. *The Guardian* 19 November 2007.
591. *Southwark Local* 14 August 1998.
592. *Transport in Peckham and Nunhead* by John D. Beasley (South Riding Press, 1997).
593. Information provided on 14 October 2008 by Terence Wynn of McGovern Wynn Architects of Maldon, Essex.
594. Information provided on 13 October 2008 by Ian Ogden of Southwark Council.
595. Information provided on 10 and 13 October 2008 by Penny Nicholls of Rye Oak Primary School.
596. Information provided by John Whitten on 14 October 2008.
597. Letter dated 1 May 2007 from Bridget Howlett, Senior Archivist, London Metropolitan Archives.
598. Letter dated 15 October 2008 from Robert Mulvey.
599. Information provided on 17 October 2008 by Alshep Patel.

600. Information provided by the London City Mission on 17 October 2008.

601. In a letter dated 20 June 2007 Spencer Hobbs stated that Hanover Chapel was 'pulled down some time between March & September 1915'.

602. Email dated 22 October 2008 from Philip Purkiss, Development Manager, Servite Houses, 2 Bridge Avenue, Hammersmith W6 9JP to Greg Henderson-Begg of Wandle Housing Association.

603. Information provided on 29 October 2008 by Ian Ogden, Street Naming Manager, Southwark Council.

604. Information provided on 3 November 2008 by Mantle Developments UK Ltd.

605. Information provided by Santander in January 2010. Santander has owned Abbey since 2004.

606. *Peckham Society News* No. 118 (Winter 2009/10).

607. *Peckham Society News* No. 115 (Spring 2009).

608. *The Brother Gardeners: Botany, Empire and the Birth of an Obsession* by Andrea Wulf (William Heinemann, 2008).

609. The Oglander in 2010 is closed but 1883 can still be seen on it.

610. *Peckham Society News* No. 114 (Winter 2008/9).

611. *Peckham Society News* No. 82 (Winter 2000/2001).

612. *Peckham and Nunhead Through Time* by John D. Beasley (Amberley Publishing, 2009).

613. *The Bitter Cry Heard and Heeded: The Story of the South London Mission of the Methodist Church 1889-1989* by John D. Beasley (South London Mission, 1989).

614. Information provided in February and March 2010 by Ian Ogden, Group Manager, Technical Support, Southwark Council.

615. Information provided by the Italian restaurant on 24 February 2010.

616. *The Illustrated London News* 10 July 1858.

617. *The Building News* 12 January 1877.

618. *Peckham Rye Park Centenary* by John D. Beasley. South Riding Press, 1995.

619. Old Ordnance Survey Maps. Deptford (North) 1914. The Godfrey Edition.

620. In 2009 the developer refused to tell the editor of *Peckham Society News* the reason for choosing the name Ashleigh.

621. Information provided in February 2010 by John Coulter, Lewisham Local Studies and Archives Centre.

622. *Read about Lewisham Street Names and their origins (before 1965)* written and published by Joan Read. (1990).

623. *Southwark Civic News* July 1971.

624. London Borough of Southwark Presentation of the Honorary Freedom of the Borough to Councillor Mrs M. V. Goldwin.

625. *Peckham Society News* May 1989.

626. Information provided by Ian Ogden on 15 March 2010.

627. *Peckham Society News* No. 105 (Autumn 2006).

628. Information provided by Ian Ogden on 17 March 2010.

629. Letter received on 30 March 2010 from Ms S. Kus of Marden, Kent.

630. Information received from Edwin Emakpose of Southwark Council on 31 March 2010.

631. Origin of bookshop 'Review' name provided by owner Roz Simpson.

Also available from Amberley Publishing

Peckham & Nunhead
Through Time

John D. Beasley

ISBN: 978-1-84868-290-0

£12.99 PB